Celtic Britain and Ireland

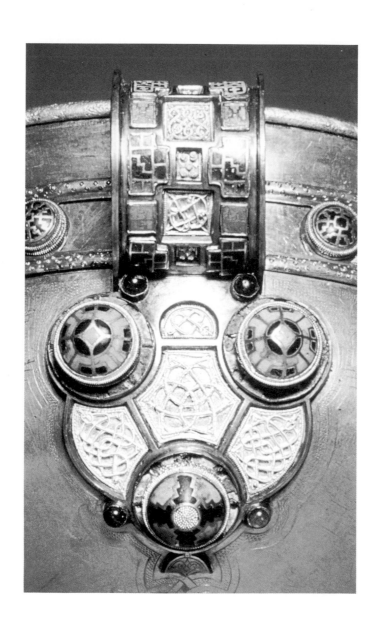

Celtic Britain and Ireland
Art and Society

Lloyd and Jennifer Laing

LONDON NEW YORK SYDNEY TORONTO

First published in Great Britain 1995 by
The Herbert Press Ltd, 46 Northchurch Road, London N1 4EJ

House editor: Susan Malvern
Designed by Pauline Harrison
Set in Columbus
Typeset by Nene Phototypesetters Ltd, Northampton
Printed and bound in Hong Kong
by South China Printing Company (1988) Ltd

CN 1039

Frontispiece: Ardagh chalice escutcheon (National Museum of Ireland)

Contents

ACKNOWLEDGEMENTS

OUR THANKS are especially due to Jeffrey May, who read considerable sections of the book in draft to its advantage, and to those who helped us in collecting pictures, and who provided drawings or photographs: Caroline Bevan, Barry Cunliffe, Philip Dixon, James Kenworthy, David Longley, Jeffrey May, Rosalind Niblett, Keith Parfitt, Chris Rudd, Richard Savage, Gwen Seller, Roger White, Niamh Whitfield, Priscilla Wild and particularly Howard Kilbride-Jones who permitted us to use so many of his drawings, and the Green Studio, Dublin who allowed us to use their colour transparencies.

PREFACE

Many areas of Europe enjoyed a Celtic past. Celtic culture and/or language is distinguishable in varying degrees in the archaeological and historical records of Britain, Ireland, France, Belgium, the Netherlands, northern Italy, Germany, Austria, the Czech Republic and Slovakia, Hungary, Romania, Poland, the former Yugoslavia and Spain. Celtic artworks have been found more widely still. Celtic languages are still spoken by around two million people, among whom are about half a million in Wales, 90,000 in the Western Isles of Scotland and perhaps 100,000 in Brittany. The majority are in the Irish Republic. Immigration in the past few centuries has resulted in large areas of the world being populated by people of Celtic ancestry. The Irish potato famine and the Highland clearances in the nineteenth century forced many Scots and Irish to emigrate to the United States, Canada, New Zealand and Australia. The Welsh went in large numbers to Patagonia in 1865, and Welsh was spoken by around 8,000 people in the 1970s. Celtic culture is discernible archaeologically from the seventh century BC until the twelfth century AD, with elements persisting long after in some areas.

Of the many groups of people that have formed the population of the British Isles and Ireland, the Celts are undoubtedly among the most charismatic. Their roots lie in prehistoric Europe – traceable to around 2,500 years ago. This longevity is remarkable less for continuity of settlement (which has happened in many other areas), than for certain features which have survived. Many 'Celtic' survivals can be distinguished today, in addition to the very many which are the result of conscious revivals.

Part of the charm and importance of the study is that 'Celt' and 'Celtic' are terms which have changing and differing meanings for different people at different times. Even the correct usage of the term 'Celt' itself is disputed, some preferring to limit it to a linguistic meaning, others attaching it to an Iron Age archaeological culture on the Continent. For others it still conjures up the wild, free spirit of dark-haired, hard-living individuals. Music, poetry, carousing and fighting figure strongly in this view of the Celts. For others 'Celtic' has modern, nationalistic connotations. This plurality of interpretations is, paradoxically, one of the qualities that has always been characteristic of the Celts and their cultures.

It is therefore not surprising that study of the Celts has caused an inordinate number of heated arguments and controversies between scholars. Very few statements can be made that would be wholeheartedly accepted by all. Unless such controversies are particularly relevant to the theme of this book we have been forced, for the sake of clarity and space, to omit them. As a result, the text undoubtedly lacks a sufficient number

of words such as 'probably', 'arguably', 'one school of thought suggests' or 'controversy surrounds' to satisfy purists. In attempting to draw together material from such minefields, the writer automatically produces yet another, personal, viewpoint. If a particular aspect or feature does not appear in these pages it is not necessarily because we consider it unworthy of prominence. It is characteristic of the material that on many occasions in the following pages even the authors disagree over the opinions expressed or the slant given, and some sentences may reflect the view of one but not the other and others may be compromises which satisfied neither. Yet, the problem of defining and pinning down the phenomenon should not prevent us from addressing it and we hope that by the end of the book the reader will have gained some insight into the ancient Celts and their world.

We have chosen to explore the Celts mostly through their art, partly because it is a close reflection of society's values and beliefs and because it comprises a significant portion of our evidence for the early Celts. Appropriately, Celtic art is paradoxical, ambivalent, even elusive in its inner meanings. Its extraordinary endurance, albeit with modifications, is a mark of the close intellectual rapport between Celts, both across geographical areas and historical time spans.

Possibly frustrated by the lack of more tangible evidence, many scholars have approached Celtic art from preconditioned art-historical viewpoints. They have striven to distinguish 'styles' and to set them in chronological order. In an ideal world, each style would follow the last, perhaps growing out of it, with the minimum of overlap. But Celtic art is the product of a very slowly evolving society (unlike the societies that produced the High Renaissance, mannerism, baroque and neo-classical styles, for example). This enduring character of Celtic society is reflected most clearly in its long-lived art styles. Although some developed later than others, 'new' styles coexisted with the old and both could be employed on the same object. Elsewhere in the literature on Iron Age art in Britain and Ireland readers will encounter numbered styles, or styles named after famous pieces. Such schemes are very valuable for the stylistic analysis of particular pieces, but are not especially helpful to the general reader in formulating a picture of the overall character of Celtic art. Because of the confusion that accompanies this phenomenon, the attribution of particular pieces to named styles has been avoided in this book.

The book is not a 'history' of Celtic art – that can be found in several general surveys, including one by the present authors, listed in the further reading at the end of the book.

Instead of examining art in isolation, the book considers art in its context, as part of society up to the twelfth century. We attempt to indicate some of the complexities of relationships between artists, craftspeople, artisans, patrons, admirers, designers and the products themselves.

Discovering the Celts and their Art

THE WAY THE CELTIC PAST has been viewed and is viewed today is coloured by the type of evidence available as well as the development of archaeological and historical thought since the nineteenth century.

The Evidence

It is salutary to reflect that the perishability of objects has little bearing on the standard of living of their owners. Simply because the Romans lived in stone buildings which have sometimes survived does not necessarily mean that the occupants were better off materially than their Celtic neighbours whose remains are sparse. Carved wooden walls and furniture, fine cloth, leather goods, furs, fillet steaks and succulent pastries after all, add up to a comfortable life without necessarily adding to the contents of archaeological finds' trays. The material available for study has been randomly selected by the agency of time and is at least partly the reason for the enigmatic character of Celtic culture. A substantial proportion of the more spectacular artworks has come from hoards – the ancient equivalent of putting savings in the bank for safekeeping was to bury them. The safest places were in areas where there was no habitation, so when found they often lack any archaeological associations. Unless the hoards themselves contain securely datable material they give rise to extensive debates. In later periods the deposition of hoards can sometimes be equated with specific historical events such as the Viking raids or the Roman conquest.

Dating Methods

Methods of dating archaeological material are numerous. Unfortunately, remarkably few are relevant for the Celts. There is practically no written evidence for the prehistoric period and what little documentary evidence exists for later periods is often difficult to interpret and partisan, since virtually the only literate individuals were clerics. Dating is easier where there are plentiful written documents, especially datable coins. For example, an undamaged mosaic which is found to have a coin datable to AD 360 underneath it, could not possibly have been laid down before this date. New pottery in distinctive shapes in crates at Pompeii has been securely dated since it clearly existed on 24 August AD 79 when Vesuvius erupted and Pliny the Younger wrote a graphic account of the event. Because styles of such pottery changed rapidly identical forms found elsewhere in the Roman Empire can confidently be dated to around this time.

By association, other material can thus be dated and dates of occupation or destruction can be established.

For students of the Celts, such luxuries as firm historical dates are generally absent. With the exception of a limited number of imported pots found only on some high-status sites, ceramics are very difficult to date. Celtic society was relatively static and many everyday objects retained the same appearance over very long periods of time. Although the later Iron Age Celts possessed coins, they do not bear dates or datable information, and even when they carry the names of kings or chiefs the precise dates are rarely determinable from historical information. While a Roman archaeologist might be able to pinpoint a date to within a few months or even (rarely) a particular month, the Celtic scholar often has to be content with a date-span of a hundred years or more.

Among the most useful guides for dating early medieval Celtic art is the occurrence of objects in Viking graves in Scandinavia, which can be fairly closely dated by other means. Unfortunately, the graves only provide a date when the objects were buried, not when they were made. Since most Celtic objects were looted, they could quite easily be a century or more older than the grave in which they were deposited.

Occasionally organic material can be dated by radiocarbon, but even then accuracy is rarely closer than plus or minus fifty years, and usually the date bracket is much wider. Tree-ring dating is being used increasingly for sites in early medieval Celtic Ireland, but structural timbers are rarely sufficiently well-preserved for it to be exploited.

Throughout the long period covered by this book, the main clues to date are provided by brooches, which were subject to relatively frequent changes of fashion. The styles are not as closely datable as those of Roman brooches, however, so again, at best they can usually provide a date only to within a century.

Attitudes to Funding Archaeology

An important factor in Celtic archaeology (and, incidentally, Saxon) is that the first archaeologists were rich, often titled, nineteenth-century gentlemen whose interest was partly curiosity about their country estates and partly the collector's instinct. More recently archaeology has been driven by tourism, so tangible and visible remains, preferably with a good measure of treasure, have attracted more funding bodies than insubstantial sites which are primarily of academic interest.

Things have changed in the past few decades. Aerial photography, developed during World War I, has revealed thousands of hitherto unknown sites from all periods. Among these are modest Celtic settlements occupied during the Roman period but previously barely suspected of having existed. Improved excavation techniques are recovering information missed by earlier investigators.

There has also been a change in the attitude of the public who now show greater interest in the lives of ordinary people in the past. As a result, more material is being recorded and studied.

The Remains

With major exceptions of churches, hermit cells and monasteries, Celtic building in most areas was of wood and has consequently not survived. Excavation of such sites is complex, frustrating and requires particular skill. Traces of wooden posts and other disturbances in the ground are often distinguishable in excavation merely by changes in texture or colour of soil. Thus the chief surviving materials for the early Celts comprise objects made of stone, pottery, metal or bone, along with pollen or other remains not readily visible to the naked eye.

With such limited evidence, we must rely on artworks made of durable materials to provide an insight into not only trade and technology, but the intellectual processes prevalent among the people. Although artists undoubtedly used perishable materials, most of what has survived is metal-work, usually in bronze, occasionally in precious metal or iron. From the Early Iron Age in Britain almost all surviving Celtic art is in metal – sculptures are extremely few. In contrast, sculpture makes up the bulk of the evidence for the Roman centuries in Britain. After a lull in the fifth to seventh centuries when it is of lesser importance, sculpture once more figures prominently in the art of the early medieval period. In this period a new medium is encountered – manuscript art.

There is very little Early Iron Age Celtic art in Ireland prior to the birth of Christ, and not much more of the first to fifth centuries AD. With the sixth century the pattern is reversed: there is an abundance of art in Ireland, very little in Britain, and from the seventh century onwards virtually none outside Ireland and northern Scotland.

In the Early Iron Age much (though by no means all) of the art is presumed to be of secular origin. In the Dark Ages/early medieval period it is mostly inspired by the Christian faith.

As a result of all these factors each period has its own distinctive characteristics.

The 'Celticization' of Britain

Celtic culture is first readily distinguishable in the British Iron Age, but it appears to have evolved slowly as a result of Continental contacts out of a Bronze Age farming society. A variety of circular buildings of wood or stone, sometimes clustered, sometimes standing by themselves in a landscape of fields, ditched enclosures and droveways have been investigated from this period. There were no towns as we think of them, but the variety of settlement types indicates a corresponding social hierarchy. Horsemanship, fighting and display were important, and cauldrons and buckets perhaps indicate the love of feasting later shared by the Iron Age Celts. Water seems to have been important in cult practices, just as it was later. Many of the basic elements usually associated with Celtic life were already apparent, and among the monuments of the later Bronze Age was the hillfort, later typical of the Iron Age Celts.

It is generally agreed that two main European cultures had an impact on Bronze Age Britain, and were the catalysts for the development of

British Celtic society. The first is not universally regarded as truly Celtic – Iron Age Hallstatt, named after a site in Austria. It endured roughly from 700 to 500 BC. The second is generally accepted as the definitive early Celtic society and was the culture in which Celtic art evolved. It is known as La Tène, after a site in Switzerland, and spans the period from the fifth century BC until the Roman conquest. The ways in which new cultural traits were introduced to Britain and Ireland are subject to intense debate. In the late Iron Age in south-eastern Britain, also subject to debate, further cultural traits were introduced as a result of close connections with north-eastern Gaul, which some have linked to Julius Caesar's reference to an invasion of Belgae. This very developed culture shows strong Celtic features.

Once established, Celtic society was temporarily disrupted in southern England, but continued to flourish for nearly a century after Julius Caesar's campaigns in 55 and 54 BC, with increasing influence from the Roman world. During the Roman period (AD 43–409) it subtly meta-morphosed into a hybrid Romano-Celtic (usually referred to as Romano-British) culture, in which some of the most outstanding achievements were in art.

The Romans had virtually no direct influence on the extreme north and west of Scotland or Ireland, and weak influence in what became Wales and the south-west peninsula of England. These areas continued an essentially Iron Age culture throughout the Roman period. With the departure of the Romans, a period of two centuries followed in which virtually nothing was written down on durable materials and in which Anglo-Saxon enterprise slowly changed the Roman province of Britannia into England. Many small Celtic kingdoms were left in other areas, eventually to become unified into the present-day groupings. Christianity was established in Britannia by the early fourth century, lapsed in the mid-fifth and was re-established in late sixth-century England. It was present in the fourth or fifth century in Wales, Scotland and south-west England, and was adopted in the early fifth century in Ireland. In the late eighth and ninth centuries the Vikings made an impact on Celtic and Anglo-Saxon culture and from the eleventh century onwards the Normans further modified the areas they settled. Ireland, Scotland, Wales and the Isle of Man were considerably influenced by England but it is notable that the 'Celtic fringe' has retained a sense of identity in the face of these later cultural onslaughts.

Historical date brackets used:
Early Iron Age From seventh century BC to AD 43 in most of England and Wales, and from the seventh century BC to AD 400 in Ireland, most of Scotland, the Isle of Man, and the south-west peninsula of England.
Dark Ages/Heroic Age The fifth and sixth centuries in both Celtic and Anglo-Saxon areas.
Early Christian Period/Early Medieval Period The fifth to twelfth centuries in Celtic Britain and Ireland.

Scholarly Opinion on the Celts

Naturally, such complex changes in society have not escaped scholarly controversy. Traditionally, nineteenth- and early twentieth-century archaeologists saw the origins of Celtic culture in Britain as being the result of immigration from the areas of the Continent occupied by people of iron-using Hallstatt and La Tène cultures. The term 'culture' was used to mean the archaeological evidence for a way of life – settlement and house types, technology, economy, pottery, tools, weapons and art. By extension, it also meant a particular social organization. The appearance of new artefacts on the Bronze Age scene was seen as inevitably heralding the arrival of Celts *en masse*. This view was reached partly because of the political and social climate of the time, which was coloured by the way in which the British Empire was being expanded. Transmission of cultural traits was seen as possible only as a result of large-scale invasion of racially distinct people. More recent experience has shown that cultural features may be spread by other means, particularly exchange mechanisms – little or no immigration needs to have taken place to explain the appearance of new objects or customs in a society. A good analogy is the Americanization of Britain after World War II when all things American, from nylons to movies and fast-food restaurants, were seen as appealing, without any large-scale migrations or invasions.

It is for these reasons that Iron Age Celtic culture in Britain is now seen as part of a continuous development from native, Bronze Age tradition on to which new ideas, technology and artefact types were grafted through contact with Continental neighbours.

The introduction of iron-working from the 'Celtic' Continent to Britain around the seventh century BC was undoubtedly important: it is likely to have created a buoyant trade arena in which other objects and possibly outlooks and attitudes could have been transmitted. Locally-made iron objects, as well as imports, have been found in a hoard at Llyn Fawr in Glamorgan, dated to this time. Although, henceforward, Britain may be said to have been technically an Iron Age society, the ferrous metal was not used very extensively until perhaps the end of the period. It is, however, easy to understand that a culture which possessed such important knowledge must have been attractive in other aspects, so that the traditional archaeologists' view that iron was a key to tracing Celtic culture was based on reasonable logic.

There is a significant body of evidence to suggest that imports were coming into Britain from the Continent throughout much of the Iron Age. It is such trade that led the nineteenth-century scholars to assume a widespread and probably hostile migration of people. There is, however, very little real evidence for immigration on any scale to corroborate the nineteenth-century views.

Incomers are likely to have been involved in the development of the distinct late La Tène culture in south-east England in the first century BC, that we have seen has been equated with Caesar's Belgae. This is accepted by most but not all scholars as Celtic since Caesar nowhere mentions Celts in respect of Britain. It was for long equated with the appearance of

coinage, wheel-thrown pottery and other intrusive traits in south-east England. Although it is not doubted that the earliest gold coins were imports from the Continent, it is now felt they were not necessarily introduced by immigrants, but may initially have been diplomatic gifts or payments, and that the wheel-thrown pottery may likewise not have been produced by incoming settlers. Despite this, and other arguments that have been advanced in favour of continuing British isolation from Continental settlement, many archaeologists still favour the view that there was some immigration of warrior aristocrats in the later Iron Age who may have taken over at the top among the tribes of southern Britain, particularly in Hampshire where the Roman name for Winchester – Venta Belgarum – perhaps preserves a pre-Roman tribal derivation.

In Ireland there is a similar dearth of evidence for any Iron Age settlement from the Continent. Although a few imports can be recognized which have come from the Continent and possibly Britain, there is even less evidence in Ireland for an intrusive, developed Celtic 'La Tène' culture arriving. The first iron objects are encountered in contexts from around 600 BC, but there is an argument for suggesting that Bronze Age culture continued very late in the area. In contrast to Britain, there is no pottery with La Tène affinities.

It must therefore be assumed that the 'Celticization' of peripheral areas (Cornwall, Wales, Ireland and the Western Isles for example) was gradual and probably first manifested itself in ways that have left no tangible evidence.

Celtic Language

Language is one important non-material way in which culture is transmitted: a modern example is the fact that a large proportion of nouns used by French youth are currently of English origin. It is now considered that Celtic languages probably evolved over a long period of time in prehistoric Europe, and that not all speakers of a Celtic language possessed a diagnostic 'Celtic' culture, just as not all people displaying features of Celtic La Tène culture necessarily spoke Celtic. This phenomenon is also not unknown today – not all English speakers are English nor do they necessarily share similar cultural traditions. The earliest 'texts' in Celtic in Europe have come to light in recent years in northern Italy, in the form of an inscription from Prestino (Como) which has been dated to the mid-sixth century BC. An inscription from Sesto Calende in the same region has been claimed as Celtic and to date from probably the seventh century. If this is correct, it shows that a form of Celtic was being spoken in northern Italy several centuries before the traditional Celtic invasion of the area recorded in classical sources. Moreover, this was well before the development of the archaeologically defined La Tène Celtic culture.

It is becoming increasingly clear that Celtic languages, which are all closely related to the parent Indo-European tongue (which may have been introduced to Europe by the first farmers), evolved in different parts of Europe by the second millennium BC, and were being spoken before a

'Celtic' culture, as traditionally defined by archaeologists, had come into being.

Currently, people in several areas speak Celtic languages and both Wales and Ireland use a Celtic language in official documents and pro-nouncements. The only surviving (but rapidly declining) Continental Celtic language is Breton. Irish, Scots, Gaelic and Welsh have never died out. Cumbric, the language of north-west England, survived until the tenth century or later. Celtic language was continuously in use in Cornwall down to the eighteenth century and Cornish has been deliberately 'revived' recently. Manx is similarly being revived, possibly having never totally died out.

Art

The most spectacular tangible and visible evidence for Celtic culture of all periods lies in the sphere of art. For a society to sustain an artistic reper-toire of any substance it requires considerable surplus to maintain the artists and produce the raw materials. By the time Celtic culture is dis-tinguishable in Britain, this level of development had already been achieved, but with the increasing prosperity of the Iron Age artistic out-put burgeoned.

Early art had a number of aspects that are different from contemporary art. The addition of 'art' to objects could increase their value as potential items in gift exchange, it could increase the status they conferred on their owners, it could give them special powers which the art itself represented, or it could do all of these things.

The 'value' of an object was not necessarily related to the time and effort spent on its production or the quality of the workmanship, though these clearly were factors. Similarly, simply because an object would normally be found serving a mundane and utilitarian purpose does not mean that it could not also serve in a ritual context. In such instances, however, there are often additional clues – if it has been made with particular care or the context is significant, for example.

To understand the role of the artist in ancient societies it is very im-portant to put aside ideas of 'art for art's sake' or 'art for the artist's sake'. It is generally assumed that ancient artists were not trying to express them-selves, though no doubt they found personal satisfaction in a job well done. They were working for their patrons, whether these were indi-viduals of high status in society or priests, and they operated within clearly defined limits. Their objectives were not the innovation of new forms of art, but the interpretation of traditional designs in acceptable forms. The artist as such probably did not exist: instead there were craftsmen/women whose skills in smithery were estimated more highly than their mastery of designs.

We cannot tell with certainty whether the Iron Age smiths, artists and designers were different individuals. There are as yet no known Iron Age sites devoted exclusively to industrial production. Some tentative answers to these problems can be gleaned from the later periods, but whether

craftsmen were itinerant or based on permanent workshops has not yet been satisfactorily resolved. No firm evidence can be discovered about the gender of the workers either.

It is not surprising, however, that it was the silver and goldsmiths who were rated above the engravers of designs in early medieval Celtic society, though they did not transcend in importance those in other crafts. An eighth- or ninth-century Irish text, the *Uraicecht Becc*, records that the gold and silversmith had an honour price of 7 sets, which was greater than the honour price of 1 dairt (half a set), which was the value put on the engraver, the leather maker and the comb maker (a set being the value placed on a heiffer or half a milch cow). Goldsmiths and silversmiths, however, shared the same honour price as the physician, the wright, the blacksmith and the coppersmith.

What is certain is that art played a prominent part in Celtic society of all periods and is a major binding factor between the ages and the regions. Superficially, the art of the Iron Age Celts and that of the Dark Ages has much in common, and some elements survived from the earlier period into the later. A number of devices are peculiar to each of the main periods and a familiarity with these greatly enhances enjoyment and under-standing of the art of all periods including the present day. Celtic patterns have enjoyed a special appeal recently, on occasion being used as therapy for certain mental disorders. Examples of pattern and motifs, often juxta-posed with bewildering complexity, will be seen throughout this book. Readers may like to peruse the appendix on the language of Celtic art before continuing with the next chapter (p. 204).

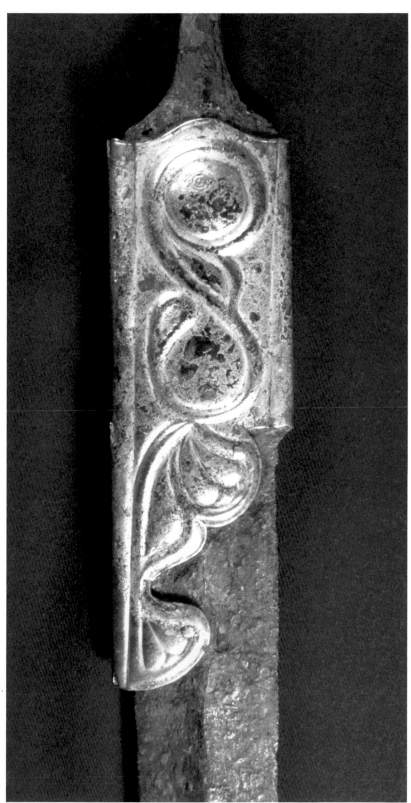

Chertsey Scabbard mount and sword,
Surrey (Chertsey Museum)

Iron Age Britain and Ireland

DURING THE IRON AGE La Tène Celtic culture became well established in Ireland and Britain. Indeed, it is this period that is often viewed as characteristic of Celtic society, from which everything that follows is merely a shadow or a deliberate revival. Certainly it can be regarded as the cultural foundation which was modified and metamorphosed as a result of challenges from outside, leading to its development in the present day.

Much is known of the structure of Iron Age society, art and way of life from a variety of sources, including literary, since, from the first century BC onwards, classical writers began to take more interest in Britain and its social organization. By the late first century BC and early first century AD the names of some tribes are known, and those of their kings. Of these, Commius, Verica, Eppillus, kings of the Atrebates, Tasciovanus of the Catuvellauni, and Cunobelin of the Trinovantes are the most notable.

The Structure of Society

Although until the time of Julius Caesar the classical accounts relate to the Continental Celts rather than the British, it is clear that in general terms there was little difference in social structure on either side of the Channel, and from the mid-first century BC the picture can be filled out from references to Britain.

Data can also be gleaned from native Celtic sources that were set down in Ireland in the Early Middle Ages which reflect a society that existed in Ireland and probably also in Britain in the pre-Roman Iron Age. Iron Age Britain must have had a heroic spoken tradition since many later literary sources clearly relate to a more ancient society. The name Caradoc (Caradawg), for example, may have been popular amongst the princes of early medieval Wales, because there existed a body of legends about Caratacus, the Iron Age chief of the Catuvellauni who resisted Rome.

The clearest picture of heroic society emerges from Irish literature which began in the sixth century. In contrast to the situation in Wales, the clerics responsible for committing it to writing did not 'Christianize' the stories, but retained many elements from the pagan past. Thus, the heroes of Irish legend go out head-hunting, as Iron Age warriors are known to have done from classical authors, and drive around in chariots. These vehicles were no longer generally in use in the sixth century (though they do appear in later Irish sculpture). The most famous (and longest) of these myths is the *Táin bó Cuailnge* (The Cattle Raid of Cooley), itself a part of the larger complex of stories known as the *Ulster Cycle*. This bears some

superficial similarity to the Greek epic of the Trojan War, which also had its heroes. In the form in which we have it the *Ulster Cycle* may owe something to that classical model, but the substance of the stories is extremely ancient, and elements can be matched in other areas of early Indo-European tradition. Thus, when the main hero of the *Táin*, Cú Chulainn, defeats and beheads the three terrifying sons of Nechta Scéne, it has been suggested that he is simply acting out a variation on an important initiation episode in Indo-European myth, in which the hero defeats either three enemies or one with three heads. In Roman literature, its equivalent is the defeat of the Curiatii by Horatius; in India its equivalent is the defeat of the three-headed son of Tvastar by Trita Aptya.

The historical setting for the *Táin* depicts a world that had vanished by the time the stories were written down for the first time; Emain Macha (modern Navan), which figures prominently in the tale, was destroyed in the early- to mid-fifth century AD, and the Ulaidh, the Men of Ulster, had been replaced by a dynasty founded by Niall of the Nine Hostages around the end of the fourth or beginning of the fifth century AD. The events of the story, though largely mythical, seem to stem from some genuine war which took place perhaps centuries earlier.

Celtic society was essentially tribal and based on the family, with a complex hierarchy of kings (or chiefs) and over-kings. Julius Caesar noted that the Celts were organized into three social orders: the *druides*, *equites* and *plebes*, Roman terms which can be translated as learned men, warriors or nobles and ordinary people. Among the warriors was an elite of heroes. Irish sources indicate that the family unit comprised the *derbfine*, four generations from a common great-grandfather. The *derbfine* owned land collectively, and succession was calculated through it – any member of a king's *derbfine* could succeed him. Each *derbfine* was grouped with others into the *tuath* or tribe, ruled over by its king or chief.

Below the kings or chiefs were the nobles, who were also warriors and who owed various obligations to their king. Beneath them were the ordinary freemen, mostly farmers who paid food-rent to the king and were given cattle from the nobles in return for various duties.

The functions of king and hero may at times have overlapped, but were distinct. Kings went to war for tribal objectives, heroes went to war as champions of individual kings, to wage solo campaigns. Kingship in early Ireland was sacred, the inauguration of kings was involved in ritual, and the king's job was to exercise wise rule and judgement. If he made a wrong decision the whole tribe would suffer, and his own fate would be sealed by the gods.

The Heroes

It is clear that the heroes, or champions, were the most prominent members of society in the popular mind since they occur frequently in the literature and myths. Cu Chulainn said: 'I do not care whether I live but a single day in this world provided I am famous' – and the literature emphasizes the individual and personal honour. The goal in a heroic society was immortality in lore, achieved through reckless feats of bravery. As Proinsias MacCana has remarked, the hero 'belongs to a warrior

LEFT Hillfort, Crickley, Gloucestershire, from the west during excavation in 1972, showing building postholes and the gateway (Philip Dixon)

BELOW A Crickley long house of the earlier Iron Age reconstructed (Philip Dixon and Crickley Hill Project)

Crickley, final gateway reconstructed
(drawing: Philip Dixon)

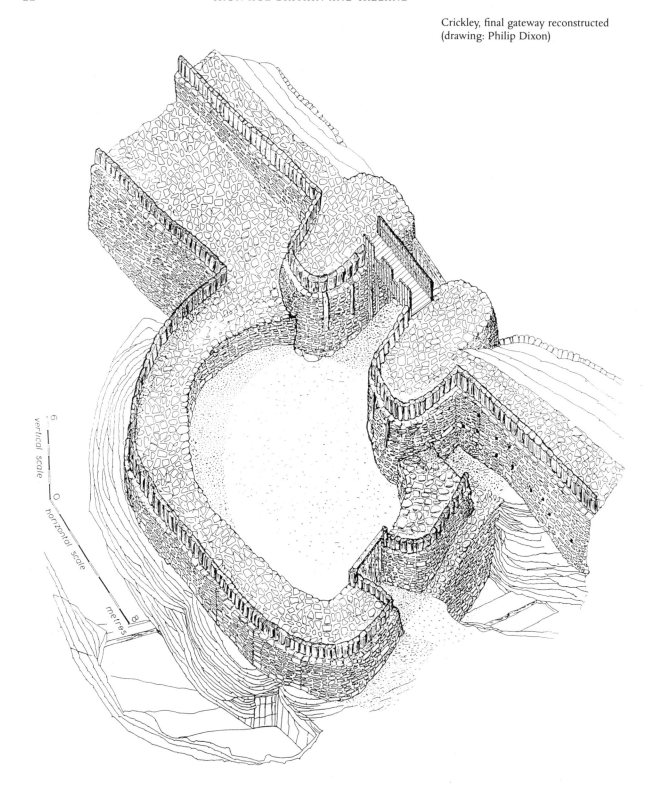

vertical scale

6

0

horizontal scale

8

metres

aristocracy which engages in warfare for glory rather than for territorial conquest, though plunder provides an adequate practical motive for what they enjoy doing anyway' (*The Celts*, 1990, 649).

The role of the champion in Celtic warrior society is known from classical sources, and reappears in Irish myths. These often set events in the hall of a chief, where a focal event was a feast, in which beef, but more particularly pork, was the main dish. This was prepared in a large cauldron into which a flesh-fork was inserted by each in turn to skewer a lump of meat. Cauldrons, albeit undecorated, are known from both Late Bronze Age and Iron Age Britain. Many of these have been found as offerings to the gods, sometimes with associated hoards, and miniature votive cauldrons are also known. Good examples include one which contained a hoard of Roman-period finds from a bog at Lamberton Moor, Berwickshire, or another from Carlingwark Loch, Kirkcudbright, the latter with a hoard of Roman and native metalwork. Drinking horns are perhaps best represented by the pair with terminals in the form of shoveller duck-heads from Torrs, Kirkcudbright, for a while attached (erroneously) to the Torrs pony cap.

The chief hero or champion was given the honour of carving up the meat for the others; in the process he was expected to allocate to himself the best or 'Hero's portion', called the *curadmir*. Naturally, fights broke out to determine who was the champion, and rival heroes had boasting contests in which disreputable events were called up (a pastime with a certain modern flavour to it!). One of the best stories is that of *Mac Datho's Pig*, in which the hero Cet (from Connaught) put to shame a succession of Ulstermen. Addressing one of them (Cuscraid for example) Cet said:

> We met on the border. You left behind a third of your people, and went off with a spear through your neck, so that you cannot speak a word properly for yourself, for the spear destroyed the sinews of your neck, and you have been called Cuscraid the Stammerer ever since.

Feasting

The Celtic love of the feast and the squabbling champions are mentioned by the Greek writer Poseidonius, who described the heroes as: 'moved by chance remarks to wordy disputes … boasters and threateners and given to bombastic self-dramatisation'. Such goings-on were clearly not peculiar to the Celts, for Tacitus, writing about the Germans in the first century AD, commented that: 'whenever they are not fighting, they pass much of the time in the chase, and still more in idleness, giving themselves up to sleep and feasting, the bravest and most warlike doing nothing'.

Beer, mead and imported wine were important adjuncts to a feast, and the Celtic love of feasting must account for a variety of works of art from tankards to firedogs, which were used for supporting spits over a fire, and have frequently been found in rich chieftains' burials in the south-east of England, such as those from Welwyn. They usually have terminals in the shape of ox-heads, and a particularly fine example, in wrought iron, was found in what appears to have been a burial at Capel Garmon, Clwyd.

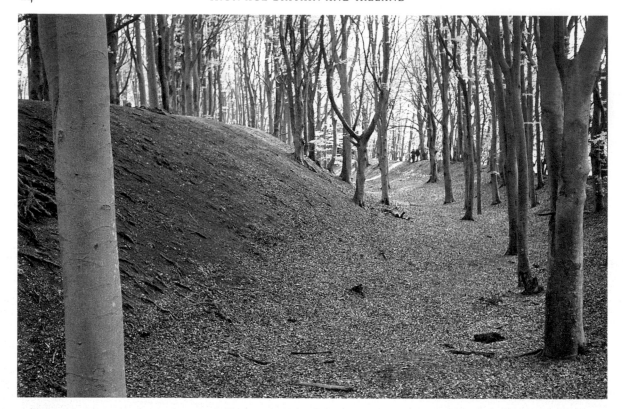

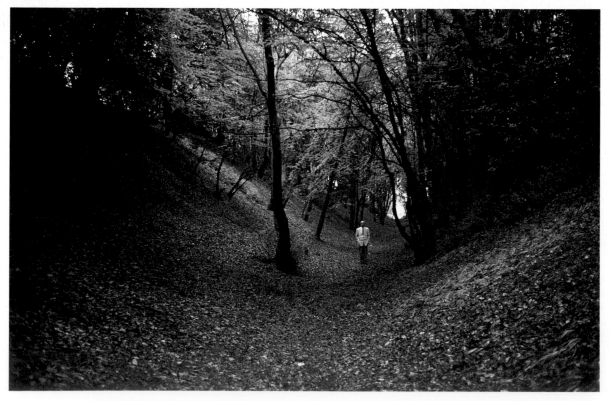

OPPOSITE ABOVE Danebury, Hamp-
shire, rampart of Iron Age fort on
south side (Jeffrey May)

OPPOSITE BELOW Wheathampstead,
Hertfordshire, the Devil's Ditch, a late
Iron Age linear earthwork (Jeffrey
May)

BELOW Broch, Orkney,
(Lloyd Laing)

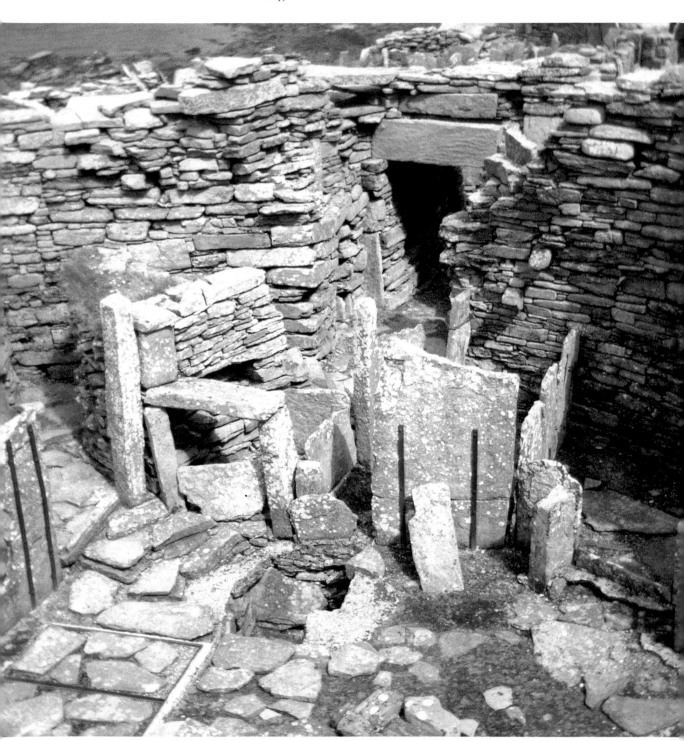

To make the feast go with a swing, music was essential. Instruments, including pan pipes, appear on coins, though it is often not possible to decide whether native instruments are being depicted or whether the designs are copying Roman ones.

The Druids

The caste known to Caesar as the druids were referred to in Irish literature as members of the *aes dana*, the 'men of art'. This group was only slightly lower in status than the nobility, and comprised not only the priests, but the bards, jurists, doctors, musicians and master craftsmen. In the medieval period the *aes dana* also included the clergy.

Slaves

Below everyone in the hierarchy there may have been some slaves, though to what extent slavery was developed in Celtic society only through contact with Rome is difficult to determine – the Roman historian Tacitus commented in the first century AD that one of the attractions of Britain was the large number of slaves that could be obtained. Archaeologically, there is some corroboration for slavery in the form of a gang-chain with neck halters from Llyn Cerrig Bach, Anglesey, and others from south-east England, though of course such restraints could have been for prisoners rather than slaves.

This type of social structure was found widespread in Indo-European society, and was therefore probably not peculiar to the Celts but, with some variation, may have operated in Europe from Neolithic times onwards. A similar type of society was apparent among the early Germans. It was a social organization which did not recognize the state as such, only the tribe and tribal territory. Family feuds and tribal rivalries played an important part, and tribal councils dispensed justice and law.

The Archaeology of Iron Age Warrior Society

Most archaeological information about the warrior aspect of society is derived from hillforts and graves.

Hillforts

Although the term 'hillfort' conjures up a picture of warriors and military campaigns, the 'hillforts' of the British Isles and Ireland were built to serve a variety of functions, not all of them connected with warfare.

In the sixth century BC – about the time that Celtic influence from the Continent was being increasingly felt to the north of the English Channel – many of the older British sites were abandoned and new forts, fairly uniform in size and layout, were constructed. They had bank and ditch defences, enclosing around 5 hectares (12 acres), and a pair of entrances. Their banks were revetted with a stone or timber wall at the front, and sometimes at the back. A variant plan with V-cut ditch became widespread in the fifth century BC.

Such hillforts seem to have had their interiors laid out systematically, with a main road and subsidiary roads through the interior, lined with

buildings. In some, such as Crickley Hill, Gloucestershire, rectangular see p. 24
timber buildings were later replaced by round. At Danebury, Hampshire,
circular buildings were the norm from the outset. There was a rectangular
structure at the centre of the complex, possibly a shrine. Clearly there was
a high degree of organization behind the building of the hillforts.

In the fourth century BC, hillforts became more sophisticated, and there
are signs that some were superior in status to others. Their defences
were extended, and sometimes their gates were made more impressive.
An elaboration of the gateways, on occasion with complex outworks or
'barbicans' to prevent a direct attack, was a feature of the last centuries
BC. The interiors of these 'developed' hillforts were intensively occupied,
and rebuilding seems to have continued over a period of several hundred
years, with the zoning of buildings for particular functions and the main-
tenance of authority in an unbroken chain. Some of the hillforts, such as
South Cadbury, Somerset, seem to have contained temples, and to have
been the focus for the range of industrial activities found in the smaller
settlements in the surrounding countryside. It cannot be doubted that the
authorities behind their construction and maintenance (who are most
likely to have been local chiefs) were powerful.

How far hillforts were built as a display of prestige, and how far for
protection against attack, is difficult to ascertain. There is evidence,
however, that some, such as Danebury, were subjected to attack. Few
interiors have been extensively excavated, and none have produced
evidence of habitations appropriate to a chief, prior to the Roman period.
It is noteworthy that some have produced equipment which may be
military – the swords from Hunsbury, Northamptonshire, or from South
Cadbury, for example, or the horsegear from Danebury.

A few discoveries, such as the evidence for massacres from Bredon Hill,
Gloucestershire, and Worlebury, Somerset, suggest that certain hillforts
figured in inter-tribal wars.

In Ireland, small defended enclosures are the norm, and hillforts of
the type encountered in Britain are extremely rare, though Rathgall, Co.
Wicklow, seems to have been first occupied in the Late Bronze Age and
again in the early centuries AD. Others, such as Clogher, Co. Tyrone, or
Freestone Hill, Co. Kilkenny, appear to have been occupied into the early
centuries AD.

Oppida

The enclosure known from Julius Caesar as an 'oppidum', literally 'town',
became widespread in the later Iron Age in the south-east of England.
These represent the closest to towns that the Iron Age Celts came.
Sometimes furnished with mints, and enclosing areas of 30–40 hectares
(75–100 acres), they served a variety of functions. Associated with their
appearance are complex linear earthworks, apparently demarcating
boundaries. The idea behind these, like that behind oppida, may have
been Continental. The earthworks can be seen in a simple form at Beech
Bottom Dyke and Devil's Dyke near St Albans, and in their most evolved
form at Colchester, where they enclose a territory of some 19 square
kilometres (12 square miles).

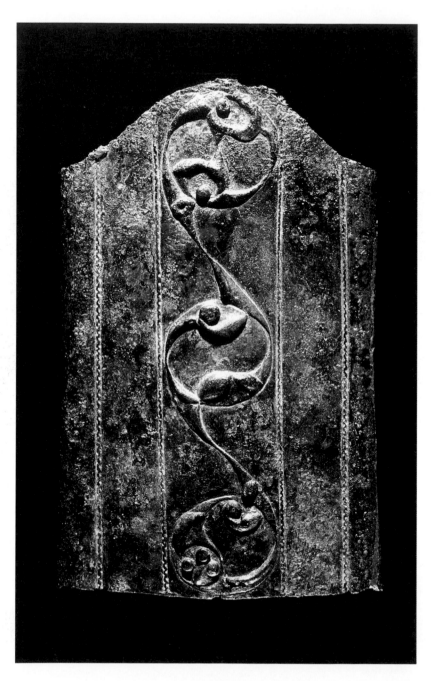

LEFT Upper portion of scabbard from Deal, Kent (Copyright British Museum)

OPPOSITE Snettisham, Norfolk, twelve torcs in hoard L as found in a pit, 1990 (Copyright British Museum)

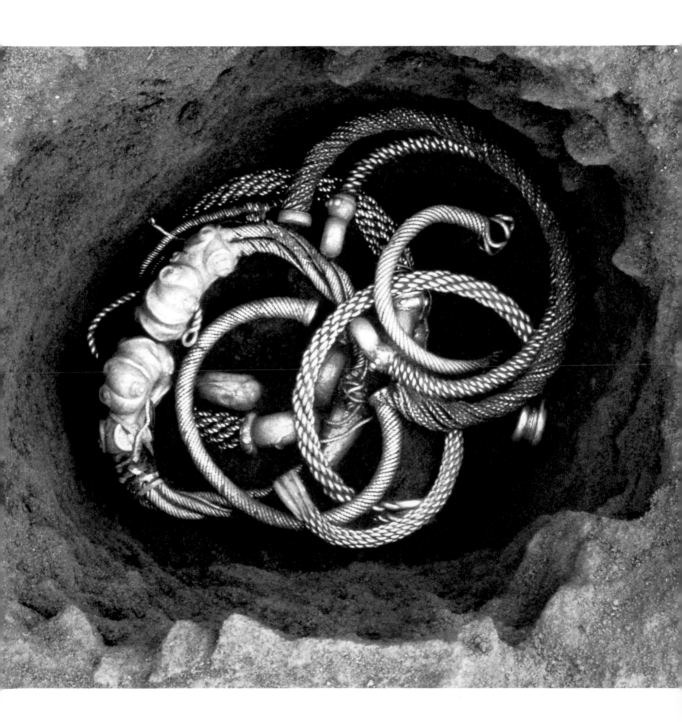

Graves

The importance of kings and warriors in Celtic society is indicated by the attention afforded to their graves. There is plenty of evidence from the Continent, rather less from Britain and virtually none from Ireland, that Celtic warriors were interred in rich splendour.

The Arras Graves The most numerous cemeteries of graves in Britain are the Arras burials, named after a classic site in Yorkshire, investigated in the early-nineteenth century, which contained more than 100 interments. A series of excavations in recent years has brought to light important information about these Yorkshire burials, and the panoply of the warrior in Early Iron Age society there.

The Arras dead were buried in rectangular, ditched enclosures. Some contain vehicles resembling chariots but most are relatively poorly furnished. Between Burton Fleming and Rudston 250 burials were excavated between 1967–1979 and found to contain crouched or contracted skeletons (one in each square barrow) each accompanied by a brooch (sometimes a brooch and bracelet) or a solitary pot. The humerus of a sheep occasionally accompanied the pot burials. At Rudston, however, some of the burials were more richly furnished. Here they were oriented in the opposite direction to the poorer ones, and were kitted out with swords, spearheads, knives and spindle whorls. The bodies were also laid out flexed or fully extended. The burials with richer belongings appear to be later, and to belong to family groups.

Cart or Chariot Burials The comparatively rare vehicle burials appeared perhaps around the third century BC as a result of influence from northern Gaul, though not necessarily through immigration. This can be ascertained from a study of the pottery, which shows no break in potting tradition from the first millennium BC in east Yorkshire. In 1970, a chariot burial was excavated at Garton Slack and in 1984 another came to light at Wetwang Slack. Between 1985 and 1987 two others were investigated at Garton Station and Kirkburn. The most interesting is perhaps the burial at Kirkburn, which contained a remarkable chain-mail tunic. Chain mail is also worn by warriors on some Continental and British Celtic coins. Actual examples are known from the Continent, and most recently from the St Albans burial, but all are later than the third-century BC date assigned to the Kirkburn suit. The Kirkburn warrior was also buried with a pair of chariot lynch pins, for keeping the wheels on. Of copper alloy, they were cast to iron pins and their terminals were decorated with pseudo-bird-head ornament.

Of the other recently-excavated chariot burials, that of a woman from Wetwang Slack contained a mirror, pork joint, dress pin and a canister or box.

The Wetwang Slack box is circular, with an attached chain, and is reminiscent of the so-called 'workboxes' found in pagan Anglo-Saxon England. It is decorated in the linear fashion found on the earliest purely indigenous pieces of Celtic art in Britain.

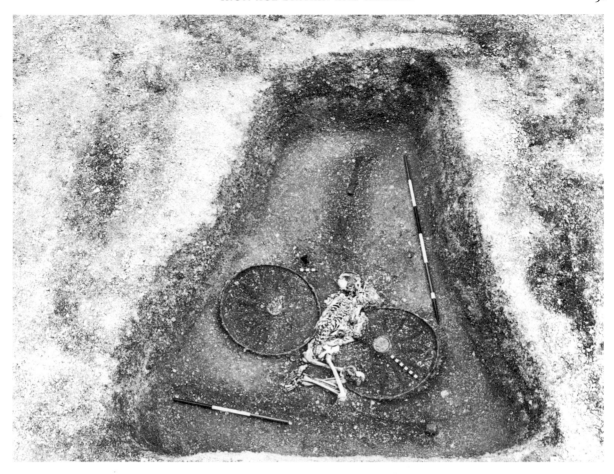

ABOVE Wetwang Slack, Yorkshire, chariot burial (Grave 11) from the south, scale in feet and inches (Hull Museums)

LEFT Reconstruction drawing by Peter Connolly of Wetwang Slack, Grave 11 (Hull Museums)

RIGHT The finest of the 1950 Snettisham find (Copyright British Museum)

BELOW Assortment of torcs from hoards unearthed at Snettisham in 1990 (Copyright British Museum)

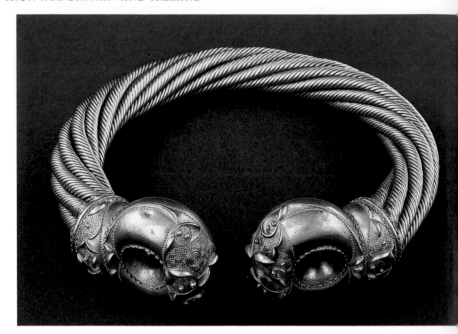

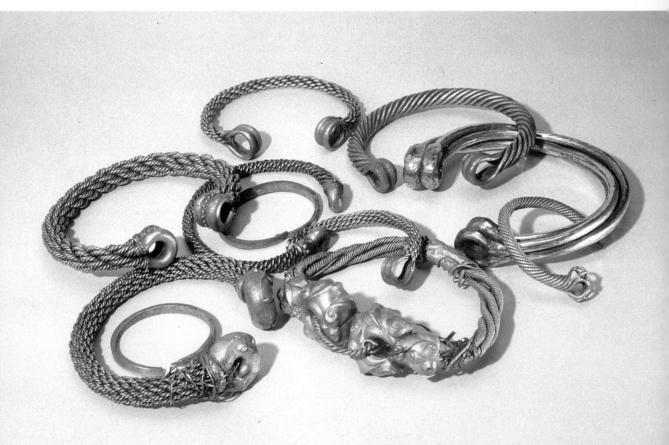

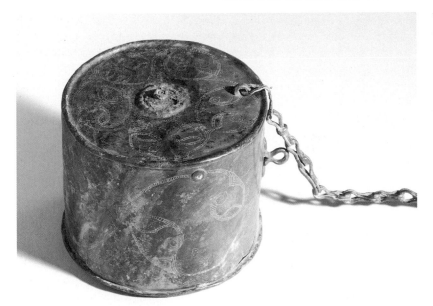

Wetwang Slack, engraved canister
(Copyright British Museum)

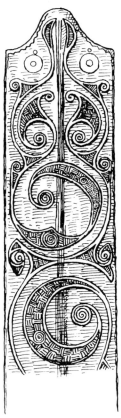

From another burial at Wetwang Slack come some sword scabbards which are decorated in a very similar fashion both to the box and to scabbards from the neighbourhood of the river Bann in Northern Ireland. Here a group of eight have been discovered, of which several have come to light near the lake dwelling or crannog at Lisnacrogher, Co. Antrim. These scabbards have all-over decoration and tight, hairspring spirals and hatching.

From another grave at Kirkburn (without a chariot) came a sword with a magnificent enamelled hilt that is unparalleled anywhere in Europe. Red glass and cross-hatched studs adorn the hilt, while engraving ornaments the sword itself. It dates probably from the first century BC.

The wooden chariots have not survived, but from the excavations it was possible to determine that the wheels of four of the five vehicles had been removed and laid flat at the bottom of the grave. The body was placed on top of them and the yoke alongside. The axle and pole had then been laid over the corpse, and the bodywork of the chariot laid over the whole, to form a canopy. At Garton station the burial was similar, except that the wheels were laid at the side of the grave.

Of the other Celtic warrior-burials known, four come from Yorkshire: from Bugthorpe, North Grimston, Grimthorpe and Eastburn. Others are known from scattered finds in the south, such as Owslebury, Hampshire and Whitcombe, Dorset. The warriors were inhumed with sword, shield and sometimes spear.

A particularly interesting burial was found with art treasures at Deal in Kent. The deceased was buried wearing a bronze headband or crown with cross-band over his skull. He was accompanied by a sword and shield, the former in a bronze scabbard richly decorated with relief ornament with pseudo-bird heads. A date for the burial of around the second century BC

Engraving on scabbard, Lisnacrogher, Co. Antrim (drawing: H. E. Kilbride-Jones)

see p. 28

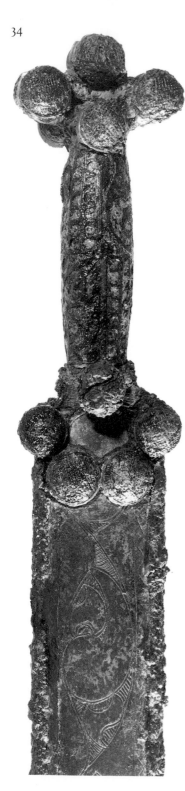

Kirkburn, Yorkshire, Iron Age sword hilt, with enamelling (Copyright British Museum)

was provided by an unusual safety-pin brooch, set with coral. Other objects from the grave were a coral-decorated belt fitting and a coral-set double ring with hatched decoration that attached the scabbard to the belt.

Later Burials A further group of burials, not specifically those of warriors, were the graves of Celtic chiefs of the end of the first century BC and early first century AD. They are found in areas of south-east England, concentrated in Essex and Hertfordshire, and are generally termed 'Welwyn' burials after two which were discovered at Welwyn in Hertfordshire. These not only show the increasing influence of Rome on southern Britain in the first century AD but also indicate the standard of living enjoyed by the richer members of society who could afford fine luxuries.

The body was cremated, and buried with a rich array of grave-goods. The commonest finds are imported Roman wine amphorae (up to six per grave), and an assortment of utensils, often including pottery imported from Gaul, and sometimes imported metal vessels. These include both bronze wine flagons and paterae or saucepans from northern Italy, and silver Roman vessels from around the time of Augustus (27 BC–AD 14), notably the silver drinking cups from Welwyn and from Welwyn Garden City. Other grave-goods include iron firedogs for preparing roasts in the afterlife feast, buckles, bracelets, beads and counters for a game akin to Ludo. Works of art were also found in the famous burial at Lexden, Colchester, which may have been the grave of king Addedomarus who ruled in this area in the early first century AD. The Lexden grave goods included a series of pieces of bronze statuary, probably imported from Gaul, and a pendant with a portrait of Augustus based on a coin.

The burials recently found at Colchester and St Albans are particularly fine. The St Albans burial is probably the most splendid Iron Age interment in Britain, and dates from just after the Roman conquest. An underground mortuary chamber was built, and the body laid out on a couch, accompanied by grave goods and a funerary feast. The body was then removed and cremated, the funerary chamber destroyed, most of the goods taken from it and deposited on the funeral pyre. The remaining fragments and ash were buried in a cremation pit beside the funerary chamber. The whole was contained in an enclosure, defined by a ditch 3 metres (9 feet) deep, some 2 hectares (5 acres) in extent. Because of the burning, many of the grave goods had been destroyed, but surviving objects included a knee-length tunic of chain mail and some harness fittings – an enamelled bronze bit and a toggle slider (harness fitting). The molten metal from the grave goods formed a solid layer at the bottom of the grave pit – nearly a pound of silver was recovered. Fragments of thirty to forty pots provided a date of around AD 50 for the burial. The burial chamber itself had been a complex structure, with double walls, containing within it a 'shrine', also double-walled, and probably roofed.

. The burials at Colchester covered a fairly prolonged period – two were pre-Conquest, three post-Conquest of about AD 60–75. Once more the graves contained wooden mortuary chambers (much less splendid than at St Albans) and an array of finds. They seem to have been the last resting

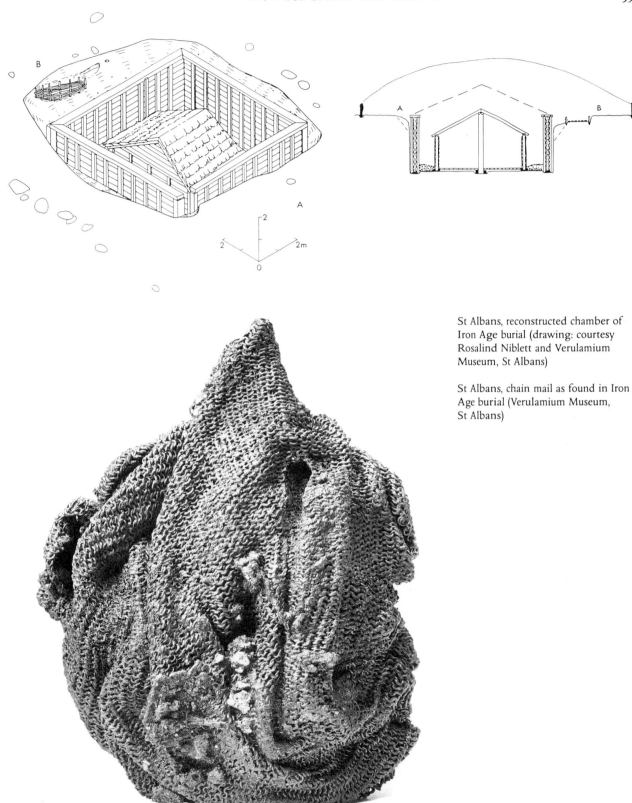

St Albans, reconstructed chamber of
Iron Age burial (drawing: courtesy
Rosalind Niblett and Verulamium
Museum, St Albans)

St Albans, chain mail as found in Iron
Age burial (Verulamium Museum,
St Albans)

RIGHT Birdlip type brooch, gilt
bronze, Dragonby, Lincolnshire
(Jeffrey May)

BELOW Metalworking debris, Gussage
All Saints, Dorset, showing moulds
and mould-making tools (Copyright
British Museum)

places of an aristocratic family, perhaps even relatives of Cunobelin of the Trinovantes who ruled just before the Roman conquest.

Some other rich south-eastern burials are notable for containing works of art. They include a cremation deposit at Aylesford in Kent, which contained a bronze-bound wooden bucket, probably imported, and a series of female burials containing mirrors and sometimes jewellery. A mirror from a Colchester burial was furnished not only with a mirror but with fine pottery of the early first century AD and a spun-bronze cup with ornamental handle decorated with a hemispherical boss of red enamel. As well as a famous mirror, a burial at Birdlip, Gloucestershire, contained a range of finds including a silver-gilt safety-pin brooch with bird head on the bow (a type of brooch known as a result as 'Birdlip type'. Others are represented at Ham Hill, Somerset and Dragonby, Lincolnshire). The Birdlip burial also included two beaten-bronze bowls in a similar style to that at Colchester (but without handles), a necklace of amber, jet and marble beads, a bronze handle in the form of a horned animal and a tubular bronze bracelet. The group was buried in a limestone coffin which came to light in 1879 when the road over Birdlip Hill was being constructed.

The Iron Age Artist at Work

From the burial finds it is clear that artistic skills were used widely to enhance objects used by, especially, the rich. Study of the artefacts themselves and of the few workshops that have been discovered have shed light on how Iron Age Celtic artists operated in Britain and Ireland. The information available relates to metalworking.

There are two 'workshop' sites in Iron Age Britain, that at Gussage All Saints in Dorset and that at Weelsby Avenue, Grimsby, in Lincolnshire. As yet Weelsby Avenue is unpublished, but the finds from Gussage provide a valuable insight into Iron Age craftsmanship.

The site of Gussage was a farmstead with several phases of occupation in the Iron Age. All the metalworking remains came from one pit (209) and indicate that metalworking took place over several centuries.

Oak was used to fuel the bowl furnaces, which had been kindled with hawthorn twigs. The furnaces were heated using bellows, the nozzles of which were protected by blocks of clay, called tuyères. Temperatures of 1,200°C (2,200°F) or higher were achieved. Copper alloy seems to have been produced in the form of 'billets' – thin bars of metal. Billets have been found on other Iron Age sites such as Croft Ambrey, Hereford, and in the metalwork hoards from Polden Hills, Somerset, or Seven Sisters, Glamorgan. Analysis of various billets has shown that the Iron Age smiths carefully weighed out their metals – the billets conform to a standard system of weights found throughout Europe. An iron weight and an equal-armed balance were finds from other contexts at Gussage. The alloy was melted down in small, open, triangular crucibles (about thirty were represented in the Gussage pit). These appear to have been covered with charcoal and heated from above to 1,100–1,250°C (2,070–2,200°F).

Pit 209 contained around 7,000 fragments of clay moulds for casting

chariot fittings and horsegear by the *cire-perdue* method: a beeswax model of the object was made, covered in clay, and then melted, leaving a hollow into which the metal could flow. To remove the casting the mould was broken apart. Bone implements were found at Gussage for modelling the wax matrices, and similar tools have been found elsewhere, for example at Glastonbury, Somerset. An iron tool was also found.

The clays for the moulds were specially prepared with carefully measured fillers, and in the case of complex centre-link moulds for bits, cloth was wrapped around the wax model to ease separation.

A piece from a three-link bit from Gussage showed considerably developed technology. It was made of forged carbon-steel which had been bronze-plated by dipping into molten copper alloy, having been first plunged in tin to aid the 'bronzing' process.

Such an establishment was clearly the result of considerable commercial development and the organization required implies that artists and designers did not also carry out production. The high degree of technological skill and manual dexterity shows that they were professionals, and were not merely the local blacksmiths who turned their hand now and again to the production of high-status, ornamental metalwork.

Designs

It is extremely likely that smiths (or their designers) worked out designs before executing them in metal. There is no firm evidence for 'motif' or 'trial' pieces in the Iron Age, though it is clear that some details were tried out in experimental exercises where they would not be seen – the examination of the mirror from Birdlip, shows that such an exercise was carried out and later covered by the handle.

Compasses

Some designs were the result of very complex laying out with compasses. The detailed examination of the design on the back of a mirror from Holcombe, Devon, showed that it was produced by a formal system of construction with the centre of each arc lying at the point of intersection of two or more arcs, each of which passed through one or more other centres. As far as could be ascertained, the designing was carried out on the mirror back itself. This may have been done employing light scratchings which were subsequently polished out, or the bronze may have been coated with a thin covering, such as wax, on which the lines were marked out before being removed when the engraving was complete. Despite the apparent complexity of the design, however, it was probably built up in sections and did not require a very extensive knowledge of geometry.

Compasses were used in the designs on some bone slips from Lough Crew, Ireland, and a bone comb from Langbank, Ayrshire. Compass-point marks can also be seen on a number of pieces of Late Iron Age enamelled horsegear.

The main elements of relief design were cast, detail being added at the engraving stage. Various tools and techniques were used. It has been suggested that the range of small tools for fine work was very similar in the Iron Age to those used in modern silversmithery.

Compass design, method of construction of a detail of a mirror back, Holcombe, Devon (drawings: by courtesy of Richard Savage; fig. A after Philip Compton)

Tools

There were four main tools in use: the scriber, graver, scorper and tracer. The scriber was pointed and used like a pencil for preliminary marking out. The graver was likewise hand-held, and its function was to cut away metal; it had to be harder than the metal it was cutting. The scorper had a broad chisel end and was used to cut away large areas of metal. Designers needed a tracer for fine work, using it with a hammer to make grooves. Various effects were produced by 'rocking', 'rolling' or 'walking' the graver, depending on its type. The term 'rocked tracer' is often used erroneously to describe zigzag lines. These can be produced by a tracer, but the zigzag effects made by Iron Age metalworkers were produced with a graver. A wide variety of effects could be produced with these simple tools.

Inlays

Other artistic techniques were employed, among which was the use of coral inlay – ultimately an import from the Mediterranean. It is found for example on the Witham Shield, on the brooch, belt and scabbard fittings recently found in the burial from Deal, Kent, and on a brooch from Harborough Cave, Derbyshire. In the early part of the Iron Age enamel (or more correctly, glass) was exclusively red, and employed by softening pieces of the material and pressing them into the voids, as for example on the Battersea Shield. In the Late Iron Age other yellow and blue enamels were introduced, and *champlevé* work first appears, the enamel being melted and poured into the voids made to receive it. Classical writers commented on the Celtic skill at enamelling. Shell and stone was occasionally used in inlay.

In the later Iron Age die stamping was used for making repetitive relief patterns on sheet metal. A triskele design with berried rosettes decorates a die from North Creake, Norfolk, and other dies are known from Wroxeter, Shropshire, and in clay from North Wraxall, Wiltshire. The North Creake design is found in a tankard from Elvedon, Suffolk.

Ideas from the Continent

Trade was vital in the dissemination of artistic ideas in Iron Age Britain. Overseas contact flourished between Britain and the Hallstatt and La Tène cultures, and later especially with the Roman world when it is notable that artistic endeavour blossomed. The majority of imports down to the fifth century BC may have been diplomatic gifts, though some more mundane items such as brooches were probably part of regular trade. From this period onwards there were two main axes of trade between Britain and the Continent, the one linking Hampshire, Dorset and other parts of the south coast of England with Armorica and southern France, the other connecting south-east England with northern France and Belgium. Trade depots flourished, such as that at Hengistbury Head in Dorset, which excavation has shown to have been importing amphorae of Roman wine from the second century BC as well as Gaulish merchandise.

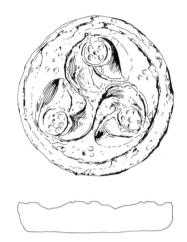

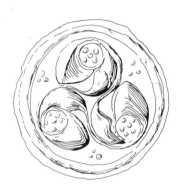

Die for casket work, North Creake, Norfolk (drawing: Caroline Bevan)

Imports

The earliest stages of the development of Celtic art in Britain are represented by a very few Continental imports or British imitations. These are often so similar that there is lack of agreement between scholars about which pieces are imports and which are native versions. The question is complicated by the fact that it is impossible to tell whether a piece was imported or made by a migrant who had brought the raw materials across the Channel.

Of the Continental devices, openwork is particularly well displayed on a disc in the same general style as that from Somme-Bionne, France, from the hillfort at Danebury.

A fragmentary find from Cerrig-y-Drudion, Clwyd, discovered with a burial in a cist, is of note since it shows affinities with early Continental work though it is probably of native manufacture. This used to be regarded as being from a hanging bowl, but re-examination suggests that the pieces are from one, or more probably two, bowl lids. A date perhaps a little before the end of the fourth century BC is possible.

A dagger scabbard from Wandsworth was enhanced by two bands of engraved lozenges with hatched infilling, and a fine openwork chape of stacked running scrolls. Such ornament is found commonly in the fifth century BC on the Continent. Stacked lyre scrolls with palmettes also decorate a scabbard fragment from Wisbech, Cambridgeshire, which has a border of hatched triangles. This type of geometric pattern is encoun-

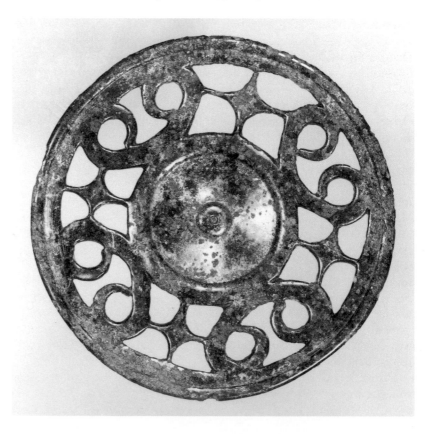

Openwork roundel from Danebury, Hampshire (photo: Danebury Archaeological Trust)

Cerrig-y-Drudion, Clwyd, bowl decoration detail (drawing: Lloyd Laing)

tered in France as well as Britain. In summary, it seems that once introduced to the new art, the insular Celts preferred to make their own rather than import.

The Arts of War and Warriors

The importance that society gave to warriors is reflected in the mastery that went into the workmanship and decoration of military gear. The most common finds of military equipment are swords, of which there is a considerable variety, both in terms of design and probable date. Other decorated items of warrior equipment are daggers, shields or, more usually, the bosses and other fittings from them, and a single helmet. The remainder of the warrior's panoply comprises horsegear, and the fittings for chariots.

Dagger, Sword and Spear

Swords were the ultimate status symbol of Iron Age warriors and Celtic artists decorated them with a combination of techniques. Engraved, linear ornament was considered appropriate for the body of the scabbards. The chapes, and sometimes the mouthpieces of the scabbards, called for relief work. A few display the type of ornament found typically on mirrors.

Wisbech, Cambridgeshire, scabbard plate (drawing: Lloyd Laing)

Some sword makers favoured decoration that is related to Continental tradition. The facing dragons on one sword from Hammersmith for example, were copied on other pieces until the animals degenerated into ornamental scrolls, for example on a scabbard from Hunsbury, Northamptonshire.

In order to reflect maximum light when the metal was new and polished, some artists employed a Continental technique of 'laddering', which involved creating a rippled effect along the scabbard, for example on one from Sutton-on-Trent, Nottinghamshire. A sword from a gravel pit at Chertsey, Surrey, has part of a particularly attractive scabbard mount with sinuous edge which has retained its lustre (p. 17).

The work of the creator of a chape from Little Wittenham, Oxfordshire, was characterized by a rendition in delicate openwork of the type of pattern usually found in engraving.

One scabbard shows strong zoomorphism on its relief-decorated chape which is contrasted with considerable skill by the engraver's art. It is from a warrior burial at Bugthorpe, Yorkshire. It is reminiscent of a fish head.

Bugthorpe scabbard, Yorkshire, detail
(drawing: Priscilla Wild)

Few spearheads survive, but one from the Thames at Datchet, Middlesex, is of iron with inlaid bronze, decorated with fine engraved patterns.

Shields

Very few shields have survived intact from Iron Age Britain, though a utilitarian example was found at Chertsey, Surrey, and a number of shield bosses are extant. Most were probably objects of parade and status, ultimately dedicated to the gods. The most famous work of Celtic art from the British Isles is the unique Battersea Shield, sold for £40 to the British Museum in 1857 by a labourer called Henry Briggs. The Witham shield is almost its equal.

The maker of the Wandsworth Long Shield Boss conceived the idea of an oval centre and a rib which flares at the ends, and then added humanizing features. One end is missing, but the designer, in a flight of whimsy, detailed a lugubrious human face with relief spiral bosses for eyes (now nearly completely destroyed) on the survivor. The design in the centre comprises two bird heads, back to back in a diagonal S-scroll. There is engraving with spirals and the face has teeth.

Fragments of a boss from South Cadbury, Somerset, display stylized bird heads. The terminal is decorated with an S-scroll. The important feature of the Cadbury boss lies in the fact that it comes from an archaeological context – it was found in the remains of a workshop of a smith or group of smiths that was operational in the late first century BC / early first century AD.

Climbers, in June 1963 at Tal-y-Llyn in Merioneth, discovered an important hoard which may be incomplete, and was probably buried in the Roman period. It seems to have been a smith's scrap-metal cache and contained a shield boss shaped like a distinctive example from Moel Hirradug in Clwyd, suggesting that its designer may have come from Wales. Another shield boss, of 'double axe' shape (though most of it is missing), was enhanced by a triskele executed in basketry, with a border of hatched triangles to its enclosing circle. The artist used another triskele, this time in relief, to decorate the centre of the boss. The hoard cannot be dated with certainty any earlier than the first century AD and, indeed, it could have been as late as the early second. One of the Tal-y-Llyn finds was a repoussé plate with one of the rare examples of a human face in Insular Iron Age Celtic art. The mount was made of brass, an alloy not encountered before the Roman period, and it has a head at each end of a scroll.

In 1942–1943, while an aerodrome was being constructed near Holyhead, Anglesey, an engraved shield boss was discovered at Llyn Cerrig Bach. At this site, no fewer than 150 objects had been thrown as offerings into a peat-bog, and included parts of chariots, wagons, eleven swords, box mounts, harness fittings and a forged-steel gang chain. The latter was attached to a tractor and used for towing before its antiquity was appreciated. There were also ox, pig and sheep bones. The objects came from different parts of England and from Ireland. The Llyn Cerrig Bach boss has a figure-of-eight arrangement of four roundels containing a triskele pattern with circular voids.

Shield boss with central triskele, Tal-y-Llyn hoard, Merioneth (National Museum of Wales)

Restored design of South Cadbury, Somerset, shield boss (drawing: Caroline Bevan, after Mansel Spratling)

Helmets

One helmet alone has been found from the pre-Roman Iron Age. The Waterloo Bridge Helmet may have been dedicated to the gods, having been found in the Thames. Found in 1868, it is notable for having conical horns. Horned helmets (usually and erroneously associated in popular tradition with the Vikings) are not unknown in prehistoric Europe, and the classical writer Diodorus Siculus refers to them being worn by Celts. They also appear worn by Celts on Roman sculpture. The Waterloo Bridge helmet is made from two pieces of bronze, rivetted together, with a separate crescent-shaped piece at the front. The horns were made separately, their terminal knobs cast on. There are rings at the sides for a strap, or more probably a cheek piece or pennant. The decoration chosen by the designer comprises five (originally six) round studs, cross-scored to take enamel. Relief pattern with bird heads and leaf patterns is juxtaposed with some basketry hatching. A date around the middle of the first century BC is likely for this imposing piece.

Helmet, from the Thames at
Waterloo Bridge, London
(Copyright British Museum)

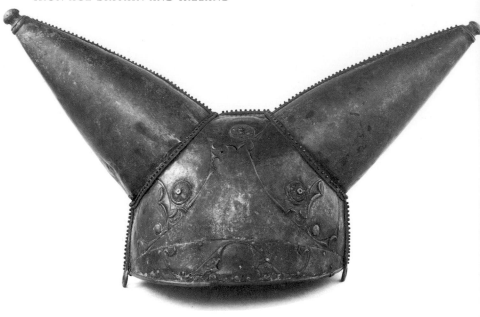

Horsegear

'In chariot fighting' wrote Caesar,

> the Britons begin by driving all over the field hurling javelins, and gener-
> ally the terror inspired by the horses and the noise of the wheels is sufficient
> to throw their opponents' ranks into disorder. Then, after making their way
> between the squadrons of their own cavalry, they jump down from the
> chariots and engage on foot. In the meantime their charioteers retire a short
> distance from the battle and place the chariot in such a position that their
> masters, if hard pressed by numbers, have an easy means of retreat to their
> own lines. (*The Conquest of Gaul*, translated by S. A. Handford)

Chariots were fashionable on the Continent in the earlier part of the Iron
Age. They had fallen out of vogue there by the time of Caesar, though
he encountered them in Britain and reported that the British leader
Cassivellaunus had 4,000 of them.

Parts of a chariot were found at Llyn Cerrig Bach in Anglesey and have
been reconstructed with wickerwork sides and with open front and back.
It was harnessed to two ponies, held by a yoke (the horse collar did not
appear until the Middle Ages). The wheel of another chariot was found
in a Roman-period pit at Bar Hill, Stirlingshire. The iron tyre was shrunk
on, and the felloe (fashioned from a single piece of ash bent in a circle)
was fastened to a turned-elm hub with lathe-turned, willow spokes.

Of the chariot fittings, the most common are terrets (rein rings), and
lynch pins to secure the wheels. Various harness fittings also occur and
what have been identified as hand-holds from the sides, and yoke mounts.

A doorknob-shaped object from Brentford, London, has perplexed
scholars. Its function and that of about five other whole or fragmentary
examples has been debated. It may have been part of a chariot or possibly

Decoration on the Brentford,
Middlesex 'horn cap' (drawing:
H. E. Kilbride-Jones)

a mace head. It bears pleasing decoration of tendrils, and may have once been enamelled.

Horses enjoyed a special place in the Celtic world and by far the greatest number of surviving works of Iron Age art are items of horsegear. Trappings mostly comprise bridle bits, rings, and harness brooches.

A pony cap from Torrs, Kirkcudbright, was clearly a parade object and illustrates the importance of horses to the warriors and the panoply of Celtic display. Here the designer's imagination ran to relief work with pseudo birds' heads. Originally, two objects were attached to the top, possibly some kind of plume holders (the illustration shows it wrongly reconstructed, attached to the horns).

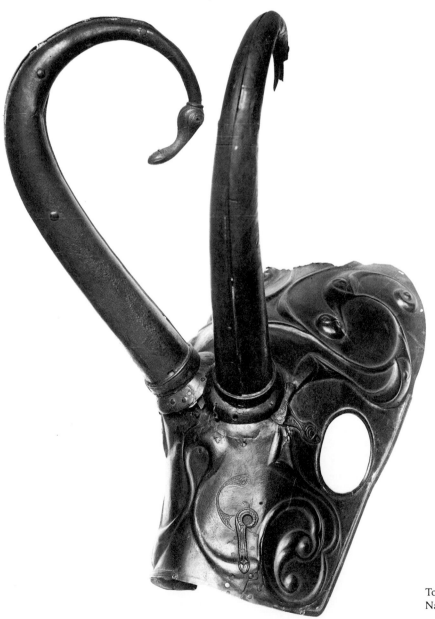

Torrs pony cap, Kirkcudbright (photo: National Museums of Scotland)

A

B

C

D

E

Quadrilobate and other horse
trappings, (A) and (D), Santon,
Norfolk (B) Westhall, Suffolk
(C) Polden Hill, Somerset (E) Stanwick
(Melsonby) Yorkshire (drawings:
H. E. Kilbride-Jones)

Even such commonplace objects as horse bits could be finely decorated if the owner was of sufficient status. The moulds from Gussage All Saints show that bits were being made there, and since five different types of terminal bulb decoration have been recognized it is clear that these were not uniformly mass-produced. The surviving bits are scattered – one from Ulceby, Lincolnshire, may have been made in Corieltauvi territory and one from Ringstead, Norfolk, is probably from the workshops of the Iceni tribe. The Ulceby Bit must have been intended for the steed of a rich patron because of the intricacy of the ornamentation. Its designer favoured small areas of basketry infilling and pellet bosses to set off rosette roundels with sharply crested ridges on the ring.

If the patron required flamboyance, artists could respond with some colourful bridle cheekpieces decorated in red, yellow and blue enamel. The best example comes from Woden Eckford, Roxburghshire.

The finest assemblages of the enamel worker's craft come from two hoards, one from Santon, Norfolk, the other from Polden Hills, Somerset. Two types of enamelled object are well represented: quadrilobate 'horse brasses', and terrets with a crescentic plate. There are at least twenty terrets, mostly from East Anglia and south-east England.

In the style of the quadrilobate mounts, and decorated in red enamel, is a lynch pin found at King's Langley, Herts.

The Arts of Peace

The basis of Iron Age society lay in farming. At the end of the Bronze Age a hardy form of wheat known as spelt was introduced, along with a new equally robust form of barley, resulting in the production of two crops in a year. Beans, rye and club wheat supplemented the diet. Cattle were of the 'Celtic shorthorn' variety, and sheep were small. Pigs were both bred and hunted.

Farms took many different forms, usually with circular timber huts in enclosures, comprising dwelling quarters and storage buildings. In areas where wood was in short supply and stone was abundant it was used in building, for example in the case of Chysauster in Cornwall, or the stone broch towers of Scotland (p. 25). In Ireland, the earthen ringfort or rath containing timber houses was a feature of the Iron Age.

Within some of these establishments artists found markets for a variety of goods, mostly for personal adornment, such as torcs or neckrings, which were made in a variety of different metals including gold or electrum. Armlets could be of precious metals, but brooches and pins were very mundane.

Torcs

Among the spectacular array of gold torcs from Britain and Ireland, one fine example is a definite import, probably from the Middle Rhine, but whether it was commissioned, bought or brought across by an immigrant is not known. It comes from the River Shannon area and is traditionally (but now known to be erroneously) called the Clonmacnois torc. The smith fashioned a gold tube and added a tenon fastener and buffer ends.

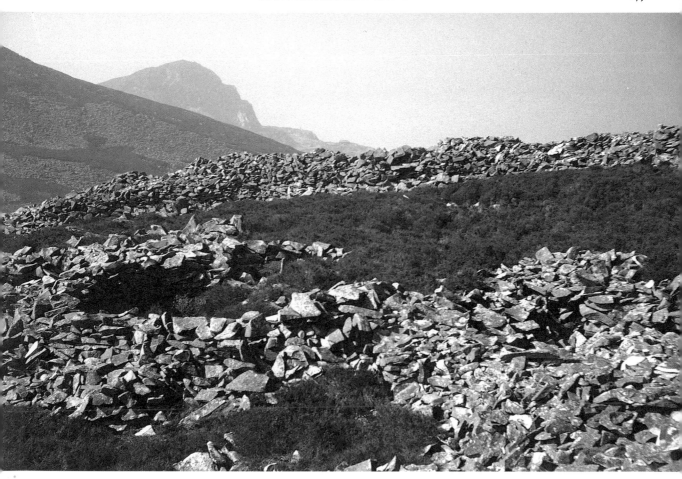

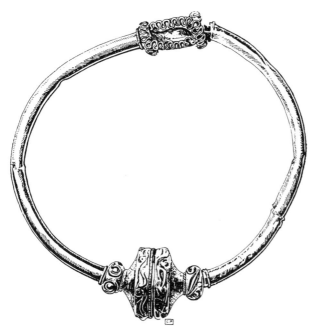

Stone huts in Iron Age hillfort, Tre'r Ceiri, Gwynedd (Lloyd Laing)

'Clonmacnois' torc, Co. Offaly (drawing: Praetorius)

The Snettisham hoards represent one of the most spectacular discoveries in British archaeology. A collection of electrum and gold neckrings of various styles were associated with coins, scrap metal and bracelets. The story of their discovery began in 1948, with the recovery of four tubular torcs, which were believed by the finder to be part of a brass bedstead. They were flung under a hedgerow next to a busy main road where they were in full view until retrieved by archaeologists some days later. Between 1948 and 1950 five hoards came to light. The most important was Hoard E, discovered in 1950 and comprising the most famous Snettisham torc, a similar bracelet, and part of another torc. Four more hoards were subsequently found scattered through the field, bringing the total, by 1950, to sixty-one torcs and possible bracelets, two certain bracelets, 158 coins and some rings. In 1990, the same field yielded yet more – hoards F, G, H, J, K, L and M. In all, the field contained between eleven and thirteen hoards. Hoard F alone contained fifty torcs, seventeen ingot bracelets, two ingots and nine coins.

The Snettisham hoards have not been closely dated but were probably buried around the time of Caesar's conquest of Britain inside a ditched enclosure in Iceni territory. Although many of the pieces appear broken, ready for the melting pot, there is very little evidence for metalworking apart from some lumps of tin and gold. Indeed, the careful grouping of different types of torc in different pits suggests otherwise. Whether they represent a treasury (possibly each representing a family's treasure?) or a collection of votive deposits has not been resolved. Unless they were votive, some very dramatic event is likely to explain their abandonment. In all, the treasure amounts to some twenty kilograms (forty-four pounds) of silver and 15 kilograms (thirty-three pounds) of gold, which as Dr Ian Stead has pointed out, translated into Roman soldiers' pay would as bullion alone be the equivalent in modern terms of about £4 million, not allowing for 'artistic' value.

The torcs are diverse – with looped terminals, buffer terminals, ring terminals and even a 'cotton-reel' terminal. They are likely to have been made from melted-down gold coins, a suggestion confirmed by the composition of some. The coins associated with them suggest a date of deposition somewhere between about 75 and 50 BC. The Snettisham smiths favoured raised bosses, sometimes with dimples and basketry hatching. Taste ran to the aniconographic with the exception of a tiny human face which appears on one of the 1990 torcs.

The finest Snettisham torc remains the electrum example found in Hoard E in 1950, though one of the 1990 finds is almost as accomplished. It weighs 1,085 grams (37 ounces) and the ornament was cast and then engraved.

Including those from Snettisham, there are over 200 gold and electrum torcs known from Britain, with a concentration in East Anglia. After Snettisham, the most important find is from Ipswich which came to light in October 1968 on the Belstead estate, when a bulldozer driver found five gold torcs. A sixth was discovered in 1970 in soil taken to form an adjacent garden. They are not very well finished off, which has led to the suggestion that they were unfinished. They are from a different workshop

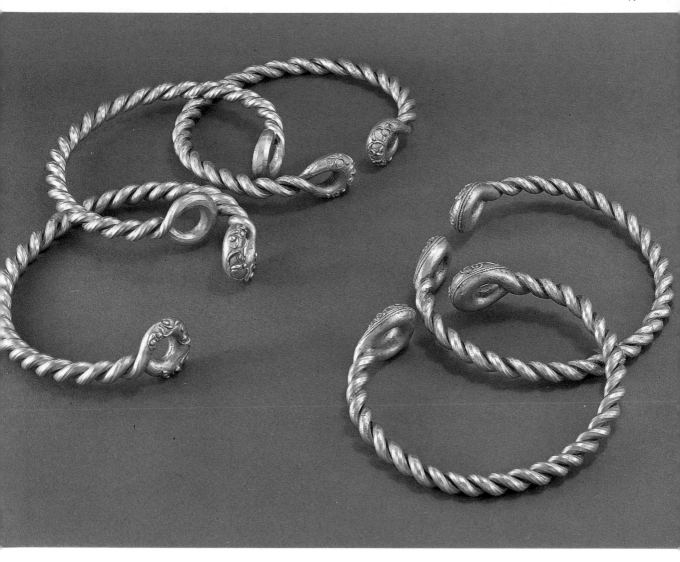

tradition to Snettisham, and may be of different date. They are comparable with torcs from Glascote and Needwood Forest, in Staffordshire.

A torc in a related but different tradition was found in an impressive gold hoard at Broighter, Co. Derry in Ireland. A model of a boat, complete with golden mast and oars, a plain bowl and a decorative chain, a second chain and two collars were found during ploughing in the late nineteenth century (not in an upturned umbrella as one report claimed!). The torc is an Irish product, though its form, which is tubular with a tenon-and-mortice fastening, is a Continental type. The decoration is chased and engraved, and the artist employed some compass work.

Not all neck adornments were torcs. A collar from Newnham Croft, Cambridge, has been suggested as being decorated to Continental taste. This object came from a grave with other early finds, including a brooch with shell inlays. The footplate takes the form of a surprised face. The

Five of the six gold torcs found at Ipswich, Suffolk (Copyright British Museum)

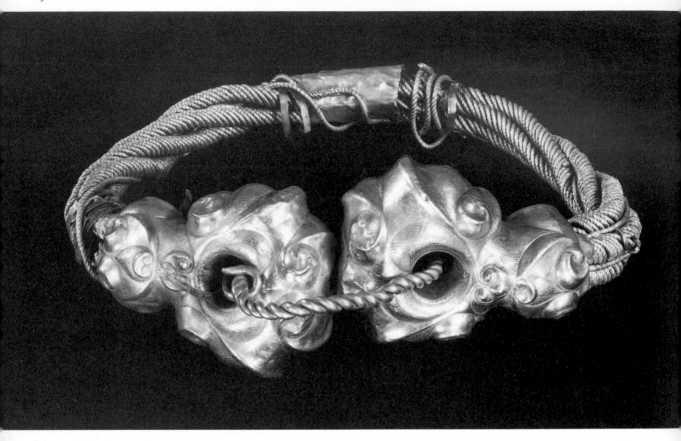

One of the torcs found at Snettisham, Norfolk, hoard L, 1990, known as the 'Marriage' torc, with an 'umbilical cord' linking the terminals (Copyright British Museum)

brooch dates the find to around the second century BC, and other grave-goods include some penannular (in the shape of a broken circle) brooches and a pony cap. The Newnham Croft armlet has an interesting dovetailed fastening, and a tendril pattern ending in small bosses.

Brooches

The main type of brooch used by the La Tène Celts, both in Britain and on the Continent, was of safety pin design, made from one piece of metal (usually bronze, but sometimes iron) with a spring and a catch-plate which was folded back on itself. Changes in brooch design reflect fashions that were comparatively short-lived and can therefore be closely dated.

A few brooches show that the patrons followed Continental fashion. Among these are two from Hunsbury, Northamptonshire, one of which has stacked lyre-scroll patterns not unlike those on the Wisbech scabbard.

A brooch from the Danes Graves near Driffield in Yorkshire is decorated with coils made of a vitreous paste, a Continental device, perhaps indicating that it was an import.

Mirrors

The very rich were able to commission fine bronze mirrors. Where they have an archaeological context, the mirrors mostly come from richly-furnished graves in the south-east, and date from the first half of the first

century AD. A series of thirty-three such decorated mirrors is distinctively treated – their makers clearly felt uniformity outweighed inventiveness. Virtually all display a circular void, surrounded by engraved ornament, though one known as the 'Gibbs' mirror, has a hatched circle surrounded by a void. The most popular design features a lyre scroll, though this seems to have developed from a simple double circle design exemplified on a mirror from Trelan Bahow in Cornwall. Other patterns were on offer, such as a triskele on a mirror from Billericay, Essex, and a disjointed pattern of trumpet-shaped voids on a mirror from Old Warden, Bedfordshire. The creator of a mirror from Great Chesterford, Essex, with its leering face and octopus-like tentacles favoured an unusually disorganized pattern.

The typologically earliest mirrors have simple looped handles, that with the progression of time became more complex with confronted loops and balusters that recall horsegear. An example from Holcombe, Devon, has a cat-like face on the handle where it joins the mirror plate. The more

Back of bronze mirror from Desborough, Northamptonshire (Copyright British Museum)

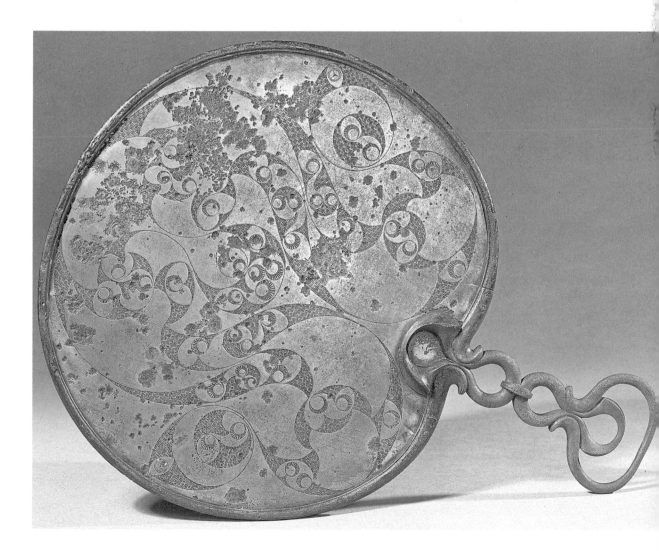

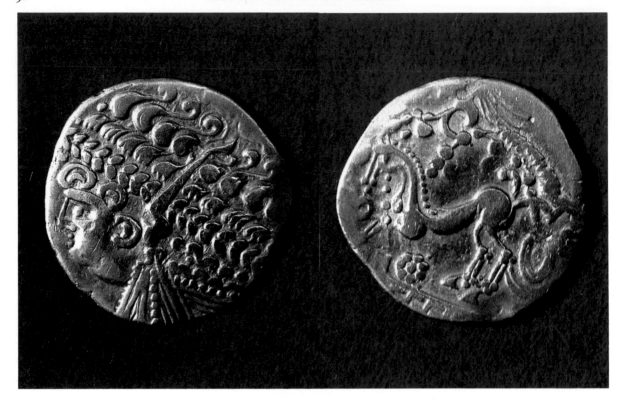

ABOVE Gallo-Belgic gold coin (Jeffrey May, from an original in the British Museum). See p. 68

RIGHT Bronze coin found near Chichester, depicting a cock with a human face on its breast, early first century BC (Chris Rudd). See p. 68

OPPOSITE ABOVE Gold stater of Cunobelin (J. May, from a coin in the Mossop collection). See p. 68

OPPOSITE BELOW Silver unit of Prasutagus of Iceni (J. May, from a coin in the Mossop collection). See p. 68

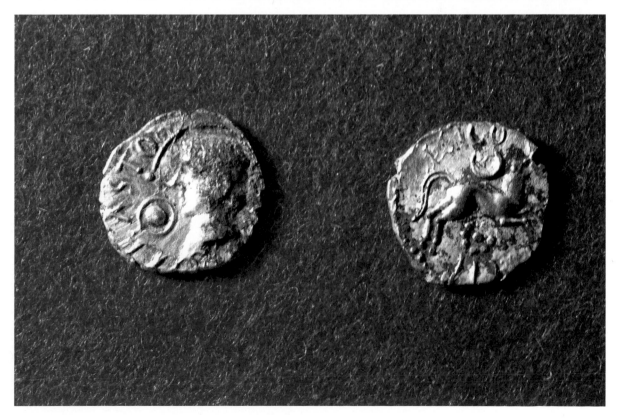

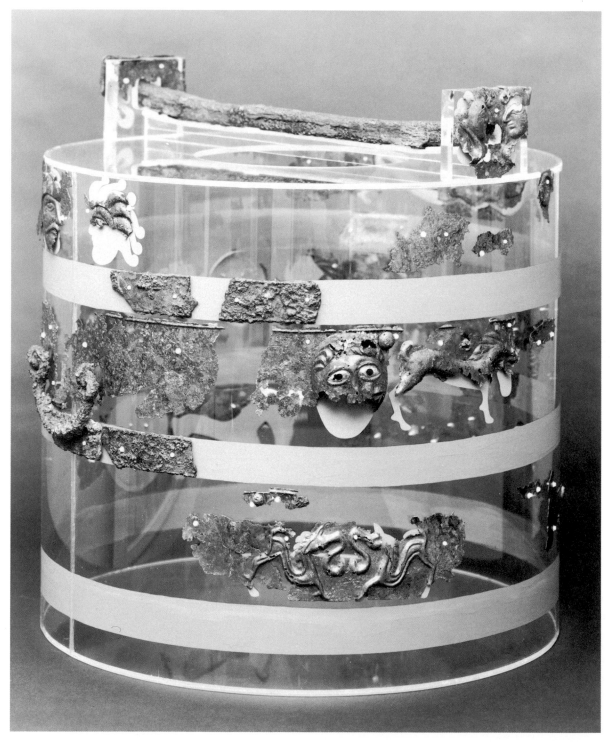

Bucket from Marlborough, Wiltshire

evolved handles have double balusters with confronted loops joined with a pseudo-link, the point where the plate meets the handle being variously elaborated, sometimes with petal and leaf ornament. One, from Ingleton, Yorkshire, has an upper loop flanked by three-dimensional ox heads.

The inspiration was clearly Roman mirrors, but the earliest, undecorated prototypes (notably one from the Queen's barrow, Arras), may date from the second century BC, before direct Roman influence could have been felt. The most accomplished are the examples from Desborough, Northamptonshire, and Birdlip, Gloucestershire.

Buckets and Bowls

For reasons of taste or economy, not all patrons favoured total decorative coverage. A group of three-dimensional items were intended as attachments for other objects. The finds from Felmersham-on-Ouse, Bedfordshire, comprise a spout in the shape of a fish head and the metal attachments for a bucket (possibly a milk pail), namely a pair of cow and bull-head escutcheons (the cow licking its nose) and the bucket handle which swivelled in them. The fish-head spout has an open mouth and bulging, originally inlaid eyes. A triangular flange was keyed with an S-scroll, perhaps to take enamel. The spout must have been attached to something with a rim at least 1 centimetre (½ inch) thick, presumably a bowl. The Felmersham bucket attachments would be at home in either an Iron Age or a Romano-British context.

A series of other such fittings continued to be made from the Iron Age into the Roman period, the finest of which is an ox-head bucket handle from the Iron Age hillfort at Ham Hill, Dorset. Here the artist depicted nostrils with spirals and placed a knob on one of its horns (the other horn must have had one too). These may represent wooden balls which were fastened to bulls' horns, to minimize potential damage. Its findspot, an Iron Age hillfort, suggests an Iron Age date.

Three-Dimensional Modelling

The Celts seem to have used relief modelling and engraving more than three-dimensional work in metal. A few examples, however, have survived.

Among the many finds from Snettisham, Norfolk (not from the same site as the torcs), was a terminal in the form of a duck's head, perhaps a mount for a drinking horn.

Although three-dimensional human heads are not common, some bronze examples exist. Some are found on anthropoid daggers, notably that from North Grimston, Yorkshire. There are some moustached heads from Welwyn, Hertfordshire, of the first century BC and undatable examples have come from Norfolk, from Gillingham and from Holme Hale. The artists used the same treatment of the hair as for the Welwyn heads, but each appears to have been attached to a larger object.

Bronze duck head, Snettisham, Norfolk (drawing: Caroline Bevan)

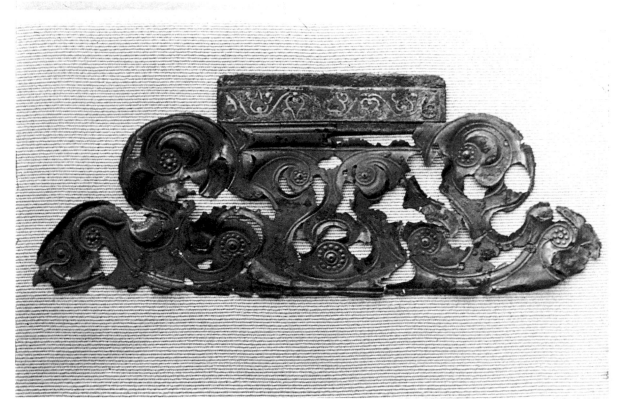

Casket mount with enamelling, Elmswell, South Humberside (Hull Museums and Art Galleries).
See p. 79

Enamelled bronze seal box lid, with swash-N (Nottingham University Museum). See p. 79

Bronze head, Gillingham, Norfolk
(drawing: Caroline Bevan)

Pottery and Wood

There seems to have been little career scope for an Iron Age artist or designer in Celtic ceramics since pottery was seldom richly decorated. The finest is known as 'Glastonbury Ware' after finds made in the settlements of Glastonbury and Meare in Somerset, though it is now known that it was manufactured in the south-west peninsula, and imported to Somerset. The designs on the best pots represent nothing more inventive than simple versions of the indigenous engraved style found in metalwork. The same kind of ornament can be seen on a wooden tub from Glastonbury. Among the more interesting examples of the potter's art is a vase in the shape of a bird from King Harry's Lane, St Albans, Hertfordshire, a late Iron Age cemetery.

A few surviving wooden figures from Britain were presumably cult figures from shrines.

The Arts of Religion

Much Celtic art was intended, directly or indirectly, to honour the gods. What is known of pagan Celtic religion is mainly derived from classical sources and from limited archaeological information, much of it Romano-British rather than Iron Age. Indirect information comes from later Celtic literature.

One of the problems of evaluating the evidence lies in its ambiguity. The Celts did not have an organized pantheon like the Greeks and Romans, but instead worshipped a diversity of supernatural beings under different names in different areas. Of the 374 gods' names known from inscriptions in Gaul, 305 appear only once, and only four or five of the remainder are found more than twenty times. Classical writers tried to equate Celtic deities with their counterparts, but this was at best a dubious exercise. No fewer than sixty-nine Celtic deities appear to have their names coupled with that of Mars, the Roman god of war, suggesting, reasonably, that a war god or gods figured prominently in Celtic belief.

Of the classical sources, perhaps the most well known are the accounts of Julius Caesar, Diodorus Siculus and Lucan. Caesar provided a graphic description of the druids, but his objectives were political, as undoubtedly were the intentions of the other classical writers. Lucan, who wrote in the second century AD, was clearly intent on shocking his readers with grizzly tales of human sacrifice, and seemed to think that only three gods were important: Esus, Teutates and Taranis. None of these figure prominently in inscriptions.

Druidic Sacrifices

Since the druids played an important social role in Iron Age society, the Romans opposed them. They were prophets who officiated at the worship of the gods and controlled sacrifices, sometimes human. There is growing evidence for the latter, including the ritual execution of a young man who was found remarkably well-preserved in a bog at Lindow, Cheshire, his stomach containing mistletoe, a plant traditionally associated with the druids. At Garton Slack a young man and a woman of about thirty were

probably buried alive. Poignantly, beneath the woman was the body of a premature baby.

The object of sacrifices appears primarily to have been divination; the Celts were much concerned with 'good' and 'bad' days and times for doing particular things. Tacitus relates how druidic altars on Anglesey were covered with human blood and entrails. There is some evidence for head-hunting in Iron Age Britain. At Danebury, adult male skulls were deposited in storage pits, perhaps to bless the corn. Skulls at Bredon, Worcestershire and Stanwick, Yorkshire, seem to have been attached to poles at the gates. Representations of human heads without bodies in Celtic art may relate to Celtic veneration of the head. A series of coins struck by the Iceni of East Anglia display what seems to be a head in decomposition, rendered with chilling realism.

Shrines

There is growing evidence for shrines in the Celtic world, much of which comes from Gaul. In Britain, continuity of activity can frequently be observed between the Iron Age and Romano-British periods, and in some cases even as far back as the Bronze Age, for example at Haddenham in Cambridgeshire.

Among the structures identified in excavation, the shrine at Heathrow, Middlesex, was rectangular and set within a rectangular enclosure. The design was very similar to that of later Romano-Celtic temples though it was dated to the third century BC by associated finds. At Frilford, Oxford-shire, two adjacent Iron Age temples lay under a rectangular Romano-Celtic shrine. One comprised a penannular ditch enclosing six postholes with a votive offering of a ploughshare and miniature shield and sword, the other simply a circle of postholes.

Ritual Centres in Ireland

In Ireland there is evidence for major Iron Age ritual centres, the traditions of which survived into the Dark Ages. Perhaps the most remarkable is Navan, the *Emain Macha* of the *Ulster Cycle*. Here a circular earthwork encloses the summit of a hill, within which were found the remains of Iron Age houses and the skull and jaw of a Barbary ape, dated to the third or second century BC. In the first century BC a huge, circular building, 37.3 metres (40 yards) in diameter, was erected on top of this settlement, perhaps to cover a cairn. The timber structure was burnt, and the cairn covered by a mound of cut turves. The timber building is the most remark-able discovered in Celtic Europe, and the various stages in the sequence of the use of the site suggest a series of planned ceremonies. Other large circular ritual buildings are known from Dun Ailinne in Leinster. A third ritual centre is at Tara, Co. Meath.

Religious Works of Art

Found within these religious contexts are some of the finest works of art of varying date, such as votive models of shields, swords and axes. A model shield from near Salisbury, Wiltshire, was discovered in a hoard which contained a variety of offerings to the gods. The earliest were found with

Carving from Margidunum,
Nottinghamshire (Nottingham
University Museum). See p. 85

Carving from Thorpe by Newark, Nottinghamshire (Nottingham University Museum). See p. 85

Miniature votive shield, near Salisbury,
Wiltshire (Copyright British Museum)

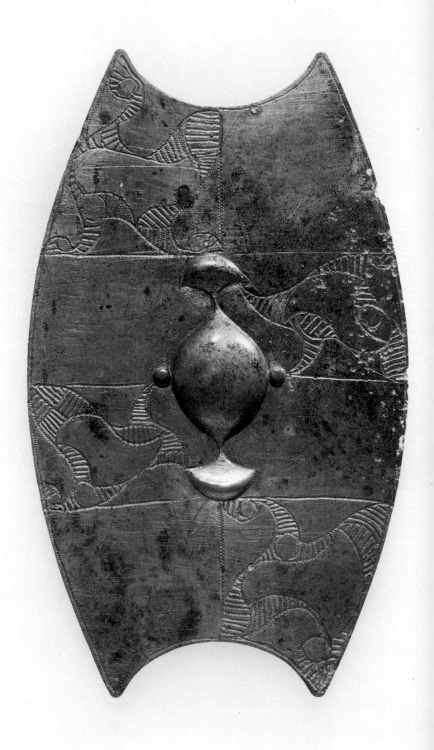

some axes of the Late Bronze Age. The shield itself is of unusual shape, with concave top and bottom, and is engraved with ornament. Other miniature votive shields are known from the Early Iron Age. They include those from Worth, in Kent, and a group recently discovered in Lincolnshire, with miniature swords. None is decorated.

Water was important in religion (probably associated with healing), in Iron Age Britain. Wells, and what are loosely termed 'ritual shafts', are often filled with offerings. Trees and groves also appear to have been places of veneration, actual trees or substitute timber posts being the focus of some sanctuaries. At Hayling Island, Essex, a shrine contained a sacred enclosure with an internal, circular building. A pit in the centre may have held a pillar or post, and the outer enclosure contained offerings of martial equipment and chariot fittings. Many objects – often extremely costly, such as the Battersea Shield (p. 207) – appear to have been offered to the gods in water.

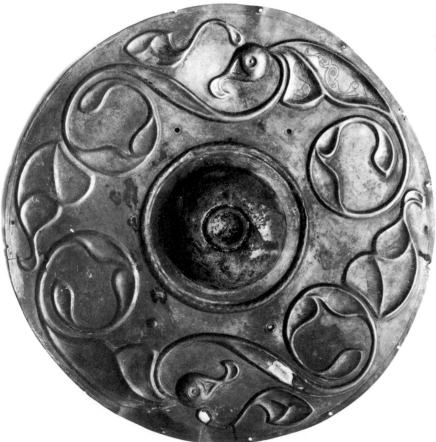

Round shield boss, Wandsworth, Middlesex (Copyright British Museum)

The Wandsworth Round Shield Boss is a superior product that was found in the Thames and was probably votive. Its maker gave it a wide flange and small dome in the centre with a hollow seating. The decoration chosen for the flange was in repoussé, with two schematic birds in procession.

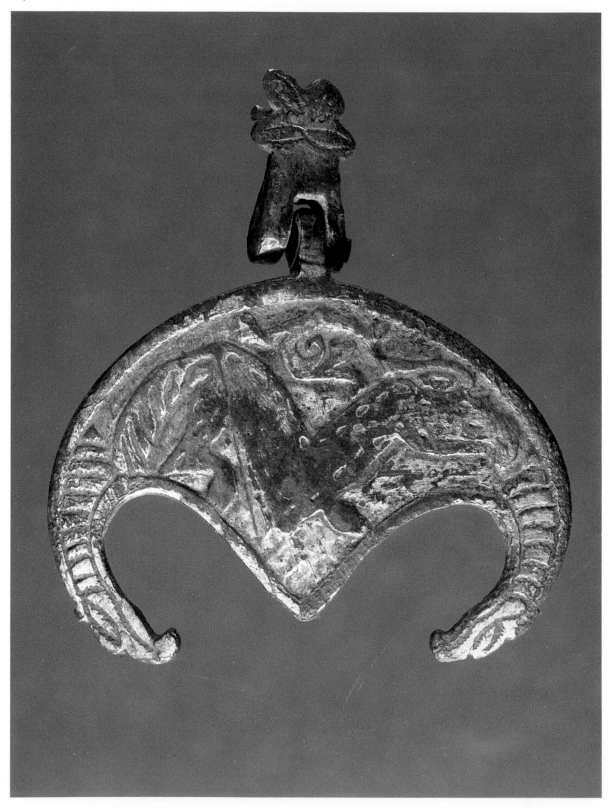

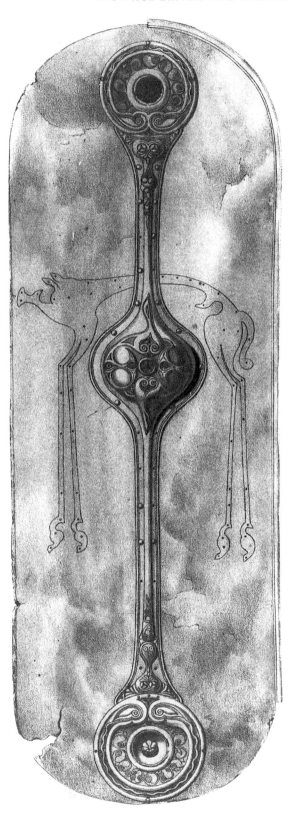

OPPOSITE Gilt bronze horse pendant, Margidunum, Nottinghamshire (Nottingham University Museum). See p. 85

LEFT Shield from the River Witham, Lincolnshire, probably at Fiskerton (drawn by Jewitt for Kemble's *Horae Ferales*, 1863)

Bronze boar, Woodingdean, Sussex
(drawing: Lloyd Laing)

The designer of the Witham Shield (which was found in the River Witham, Lincolnshire) opted for a long-legged, stylized boar, fastened with rivets as the central feature. This was subsequently removed leaving a more conventional one-piece long boss, allowing us a rare and fascinating insight into changing fashion. In the very centre the smith placed three studs of coral, holding them in place with pins.

Certain figurines in the Early Iron Age appear to have been intended for devotional purposes. A bronze figure of a boar, found with two bronze discs which were thrown away by the finders, were associated with a swan's-necked pin at Woodingdean, Sussex. Such pins were popular on the Continent in late Hallstatt times, but gave rise to a series of much later survivors in Britain.

A few statues which must be cult effigies are known from Iron Age Britain. A chalk figure was found in an oval chamber at the bottom of a pit at Deal in Kent, some 2.5 metres (3 yards) deep. The body was featureless, the head well carved. There were footholds in the shaft, and the chamber could have held four or five adults at a time. The shaft may be of the first or second century AD. Other statues include chalk warriors from Garton Slack and Wetwang, presumably deities, and a wooden figure from Dagenham, Essex.

A couple of carvings in abstract style are datable to the Iron Age in Ireland. The Turoe Stone is a pillar with domical top, richly carved with curvilinear patterns. Once considered as the work of immigrant Continental craftsmen, it now appears that the sculptor shows more familiarity with the mirrors of south-east England, and a date around the first century AD is likely. It stands near an early rath.

Included among the various cults found in Celtic Britain are those relating to sun and sky, the former symbolized by a wheel. Also found are cults relating to fertility and to mother goddesses, war deities and finally deities concerned with water and healing. Much evidence for these beliefs can be found in coinage.

The Arts of Trade and Commerce

As trade developed, the Celts took up the classical concept of coinage, taking classical coins as their models. The basic design of almost all the earliest coins in western Europe was ultimately inspired by the gold staters of Philip II (the Great) of Macedon. The 'phillipus', as it is called, had the head of Apollo on the obverse and a two-horse chariot (biga) on the reverse. Although the head mostly retained some of its human features, the chariot was rapidly reduced to a single horse, sometimes with a token wheel beneath. It may well have been that the retention of the wheel was due to its symbolic value in the Celtic sky cult, though it may also have served as a mark of value, since miniature wheels (and sometimes rings) are found in Gallic hoards where they may have been symbolic 'money' to offer to the gods.

Imported Celtic coins first circulated in Britain in the late second century BC, when a series from Belgic Gaul appeared in the south-east. Various issues were brought in down to the time of Caesar's Gallic war,

Sculpture of a man or god, Deal, Kent
(drawing: Lloyd Laing)

and one of the most abundant has been claimed to be payment to British supporters of the Gallic cause.

Early British Coins

The earliest coins made in Britain are thin, cast pieces of potin (an alloy of bronze with a high tin content), which copied Greek bronze coins issued at Marseilles, with an Apollo head on the obverse. They display a butting bull on the reverse, a subject which no doubt appealed to the cattle-conscious Celts. There are two series, both found in Kent and Essex – the first comprises fairly good copies of the prototypes. The moulds were formed by taking impressions of the originals which were issued around the end of the second, or beginning of the first, century BC. These became progressively cruder so that the second series is very basic. They represent streamlined technology, since they could be produced in large numbers without particular skill.

Soon after the time these coins were circulating, British copies of the 'phillipus' coins were struck. These British versions display artwork which is closely related to that on Continental coins, but markedly different from the art displayed on insular objects, possibly implying the immigration of moneyers. Apart from the horses, which are frequently partly disjointed, the designs tend to be composed of crescents, pellets and rings, and many diverse symbols appear as fillers in the field, such as suns, flowers, bull heads, leaves, shield-like shapes, wheels, rings or even birds or footprints and comets. The meanings of the motifs are lost, though the coins bearing them display regional variations which have resulted in their traditional attribution to particular tribes which are known from later Roman sources. Where the individual types have distributions that appear to extend beyond the known tribal boundaries, the explanation is often seen as trade. In reality, we know virtually nothing about the tribes of the earlier first century BC, or even the time of Caesar, who records the names of peoples not recognized from later sources.

After the time of Julius Caesar, British coin designers in the south-east showed progressively more interest in the classical world.

Art on Coins

As the coins with representational art are all, to a greater or lesser degree, influenced by classical models, it is not always easy to be certain whether depictions are of Celtic subjects or subjects taken from classical sources. Some, however, are undoubtedly Celtic. Take for instance the rare depictions of boats, which appear on coins of Cunobelin (c. AD 20–43). Cunobelin's boat has a high stem projection and is a deep vessel with mast and square sail; it appears to be a ponto, a type of ship known from classical writings.

Horse trappings appear on a group of British coins. One issue of Verica, a ruler of the Atrebates (c. AD 10–35), shows a saddle cloth with four girths and straps which pass through rings on the shoulders and haunches of the horse, from which are hung decorative bands. The horse has a braided mane. On other coins, warriors carry spears, swords and sometimes a carnyx (a boar's head trumpet). The head of a carnyx was found at

Deskford in Banff, dating from the early centuries AD. Two types are represented on coins, one with flaring mouth, shown being brandished by a horseman on a coin of Tasciovanus (*c.* 25–15 BC); the other has a less angled head which is carried over the shoulder of a horseman on the reverse of a coin of Eppillus, struck around the time of the birth of Christ. Chain mail is worn by figures on some coins of Tasciovanus, and helmets are of the bowl variety, unlike the Waterloo Bridge example. Shields include an elliptical type with long, pronounced midrib. Other subjects represented include chairs and metal vessels. In a rare representation of an artist at work, a smith is shown hammering a vessel with a footring, on a coin of Cunobelin. Coins can also provide information about costume – figures wear a short tunic or kilt and women wear long dresses.

The style of Celtic coins is distinctive, though artists in other media were influenced by it. A good example is the original boar on the Witham Shield which, with its long spindly legs, is not unlike some boars and other creatures that appear on Celtic coins. A similar boar appears on some coins of the Corieltauvi (in whose territory the shield was found) and a see pp. 52–3 three-dimensional relative can be seen in the piece from Woodingdean, Sussex.

Research has shown that in a number of cases the models behind the classical-style coins were Roman, and less frequently Greek, coins. In some cases, the designs are found on Roman gemstones or plate. Some, however, appear to be distinctively British subjects – Celtic warriors, gods and goddesses. The stag-headed god Cernunnos appears to stare out from a unique, silver coin found at Petersfield, Hampshire, with a wheel between his horns. On a coin of Cunobelin, a goddess, often misread as a male figure, rides side-saddle. The maker of a disc brooch from Santon Downham, Suffolk, conjured up a griffin-like monster which clearly had wide appeal, since it appears in almost identical form on a coin bearing the legend RUES, struck in the territory of the Catuvellauni, in the first century AD. A gold quarter stater of the Atrebates, struck around the middle of the first century BC, has a whorl with legs ending in animal heads. This is very close in style to the triskele ending in animal heads on an antler roundel from Meare East, Somerset.

This buoyant interchange of ideas between artists and designers in different media is also demonstrated by two wooden objects, covered with metal plates, that show similarities to some coin designs. The first, a tripod bucket from Aylesford, Kent, had escutcheons with helmeted heads, to carry the handle. The backward-looking horses with open mouths can also be seen on coins from Essex, probably struck by a chief called Addedomarus, and the bird-head whorls have distant relatives on the Torrs pony cap or Wandsworth round shield boss, while the central flower can be seen in a variant form on coins.

The second is a fragmentary wooden tub or vat from Marlborough, Wiltshire, which was decorated similarly, with repoussé figural designs, most notably seahorses and facing human heads. The Marlborough vat fell to pieces soon after discovery in 1807 at Collingbourne, but fortunately its appearance was sketched. The surviving fragments and original

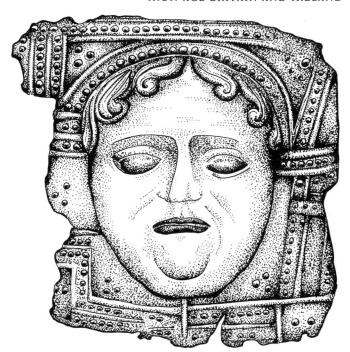

Bronze repoussé plaque, South
Cadbury, Somerset (drawing: Priscilla
Wild)

BELOW Pot from Kelvedon, Essex,
with stamp of horseman (drawing:
Lloyd Laing, after Warwick Rodwell)

drawing show that it had two 'ears' at the top, to take an iron bar. These had plates on which the artist had depicted facing human heads with beaded hair. The top register showed trumpet patterns and facing human masks. On the central band, a human mask with perforated eyes was flanked by confronted horses, on the third there were confronted seahorses. For a comparable facing mask one should turn to the bronze coinage of Cunobelin, though there is a similar mask on an appliqué plate found at South Cadbury, Somerset. This came to light from under the destruction level in one of the gatehouses and was thus clearly buried at the time of the Roman conquest. For the animals on the Marlborough vat, coins again provide models – Tasciovanus' bronze series provides a comparable seahorse, and a creature not unlike the long-snouted 'horses' or 'griffins' can also be seen on Tasciovanus' coins.

A unique potsherd from Kelvedon, Essex, was found in a well of the first half of the first century AD. It appears to be in a local fabric, perhaps imitating Terra Nigra (an imported Gallo-Belgic ware), and has been stamped by a metal die with a design of a mounted warrior with Celtic shield. Here the potter was clearly attempting to imitate Roman relief-decorated pottery, such as Arretine, or even Roman silverware. The design, however, is very close to that on some coins of Verica, which display mounted figures with similar shields.

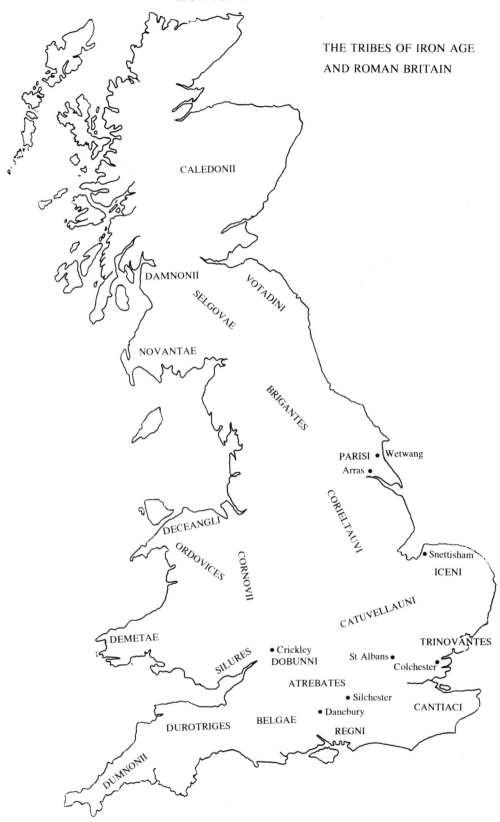

THE TRIBES OF IRON AGE
AND ROMAN BRITAIN

CALEDONII

DAMNONII

SELGOVAE

VOTADINI

NOVANTAE

BRIGANTES

PARISI • Wetwang

Arras •

CORIELTAUVI

DECEANGLI

ORDOVICES

CORNOVII

• Snettisham

ICENI

CATUVELLAUNI

DEMETAE

TRINOVANTES

SILURES

• Crickley
DOBUNNI

St Albans •

Colchester •

ATREBATES

• Silchester

CANTIACI

BELGAE

• Danebury

DUROTRIGES

REGNI

DUMNONII

Celts and Romans

BY THE FIRST CENTURY BC the culture in Ireland and Britain was thoroughly Celtic. This was challenged by the arrival of Roman civilization and created a considerable difference between those areas which came under Roman rule and those which did not. Traditionally, archaeologists and historians saw the creation of the Roman province of Britannia (roughly what became England, Wales and southern Scotland) as ending Celtic life, and the Romans as having virtually no influence on the areas outside the province. More recent research, however, has shown that Celtic life did not die out under Roman rule and the Empire's influence over the areas it did not conquer was measurable. The two areas will be dealt with separately in this chapter.

The Roman Conquest

After Julius Caesar's expeditions in 55 and 54 BC contact between the Romans and Celts was confined to trade and diplomacy, evidence for which has been seen from the grave goods discussed in Chapter 1. The legions arrived to stay in AD 43 and for the first time there are more detailed contemporaneous historical documents relating to the Celts in Britain.

Despite resistance on the part of many tribes – the initial efforts to repel them by Togodumnus and Caratacus are particularly well-known – by AD 59 the Romans were ready to tackle Wales where they met formidable resistance inspired by the druids in Anglesey. Consolidation of the conquest took some time, and was delayed by two occurrences of native resistance: in AD 69 by the Brigantes under Venutius in northern England, and more famously by the Iceni in Norfolk under Boudica in the year AD 60.

The Roman conquest of Scotland did not begin until AD 79, though ambassadors from the Orkneys had been sent in AD 43 to the emperor Claudius.

A line of forts along the Forth-Clyde line was established by Roman forces under the leadership of the general Agricola between AD 82 and 90. Here a turf wall was built by Antoninus Pius in AD 142. In the interval, however, the building of Hadrian's Wall had begun (in AD 122). The Antonine Wall was held until AD 161, but although it was briefly re-occupied in the later second century, from this time on until the end of the Roman occupation of Britain Hadrian's Wall effectively remained the northern frontier of the province. The significance of this boundary was that it prevented large-scale migrations and contact between Celtic peoples. It therefore had a particularly lasting and dramatic effect and as

a result the Celts within Roman Britannia and outside it fared very differently for the following four centuries.

Within Britannia there were two distinguishable zones – the civil and the military. The south had always been more receptive to influence from the Continent and after the initial period of conquest it settled down to a Romanized lifestyle, with towns, theatres, public water supplies, baths, villas and all the other adjuncts of civilization. Christianity was adopted as the official religion under Constantine in the early fourth century and became well established in later Roman Britain, as the Christian silver from Water Newton, Huntingdonshire and the Romano-British church at Silchester attest. British bishops and a deacon attended the Council of Arles in AD 314, and there are Christian wall paintings from Lullingstone, Kent.

Art was imported from the classical world and such luxuries as mosaics became popular among the rich. The highly Romanized remains of the period lie outside the scope of this book, since any Celts who took up a Roman lifestyle clearly wished to be regarded as Roman and we must respect their decisions.

In the Highland zone, however, the Roman presence had to be enforced by forts and military power and Romanization was much less successful. In this military zone, definable indigenous culture survived to a far greater extent than in the south-east: there were no towns or rich villas for example. Beyond the frontiers life continued with only minor influence from the Roman world. However, the significance of this was that the 'free' Celts were cut off from their traditional trading partners and slowly, over the next few centuries, their culture ceased to flourish. It is notable that archaeological sites are particularly impoverished from this period and no artworks have been discovered. There appears to have been little innovation until the Romans left the scene, as will be seen.

Celtic Culture under the Romans

As the Celts in the south enthusiastically adopted Roman ways, in the north of England and in Wales people were both less willing, or possibly less able, to do so. Even so, Roman influence permeated. Native farms, traditionally built of timber, were now frequently rebuilt or built in stone or had stone footings. Roman-style, Celtic houses are distinguishable not only from the building material but from the fact that they are rectangular not round, as they usually were in the Iron Age. The shape alone, if seen from the air for example, can provide a Roman-period date even without associated finds or excavation. Typical of North Wales are enclosed hut groups – farmsteads enclosed by a wall, which in some cases show Roman influence by their rectilinear planning. A good example is Din Lligwy in Anglesey, which is in effect a Celtic response to the villas of the civil zone. In Cornwall, some of the traditional farmsteads, known as 'rounds', similarly show evidence of Roman influence by the occasional rectilinear planning. These and other native farmsteads often betray contacts through trade with their Roman neighbours – Roman pottery, coins and brooches are frequent finds.

Celtic Art under the Romans

While the rich Celts embraced the Roman way of life, importing Roman furniture, wine, pottery, metalwork and classical sculptures of Roman deities or recognizable imperial figures, the taste of their poorer counterparts was still rooted in the past.

The classical art of the Romans was concerned with two major objectives – the imitation of nature and the search for the ideal. Thus, sculptures may be portraits of living people, and mosaics and wall paintings are dedicated to realistic depictions of flowers, leaves, animals and so on. This major (but not exclusive) absorption with things naturalistic probably stems from a desire to mitigate the highly artificial and developed lifestyle in an uncompromising urban landscape. Stone-built houses and public buildings with harsh, rectangular lines require softening to provide visual comfort and as antidotes to the soulless State bureaucracy.

In contrast, Celtic society depended on familiar and tribal loyalties, and rural life was the norm. There was little room for consideration of such ideals as the glorification of man or the state and the quest for beauty. Celtic art is often abstract, and its motives are diametrically opposed to those of the Roman. It leans heavily towards the stylistic, abounding in ambiguities (see appendix). Pattern and symbolism are of paramount importance.

Traditionally, classical scholars regarded all Roman art as derivative of the Greek and all provincial Roman art as the result of not very skilled Celts attempting to imitate classical models. Indeed, it is possible to see Roman art as infinitely eclectic and vibrant, taking on aspects of the areas in which it was produced and always moving on. Thus, Celtic art under the Romans can be divided into two – Celtic influence in what were intended to be classical pieces, and purely Celtic-style ornamentation on either traditional objects or Roman ones.

Celtic ornamental styles manifested themselves not on major and expensive objects but on the smaller items of personal adornment and occasionally on things used about the home. Increasingly, careful excavation is showing that Celtic art did not die out in the second century AD but continued in the third and enjoyed a modest resurgence in the fourth. This is a fundamental change in scholarly stance over the past few decades, before which Celtic art was seen to have died out completely to enjoy a totally inexplicable resurgence in the Dark Ages/early medieval period.

The Arts of Resistance and War

During the period of the Roman conquest, the Celts who were opposed to Rome continued to produce equipment for their resistance fighting. From this period comes an assortment of swords, a helmet and a diversity of equipment for ponies and chariots, as well as an unusual boar's-head trumpet.

The Brigantes in northern England and Caledonians in Scotland were at the forefront, and it is very easy to distinguish their products since their artists favoured slender-stemmed trumpets and high-relief modelling.

The work of the Brigantian smiths and artists is best known from the finds in a hoard from Melsonby, Yorkshire, which consists of a diversity of objects, mostly horsegear, deposited some time after AD 70 when the Romans advanced into Brigantia. Two sheet-metal, repoussé mounts, one in the form of a horse head that is distinctly melancholy-looking, the other a moustached human face, have a distinctly archaic feel about them. The piece with the human face with its twirling moustachios may have been a tutelary guardian for a chariot to which it was attached.

The Deskford carnyx from Banff is one of the few surviving examples of a Celtic boar-headed war trumpet of which only the head survives. It was originally furnished with a wooden tongue on some kind of spring mechanism (which was lost after discovery). Only the mouth piece survives, with hollow voids for eyes that must once have held enamelled insets. It is an awesome object, and may well have been carried by the Caledonians into battle with the Romans in the first century AD. It displays lobes and slender-stemmed trumpet patterns.

Some archaeologists deduce that status symbols amongst Celtic chiefs in Scotland were produced by the Caledonian smiths in the form of heavy penannular armlets. These unwieldy objects were decorated with a particularly refined design of slender-stemmed trumpets. Some bear inset glass settings in their round terminals, and all are modelled in high relief. They can be seen as a flamboyant assertion of Caledonian independence. The most famous is perhaps that from Castle Newe, Banff, now in the British Museum, which retains one of its glass insets with a hatched

ABOVE Harness trapping, Melsonby (Stanwick), Yorkshire (drawing: Lloyd Laing)

BELOW Head of carnyx of trumpet from Deskford, Banff (National Museums of Scotland)

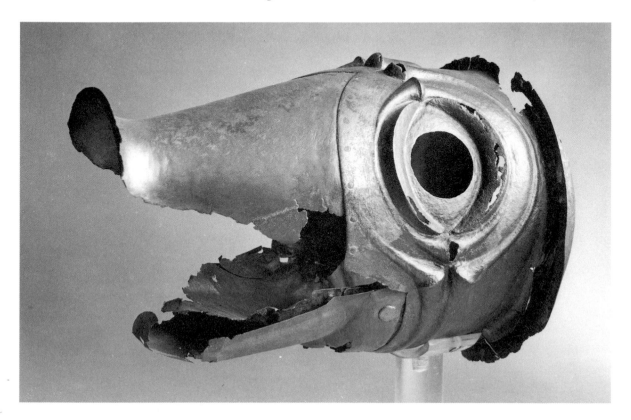

Caledonian armlet, Belhelvie,
Aberdeenshire (National Museums of
Scotland)

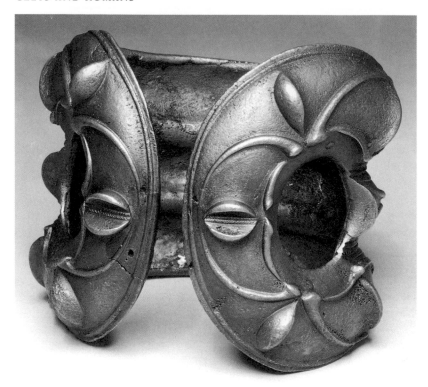

pattern. It is divided into ribs by feather pattern bands. This example was
found near a coin of Nerva (AD 96–98); another was associated with
Roman material of AD 150–250, perhaps suggesting a currency from the
end of the first century through the second and beyond. Another good
example comes from Belhelvie, Aberdeenshire.

Also from Caledonian workshops are a few substantial, spiral-snake
bracelets, the best example of which was found at Culbin Sands, Moray.
Where did the smiths get this idea? While an ancestry traceable to a snake
bracelet from a pre-Roman Iron Age burial at Snailwell, Cambridgeshire,
has been suggested, they are equally likely to have been influenced by
Roman snake bracelets which were produced in both silver and bronze
to a variety of designs. The bracelet from Culbin, itself, is the most
advanced, the artist having used slender confronted trumpet patterns and
a setting in the head for enamel (now lost). The blue, glass eyes survive.
It also displays spiral bosses. As the Roman period progressed, such works
seem to have declined, presumably because the presence of Rome severely
curtailed the prosperity of the tribes.

Not all the equipment made for the fight against Rome was produced
by the Brigantians or Caledonians. The Meyrick Helmet (named after a
north of England collector who owned it) now in the British Museum, is
one such piece. It is a Celtic smith's version of a Roman auxiliary helmet,
with conical cap and neck guard. Originally it had side pieces. Both the
side pieces and the neck guard have repoussé ornament. The pattern
chosen for the neck guard comprises a degenerate lyre scroll with keeled

half moons. Two studs are cross-hatched as though for enamelling, in the manner fashionable in the first century BC. Someone roughly scratched the Roman numeral II on the helmet, perhaps suggesting that it saw some service on the head of an auxiliary in the Roman army in the later first century AD.

Some swords are also noteworthy. Among the finest is that represented by its scabbard from Mortonhall, Midlothian. Its chape was decorated with a broken-backed scroll with pronounced bosses, and with a saltire in similar style. The main motifs are outlined with slender-stemmed trumpets at its mouth. Other swords dating from this period include an Icenian one from Congham, Norfolk, a Brigantian example from Stanwick, Yorkshire, and one from Battersea, London.

On a more mundane note, the less wealthy could acquire a series of decorated button-and-loop fasteners. Some may have been dress-fasteners, but they may have been more often used as harness fittings. Some, confined to north Britain, are decorated with a pellet-and-leaf device that was first used by Iron Age artists. They seem to have become popular in the late first century, continuing in vogue through the second century. The leaf's point is sometimes formed of two debased, confronted

Meyrick helmet (Copyright British Museum)

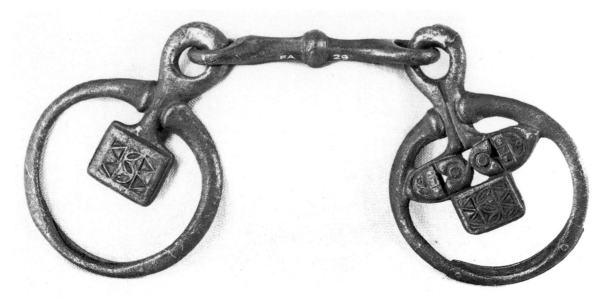

Bronze bit, Birrenswark, Dumfries-shire (National Museums of Scotland)

trumpets, and crude trumpets adorn some of the other forms of button-and-loop fasteners. One from Carlisle has two leaves conjoined with a circle inside an oval at the junction – it is set with enamel inlay. One square-headed fastener has an enamelled pattern of a swash-N.

The same motif was employed on a variety of other types of horsegear, such as strap junctions. Corbridge, the Roman supply fort and settlement, has yielded a mount with four radiating petal rings combined with bosses. Petal-and-boss strap junctions also appear in the Middlebie hoard, Dumfriesshire, while similar objects were recovered from the Roman fort of Newstead, Roxburgh, and the native fort of Traprain Law, East Lothian. Clearly, the Romans were not averse to using Celtic horsegear (and to judge from Bar Hill, chariots), implying a degree of commercial interplay. An example of the kind of horsegear that often turns up in Roman contexts takes the form of a double leaf-strap junction found in the Middlebie hoard. Richly decorated with enamel, it has a central stud with a four-petalled enamelled flower.

The makers of a series of bridle bits also used petal-and-boss decoration. One from the native fort of Birrenswark, Dumfriesshire, was given pairs of leaves with central double circle, and other enamelled ornament. A plain three-link bit from Newstead originally had a pair of petal bosses back to back; the same device, enamelled, appears on one from Rise, South Humberside, with four-petal flowers in enamel on the studs.

This type of decoration was essentially part of the northern smiths' repertoire, with a particular focus in south-west Scotland, though the use of enamelling may be a borrowing from further south.

The Arts of Peace in Britannia

Within the Roman province of Britannia, a variety of objects has now been distinguished as having been produced to Celtic taste for native

patrons. They mostly comprise brooches and a few other pieces of personal adornment, though there is in addition a series of decorative mounts for a variety of objects, a couple of tankards, and rather more handles of others that are now lost.

A series of die-stamped, metal mounts for caskets, brooches, couches, collars, bracelets, mirrors, tankards, buckets and one or two items of more military purpose, such as scabbards and shields, have been found in the south-east of England. As with the Brigantian and Caledonian metalwork, slender-stemmed trumpets are a notable feature, but the smiths' repertoire also included other ornament, such as the 'berried rosette' and the 'swash-N' (see p. 57). Patterns are repetitive.

Examples of this popular 'casket work' come from a range of findspots, ranging from the Roman town of Silchester to Llyn Cerrig Bach in Anglesey, where it is likely to predate the Roman conquest. It was current in the repertoire of artists in the late first century, as attested by finds from the Roman fort at Newstead, Roxburgh, and it was still being produced in the fourth century, as witnessed by finds from Lydney, Gloucestershire, and Silchester, Hampshire. The finest example is a mount from Elmswell, South Humberside (see p. 56). A panel of enamel with a Roman ivy scroll appears either above or below (since its function is unknown), a Celtic-inspired scroll with a variety of motifs.

Rosettes and slender trumpet patterns were chosen to decorate a mirror from the hoard from Balmaclellan, Kirkcudbright. The designer gave prominence to a palmette and the flat handle is unlike any found on Iron Age mirrors, but is perforated with a simple triskele. Its shape is too close to that of circular-pierced Roman patera handles of the first century AD to be fortuitous.

Brooches and Plaques

It is usually assumed that these 'casket ornaments' were being made in the first century AD, but artists continued to use die-stamping for the production of disc brooches into the second century and beyond. The disc brooches are composed of die-stamped roundels affixed to a base plate. They seem to have been made first when designers copied coins of Hadrian. The most notable have a triskele as their main motif. Of the half a dozen or so brooches known, a good example was found at Victoria Cave, Settle, Yorkshire. The related enamelled triskele disc brooches, mostly from southern Britain, and probably of the second century, show the popularity of the motif in Roman Britain.

The maker of the Aesica Brooch from the Roman fort of Greatchesters, Northumberland, chose 'casket ornament' for this remarkable object of gilt bronze. It belongs to the family of Romano-British, bow-and-fantail brooches, which were current from the mid-first to the mid-second century. The artist used two confronted hippocamps (seahorses) with duck-like heads on the footplate and slender trumpets. The Roman-derived ivy leaf on the head was successfully Celticized.

The smith hammered the now-lost plaque from Moel Hirradug, Clwyd, on to a die made with a wooden model. The ornament is in shallow but angular fashion with a broken-backed triskele in a diamond. The plaque

The 'Aesica' brooch, gilt bronze, Greatchesters, Northumberland (drawing: attributed to H. E. Kilbride-Jones)

Bronze plaque, Moel Hirradug, Clwyd
(National Museum of Wales)

was found with shield mounts in a small hoard buried under the collapsed
rampart at the bottom of a ditch – it is likely to have been from a smith's
cache of the later first, or more probably second, century AD.

Tankards
Tankards, important adjuncts of Celtic feasts, were frequently dignified
with decoration and a series was made by Late Iron Age and Romano-
British smiths. The finest is the Trawsfynydd tankard from Gwynedd,
which is usually considered to be of pre-conquest date, but need not
have been. Normally only the handles survive, though the tankards have
occasionally been found. The Trawsfynydd example comprises a stave-
built vessel with elegant curving sides and a solid base, decorated with
a boss and a wavy metal line hammered into the wood. The tankard's
designer covered it with sheet metal, to which the openwork handle was
attached. This holdfast has broken-back scrolls; where it meets the body
of the vessel it has openwork triskeles with large, central bosses.

The same type of triskele was chosen for the centre of a dragonesque
brooch from Lakenheath, Suffolk, and similar motifs appear on openwork
studs (triskele fobs) from various provenances and of various dates. These
pieces are often decorated with large bosses, and use a distinctive type of
broken-backed scroll.

Torcs
The broken-backed scroll used by the smith on the Trawsfynydd tankard
handle is echoed on a beaded torc from Lochar Moss, Dumfriesshire. Such

torcs (of which sixteen are known) have a series of massive beads and a crescentic plate above. They are probably Brigantian works of the later first, and earlier second, century AD.

A patron in Scotland commissioned the magnificent Stichill Collar, from Roxburghshire, on which bosses are a prominent feature. It was apparently found with a massive Caledonian armlet, indicating a deposition date in the late first or second century AD. The technique employed by the maker is a little reminiscent of the Bann Disc. It is closely related to a series of collars from the south-west of England, such as that from Wraxhall, Somerset, which has running scrolls and settings for now-lost glass studs, or one from Portland, Dorset. A related necklet which combines elements of both the beaded torcs and of the collars has recently been published from Dinnington, South Yorkshire.

Openwork Mounts

Common in Roman Britain are openwork mounts of various types, usually for horse harness, the makers of which employed slender-stemmed, wide-headed trumpets, often confronted. They also used triskele patterns. Large numbers have been found in northern British military contexts, especially Corbridge, Newstead and South Shields. They appear to have remained

Tankard, Trawsfynydd, Gwynedd
(National Museums on Merseyside)

Bronze collar, Stichill, Roxburghshire
(National Museums of Scotland)

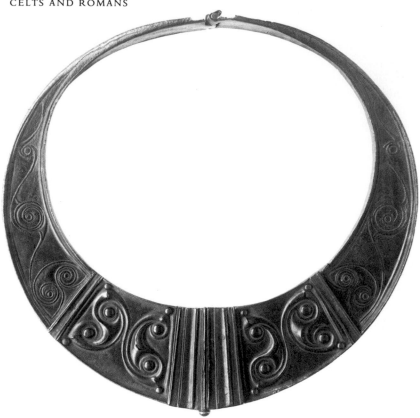

fashionable through the second century and into the third, and certainly
were one medium through which Celtic art was kept alive in Roman
Britain.

Romano-Celtic Art

The works of art that have been so far considered are essentially survivals
of the Celtic tradition, but many works produced in Roman Britain were
classical in intention, though some inadvertently reveal something of the
artistic outlooks of the Celtic creators.

Romano-Celtic art can be observed operating on different levels that
betray the process of Romanization. In the first century AD much of the
art was either imported, or the work of immigrant craftsmen. But pro-
gressively, Celtic artists were trained in Roman workshops and traditions,
and emulated the ideals of their teachers.

It is often difficult to say with confidence whether the artist of a particu-
lar work was striving to achieve the stylized result that was attained, or
whether the lack of realism apparent was due to lack of competence. In
the past, the latter has been advanced as the explanation of such works
as the mosaics of Rudston or Aldborough in Yorkshire. At Rudston, a
Venus adorns the centre of a mosaic found in 1933 and dated to the fourth
century. The nude, female figure can only be identified as Venus by her
apple and dropped mirror since she has a pear-shaped figure rather than

classical proportions. While some experts have considered that she is extremely badly executed, the mosaic was expertly laid, and there is a growing opinion that, in fact, the artist achieved exactly what was intended: a simplification of the design to its essentials – and a certain realism.

In classical art the height of the figure was directly related to the size of the head, though the proportions could be adjusted. The concept of harmonious naturalism was fundamental to representation. A detailed study of Romano-Celtic representations of classical deities has demonstrated that the beginnings of a Romano-British figural style were apparent in the first century AD. During the second and third, the distinctive style evolved, in which a balance was maintained between classical naturalism and Celtic abstraction. This reached its peak in the third and early fourth centuries. Celtic features include the enlargement of the head, stylization of the hair into formal patterns, emphasis on the eyes, simplification of the overall form, and enlargement and elaboration of such features as helmets.

The corpus of Romano-British art is substantial, and all degrees of stylization are apparent within it. There is controversy as to whether such hybrid pieces should be regarded as Celtic or Roman, and a few examples will suffice to illustrate the difficulties. The first is a jet medallion with a head of Medusa found at Strood, near Rochester, Kent. Unlike the more usual depictions, Medusa is shown in profile, with a benign face and braided hair. The wings, normally shown attached to the head, are detached, and the snakes have been symmetrically arranged to fill the field, rather than tied in a knot under the chin. Like other such Medusa pendants it was presumably used to ward off evil. But was it really understood as a classical Gorgon? Dating from the fourth century, it recalls the severed heads on pre-Roman Celtic coins.

Jet pendant with Medusa head, Strood, Kent (drawing: Lloyd Laing)

If Celtic abstraction is sought in what were essentially Roman objects, no finer example can be given than in a relief of three Genii Cucullati from Cirencester, Gloucestershire. Their designer reduced them to flat, outline shapes that show their most characteristic attribute, their hooded capes. They were minor, dwarf-like fertility deities popular in Gaul and encountered from time to time in Britain; another relief from Cirencester provides them with faces and stylized folds on their draperies. Although some of the simplicity of the relief as it is today is due to weathering, they were probably never very detailed. Their appearance in threes, the Celtic magical number, is a British phenomenon.

The Arts of Religion

Celtic religion survived during the Roman period and manifested itself in diverse works which epitomize the Celtic in Romano-British art. Indeed, as was noted in the previous chapter, most of what is known about pagan Celtic religion is derived from Roman-period finds.

Most of the works of art relating to Romano-Celtic religion are sculptures, but there are in addition a number of minor works, such as votive offerings or occasionally gems, with subject matter set out to a greater or

Relief depicting *genii cuculatii*, from Cirencester, Gloucestershire (Corinium Museum, Cirencester)

Stone head, supposedly of Maponus, Corbridge, Northumberland (drawing: Lloyd Laing)

lesser degree to accord with Celtic taste. Votive plaques from Bewcastle, Cumbria, depict in crude form the native deity Cocidius. Found in 1937 in the Roman fort, they bear punched inscriptions DEO COCIDIO and one shows the god holding a shield and knobbed staff. He is essentially a 'pin man' stripped of all but the essential attributes. Cocidius was linked with Mars, as a protector of the farm.

Another native Celtic deity was Maponus, whose cult centre may have been in the modern burgh of Lochmaben in Dumfriesshire. To judge by the quality of the dedications to him, he was important, and it has been suggested that a remarkable head from Corbridge, with a hollow on the top for offerings, represents him. However, Maponus was the 'divine youth' and this figure is of an old man, so the attribution is probably incorrect. Whoever it depicts, however, it is a classic example of Romano-Celtic art, with face reduced to a formal pattern, with huge eyes and slit mouth.

A relief from Wall in Staffordshire serves as a potent reminder of the importance of the head in Celtic cult. Here the sculptor depicted a severed head with round eyes and no mouth, set in a circular niche, presumably a sculptural rendition of an actual head set in a niche of the type known from southern France in the Iron Age. Another severed head, this time juxtaposed with a crude figure of Hercules, appears on a second sculpture from the same Roman site.

Two sculptures from Nottinghamshire illustrate aspects of Romano-

Celtic religious art. The first, a miniature carving in sandstone from see p. 60
Margidunum, displays a simple rendition of a warrior god. Out of all pro-
portion to his horse, he brandishes a spear, and the treatment used on
head and body is not unlike that of the Iron Age figure from Deal. Rather
more sophisticated is the relief from Thorpe-by-Newark, which displays
two figures in flanking niches. These have been identified as Sucellos the see p. 61
hammer god and Nantosuelta, a mother goddess, usually found in Gaul
not Britain. The goddess has a torc round her neck.

Items which continued to be in vogue throughout the Roman period
are representations of cult animals, especially bulls, boars, cocks, ravens,
geese, stags, bears, dogs, horses, hares and snakes. The cult creatures
appear as statuettes and in relief sculptures, as well as in other guises. Some
of the creatures were given supernatural features, such as three-horned
bulls, and the ram-headed snake. This was first encountered on Iron Age
coins, but reappears on Romano-British sculpture, for example at Ciren-
cester, Gloucestershire.

Naturalistic or slightly simplified animals were common in Roman
Britain. Enamelled animal brooches were especially popular, perhaps
because of the cult significance of animals with the Celts, and Celtic-
looking animals are found in other contexts. A good example is the long-
legged horse from Silchester, which seems to have been the handle of
a fourth-century metal vessel.

As well as Celtic beasts two other types of animal, one surrealistic,
the other more naturalistic, can be found. The former type can be exempli-
fied by a creature on a harness pendant from Margidunum, Notting-
hamshire. The Margidunum pendant is shaped like a pelta, with bird heads see p. 64
on the extremities. In the centre, however, is a strange creature with a long
nose and a foliage crest, not unlike a tapir.

The more naturalistic type of animal was used for example on a knife
handle from Corbridge and on a series of buckles with confronted sea-
horses or dolphins that originated on the Continent, but were widely
imitated in the last days of Roman Britain. Such creatures probably con-
tributed to the animal styles of post-Roman Britain in both the Anglo-
Saxon and Celtic areas.

Art in the Fourth Century

Artistically, the fourth century was a period when art based on classical
lines flourished in Roman Britain. To this time can be ascribed such
valuable treasures as the Roman hoards from Traprain Law, East Lothian;
Thetford, Norfolk or Mildenhall, Suffolk. It is clear from the sumptuous
treasure from Hoxne, Suffolk, that such treasures were still around to be
buried in the early fifth century. Apart from metalwork, the fourth cen-
tury was an important period for the installation of mosaic floors both in
towns and in the country, and sculpture likewise seems to have flourished.

Celtic art proper also flourished in this late Roman environment –
possibly as a response to the evidently growing weakness of the Empire.
It seems very likely that it filtered into Britannia from the frontier areas
along Hadrian's Wall and the region to its north, notably areas of

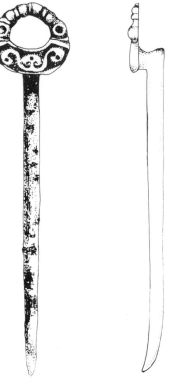

Oldcroft, Gloucestershire, proto-hand pin (drawing: Gwen Seller)

particular weakness. Making both penannulars and various projecting ring-headed pins continued in an unbroken tradition during the first four centuries AD and within Britannia; the mere presence of penannular brooches reflects Celtic taste. Many items continued in uninterrupted production well into the post-Roman period.

A type of pin developed in north Britain earlier in the Roman period is characterized by a projecting ring head. An example in silver, deposited in the mid-fourth century AD, was found in a hoard with Roman coins at Oldcroft in Gloucestershire. Its plate is decorated with a central pelta and eyed scrolls or 'dodo heads'. It was enamelled in red, showed signs of wear, and may have been made in the third century AD. Similar 'dodo heads' appear on a crescentic silver plaque from the Roman villa at Atworth, Somerset, keyed to take enamel; also on an enamelled, silver roundel from near Coventry, with a central triskele and lateral dodo-scrolls.

Hand-pins continued to develop from models such as that from Oldcroft. A silver example from the Roman settlement of Tripontium in Warwickshire, has a design of C-scrolls and a number of features which were all forerunners of Dark Age pins.

The Celts beyond the Roman Frontiers

During the Roman period the Celtic areas outside Britannia were free to develop without outside political or military interference for the first four centuries AD. This liberty had a down side in that settlement types and artefacts remained the same, as technological skills were static and no fresh ideas came in as the areas were cut off from the rest of Europe. Whereas before the arrival of the Romans, Celts across Europe, from Austria to Spain and Britain, had been relatively free to interact, after the Conquest of Gaul and Britannia such stimuli were denied. Consequently, developments in society were very slow and are sometimes not discernible at all from archaeological evidence. This is the period when it is most difficult or even impossible to date sites accurately.

In the first five centuries AD the climate was particularly dry and warm in Britain, and this, along with improved farming techniques, contributed to an expansion of population. The study of pollens at Hallowell Moss, Co. Durham, has shown that tree pollen declined in the Roman period and went on declining, indicating clearance of woodland for farming. Similar evidence has come from Ireland, where the expansion in farming seems to have started in the third century AD, shown for example at Red Bog, County Louth. It has been suggested that this was due in part to the introduction of the coulter plough from Roman Britain, though there is no firm evidence for this.

Roman Influence in Ireland

Despite the strong barriers between Roman and Celtic culture during the Roman period, the indirect influence of Rome should not be underestimated. The military threat of Rome led to new political groupings

among the Celtic and Germanic tribes in the second or third centuries AD and its importance in changing patterns of trade led to the introduction of new types of artefact and new technological skills.

Traditionally, Ireland and Britannia had no contacts and evidence such as the Roman burial found in Stoneyford, Ireland, in 1852 was ignored by early archaeologists. There is now growing evidence for trade between Roman Britain and Ireland, concentrated in the first century AD and again in the fourth, notably coinciding with the period of Irish raiding and settlement.

A number of objects from Ireland show that Irish artists rose to the challenge of Roman stimuli while maintaining the integrity of traditional Celtic art. Items of this type include a decorated strap-end from the fort at Rathgall, which follows the form of Roman pieces of the second to third centuries AD, and a harness mount decorated with a human figure from Feltrim Hill, Co. Dublin, a site which has also produced a Roman coin of AD 284–305.

Many objects from the period cannot be precisely dated. One group of objects that is usually ascribed to the first century AD has distinctive features such as the use of compass ornament, slender trumpets and broken-backed scrolls, as well as cast, relief trumpet and lentoid bosses. These pieces are best known from the engraved bone slips from Lough Crew, Co. Meath and from a hoard found at Somerset, Co. Galway. It is clear that the designers were familiar with each other's work since the objects share features with work produced in northern Britain at this time. Examples of similar British pieces are the Mortonhall scabbard, the Lochar Moss collar and a bone comb from Langbank, Ayrshire. These perhaps point to growing links between Ireland and western Scotland. This later grew into an alliance between the Scots and the Picts which in the fourth century AD temporarily smashed Roman defences. A Caledonian armlet has been found at Newry in Co. Down, and both Scotland and Ireland share distinctive knobbed spear butts. Individual decorative devices also seem to have been shared between Celtic artists in Scotland and Ireland, such as the swash-N.

Rather fine and delicate in their ornament are the 'Petrie Crown', 'Cork Horns' and the Bann Disc in which the craftsman employed bird heads on the ends of spirals. With the exception of the Bann Disc, which seems to have been suspended from chains, they may have been items of priestly regalia. The essential element chosen for the Bann Disc's ornament is a triskele, and its symmetry probably owes something to that of the Romano-Celtic triskele brooches discussed above. Another triskele very like Romano-Celtic examples appears on a disc from Lambay, Dublin, which has a beaded border like Romano-Celtic disc brooches.

A series of mysterious discs have high-relief repoussé ornament, slender-stemmed trumpets and snail-shell spirals and share elements with Caledonian metalwork. Found in Ireland, the 'Monasterevin' discs are named after one found at Monasterevin, Co. Kildare. The design on these often gives the impression of a quaint or even astonished face.

To the early centuries AD, too, have been assigned a series of horse bits from Ireland, some of which have ornament not totally dissimilar to that

Bronze disc from Monasterevin, Co. Kildare (drawing: H. E. Kilbride-Jones)

Petrie Crown (National Museum of Ireland)

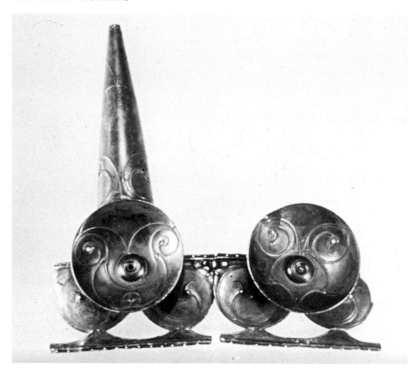

on Romano-British fantail and trumpet brooches. A whole range of new types of objects appear to have arrived in the fourth century as is suggested by the Roman-style toilet set from Freestone Hill, Co. Kilkenny and the discovery in Ireland of some types of Romano-British brooches, particularly penannulars, of fourth century date. It is in the field of personal adornment that this Roman influence is most apparent, but it is also discernible in weaponry (which shows the influence of the Roman army) and such things as barrel padlocks, axe-hammers and skillets.

Roman influence extended to language and literature. Ogham – a type of alphabet developed in Ireland involving lines incised on a stem line – was derived from the Roman alphabet. Some words borrowed into Irish from Latin seem inexplicable in a Christian context, such as the names of the days of the week *Mercuir* and *Saturn* (from the name of the Roman gods Mercury and Saturn), implying that their adoption predates the conversion of the Irish in the early fifth century.

The Late Roman Period

At the end of the Roman period the population of Britannia was relatively cosmopolitan, and a considerable degree of devolution had taken place in the administration. Five provinces were created by this time out of the one and the military had been reorganized with a mobile field army under an officer known as the Duke of Britain. In addition, there may have been some drift of population out of towns back to the countryside. In the fourth century there are indications of considerable prosperity in Roman Britain. During this period many villas were elaborated into complex

spreads organized around one or more courtyards, such as those excavated at Chedworth or Woodchester, Gloucestershire, or Bignor, Isle of Wight.

Inflation, however, was rife, and there were growing threats of attack from outside the province. Sea-borne raids of Germanic tribes such as the Angles and Saxons became common and what are known as the Saxon shore forts were built at various times and probably for different purposes. They formed a formidable coastal defence from Brancaster in Norfolk, south to Portchester in Hampshire and Carisbrooke in the Isle of Wight. Further north, in Yorkshire, signal stations were built to give advance warning of danger. These eastern and southern defences were matched by a less extensive series of forts in the west, to protect the Irish Sea coast, extending from Lancaster to Caer Gybi on Holyhead, Caernarvon and, in the south, Cardiff.

It is in this period that the Picts and the Scots first come to prominence in Roman accounts. The Picts – the name is a Roman one meaning 'the painted men' because they were allegedly tattooed – were the descendants of the Caledonians and other peoples in northern Scotland. They harried Britannia in an alliance with the Scots from northern Ireland and on occasion with a people known as the Attacotti, which historians have been unable to locate geographically. In AD 367 all three peoples were documented as taking part in a 'Barbarian Conspiracy', though to what extent this was fortuitous, opportunistic or planned is unknown.

There is archaeological evidence for Irish raiding and settlement in western Britain in the late Roman and early post-Roman period but it is very limited. This is hardly surprising since successful raiders, by definition, leave nothing behind them and it is unlikely that any settlement took place on a very large scale. Decorated querns for grinding grain, found in Anglesey, part of Gwynedd and Ulster, may be one of the few indicators of settlers from Ireland before the end of the Roman period. Despite the by now heavy overlay of Roman culture, there are signs in late Roman Britain of some revival of Celtic cult practices. Romano-Celtic temples, for example, such as that dedicated to Nodens at Lydney in Gloucestershire or that built within the ramparts of the Iron Age hillfort at Maiden Castle, Dorset, enjoyed the support of devout worshippers. This phenomenon may have occurred since the Empire was seen as weakening in the face of Celtic and Anglo-Saxon strength.

Imperial policy towards the tribes in the frontiers changed. Whereas in the first century AD the border tribes had resisted Romanization, by the fourth century some were befriended and occasionally rewarded with Roman titles. This deliberate policy probably explains the fact that Roman names and titles occur with frequency in the genealogies of the fifth- and sixth-century British kingdoms in Wales and Scotland, though scholars disagree over this. What cannot be disputed is the respect for Rome and its institutions among the Celtic élite of the fifth and sixth centuries. It seems that while Romanization of the south of England had been relatively rapid, the northern areas were won over only as Rome was preparing to leave. Roman influence in the Celtic fringe was therefore, paradoxically, never so great as when the Romans had withdrawn from Britannia.

The Dark Ages and Early Christian Period

IN THE EARLY FIFTH CENTURY the Romans abandoned the province of Britannia to organize its own defences, partly due to increasing pressure on the Empire from Germanic tribes such as the Angles, Saxons, Goths, Vandals and Franks, and others such as the Huns. What had been Roman Gaul eventually became a Frankish kingdom and later Carolingian. The Visigoths eventually took over Spain. Italy was taken over by the Ostrogoths, then the Lombards. Under Constantine, in the early fourth century, the Roman administration had been moved east and what became the Byzantine Empire increasingly became the focus of the civilized world. Rome was primarily important for providing Christian leadership. These events, although played out elsewhere, had an immense impact on the former province of Britannia, and a surprising knock-on effect where Roman influence had been negligible.

Celts and Anglo-Saxons

In the former Britannia, the Anglo-Saxon settlements gradually became dominant. The dearth of evidence for Romano-Celtic survival available to early archaeologists, coupled with such indisputable evidence for the Anglo-Saxons as numerous placenames, led to the belief that many Romano-British Celts fled to the west of Britain. However, more recent evidence suggests that the two cultures were gradually fused, sometimes with fire and sword, at other times more peacefully.

Both archaeological and literary sources suggest that the numbers of Anglo-Saxons were very small. Literary evidence, which is not accepted by all scholars, relates that 300 of the Romano-British aristocracy were killed dramatically at a conference by the Saxons around AD 440, and more reliable literary sources on the Continent inform us that there was an exodus of rich Britons to Gaul in AD 461.

The chief dating evidence of coins and pottery is lost after the removal of Roman support, making the archaeologist's task difficult. Archaeological evidence for continued occupation in towns and villas peters out in the mid-fifth century, notably corroborating the literary evidence for a decline in British aristocratic life. Literary evidence suggests that some towns survived within their own small territories into the fifth or even sixth century. Work at Wroxeter in Shropshire, where Anglo-Saxon settlement came fairly late, suggests that Roman-style building work (albeit in timber) was still going on there in the fifth century. After the seventh century, effectively most of the areas that became England were no longer Celtic. In some areas resistance groups are known to have existed from literary sources, such as the writings of the sixth-century monk Gildas

The Dalriadic citadel at Dunadd, Argyll (R. S. Thompson)

which graphically describe the violence between pagan Saxons and Christian Britons. Archaeology supports their existence by the fact that some Iron Age hillforts were reoccupied in the fifth and sixth centuries. Sometimes these were given new defences, and a number of forts were built *ab initio*. Among the redefended hillforts were South Cadbury, Somerset (associated with King Arthur in tradition), and Cadbury Congresbury in the same county. In Wales, defences were put up on a previously occupied site at Dinas Powys, Glamorgan, and in the north at Dinas Emrys and Degannwy in Gwynedd. These forts seem to have been occupied mostly in the late fourth to seventh centuries. This is the period in which the legendary King Arthur fought on the side of the Romano-British Celts against the Anglo-Saxons, with notable lack of lasting success.

Despite this, the removal of the Roman troops and the bureaucratic organization led to a gradual breakdown of Roman lifestyle and values. Villas, towns, roads and industry eventually fell into disuse and mass-produced goods were unavailable. Life was perforce organized on a more regional basis. The Anglo-Saxons built in wood, and had relatively self-sufficient communities, not totally dissimilar from those of the Iron Age Celts, both communities coming under the Roman term 'barbarian'.

The Anglo-Saxon advance was gradual, with the western Roman cities (Bath, Cirencester and Gloucester) not being taken until the battle of Dyrrham in AD 577. By the seventh century a system of small Anglo-Saxon kingdoms had sprung up in what was, effectively, from this period on, England. Of these, Kent, East Anglia, Northumbria, Mercia and Wessex were the most important.

Recent research has shown that there was modest influence over the Anglo-Saxons from the native Romano-British Celts. A few words in

modern English were assimilated through Anglo-Saxon, and Romano-Celtic goods have been found in Anglo-Saxon graves. But eventually, it seems that Anglo-Saxon lifestyle became predominant, leaving relatively little of the Celtic remaining. As will be seen, however, in art, Celtic and Saxon did in some measure converge, implying a much greater mix in population, beliefs and attitudes than was previously supposed.

The Celtic Areas

In the areas outside the former Roman territories, life changed less dramatically and the break that can be seen clearly in Britannia at the end of the Roman period is not so marked in Ireland, northern and western Scotland, Man or the south-west peninsula. Despite this, the beginning of the Dark Ages in Britain and the Early Christian period in Ireland is conventionally set around the beginning of the fifth century AD, the divide being marked by the mission of St Patrick in Ireland and the withdrawal of the Roman forces from Britain. However, Christianity had probably reached the Celts immediately beyond the frontiers of Roman Britain well before the end of the fourth century, and is likely also to have reached Ireland.

Economically and socially, there was no change in the pattern of life in Celtic Britain or Ireland in the fourth to fifth centuries, and it is extremely difficult to be confident of chronology, without some radio-carbon or tree-ring dating. Most sites do not produce suitable organic material.

The organization of society is known from sparse literary sources as well as archaeological inference. Much of the written evidence is difficult to evaluate, and comprises such sources as genealogies and king-lists, poetry, annals (lists of dates with cryptic references to events under particular years) and, slightly later, saints' lives. These are available for Wales, much of Scotland and Ireland and demonstrate that the society still saw itself as heroic. Historical records proper are virtually nonexistent.

In fifth-century Scotland a number of distinct groups of people can be recognized. To the north of the Forth-Clyde line were the Picts, the Cruithni as they called themselves. They spoke a British dialect which may have contained an older non-Celtic element. They had emerged out of the Iron Age tribes of the Caledonians and Maeatae, as well as (probably) some others. Two main groups were distinguished, the northern and the southern Picts, who were ruled over by a number of kings or chiefs with their own followers and territories. In the late fifth century the western part of what had been Pictland was settled by Irish colonists from Ulster, who founded the Irish-speaking kingdom of Dalriada. To the south of the Picts and Scots were the North Britons. They spoke the same language as the Welsh, and during the early part of the Dark Ages they became grouped into kingdoms. In south-west Scotland, and extending south into Cumbria, lay the kingdom of Rheged. Centred on the Clyde valley was Alt Clut, named after its stronghold, Dumbarton Rock, later known as Strathclyde. In the east lay Gododdin, part of which was known as Manau, which centred on the Firth of Forth.

From here a group (perhaps by Roman instigation) migrated to North Wales under their leader Cunedda in the early fifth century. His name appears in many of the Welsh royal genealogies. Manau was annexed by the Anglo-Saxons of Northumbria in the early seventh century, and Northumbrian control also extended into south-west Scotland.

The British kingdom of Elmet survived in Yorkshire for a while. British too (though we do not have a name for the kingdom or kingdoms) was Cumbria and, until also conquered by the Anglo-Saxons, Lancashire and Cheshire.

Like Scotland, Wales was divided into a number of kingdoms that seem to have emerged through the coalescing of smaller groupings. These were known as Dyfed, Gwent, Ceredigion, Powys, Brycheiniog, Glywysing, Buellt and Gwynedd. This last kingdom rose to considerable prominence under its king Maelgwn who was a contemporary of the sixth-century historian Gildas who particularly disapproved of him. The literary sources mention that he died of the 'yellow spectre' – one of the many plagues that are described at this period.

We know nothing of the individual kingdoms of Dumnonia, the south-west peninsula of England, although the names of some rulers of the post-Roman period prior to its annexation by the Anglo-Saxons are available.

Ireland was divided up into Ulster, Connaught, Meath, Leinster and Munster. Within these kingdoms there were a large number of kings and, above them, high kings. These groupings seem to have evolved in the early centuries AD. The north was dominated by the Ui Neill dynasty, the south by the ruling family of Munster, the Eoganachta.

The Irish settlement in western Britain which had begun in the Roman period escalated in the late fifth and sixth centuries, and the evidence comprises a mixture of inscriptions, place names and documentary sources. Of these, the most useful are inscriptions in ogham. They are concentrated in Gwynedd and Anglesey in north Wales and in the extreme south of Wales, particularly Pembroke, though there are others from south-west England. From such clues it is apparent that parts of Wales enjoyed fairly extensive Irish settlement in the Post-Roman period. South-west England may have been settled by Irish Celts partly as a result of secondary migration from South Wales. The Isle of Man was also settled by the Irish, around the same time as the settlement of Wales. In south-west Scotland there is some evidence for late Dark Age settlement, but most of the data relates to the foundation of the Irish kingdom of Dalriada in Argyll and the adjacent islands in the later fifth century.

Everyday Life

In both Ireland and non-Saxon Britain, society and economy was generally similar, with a comparable range of material possessions. The first real evidence for innovations in farming technique, for example, takes the form of the appearance of the mould-board plough in sixth-century Ireland, at a time when ridge-and-furrow cultivation may also have been introduced. Until introduced to Ireland by the Vikings, there were no towns. Christianity was introduced to most Celtic areas between the early fifth

and late sixth centuries, being focussed on a number of monasteries of which Iona was prominent. Artworks in the form of cross slabs and manuscripts become increasingly abundant for study. The economy was based on mixed farming, though cattle were particularly important.

The population seems to have occupied a diversity of settlements, reflecting regional variations, which in some cases were established in the Iron Age. The Irish Celts built a variety of farmsteads, of which the most important was the rath, or ringfort, an earth-banked enclosure with usually one, but sometimes more, ramparts and a single entrance, containing several buildings. In areas of stone the earth bank was replaced by a stone wall – such enclosures are known as cashels. Raths seem to have been built from the Late Bronze Age through to the twelfth century or later, and there are more than 30,000, probably over 40,000, raths in Ireland, though only a small number have been sampled by excavation and fewer excavated to any degree extensively. Each rath represented a farm, and between 16 and 32 hectares (40 and 80 acres) were required to maintain its occupants. Where raths have been plotted in relation to

Tara, from the air, showing raths (Irish Tourist Board)

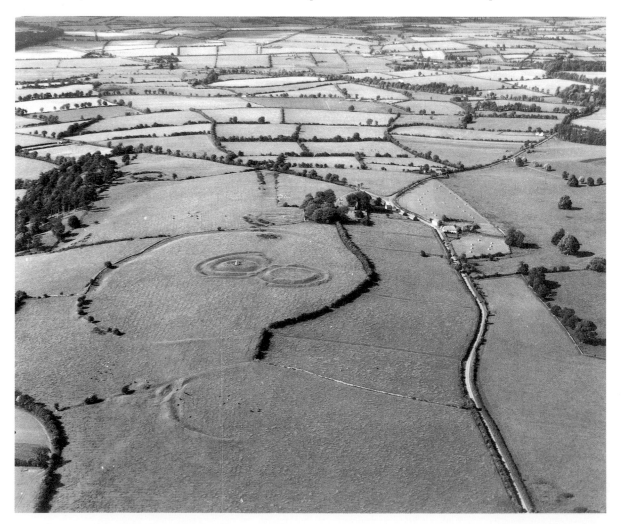

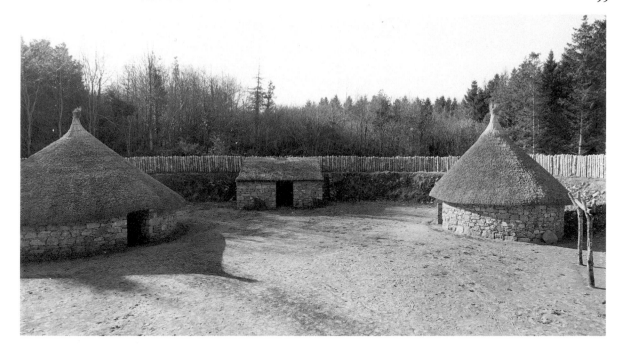

Rath, Craggannowen, Co. Clare, reconstructed (Irish Tourist Board)

cultivable land in Co. Down, it has been shown that each had a territory of about 24 hectares (60 acres).

Single dwellings on artificial islands, known as crannogs, appear to have been high-status sites. The most famous are the royal crannog of Lagore, in Co. Meath, the crannogs at Ballinderry in Co. Westmeath/ Offaly, and the site currently being excavated at Moynagh Lough, Co. Meath. Crannogs continued to be occupied into the sixteenth century.

Subterranean, or partly subterranean, passageways known as souterrains are found concentrated in Northern Ireland with a few in Scotland. They were probably for the storage of farm produce and appear to have been connected with above-ground structures.

A few hillforts are known in Ireland and, particularly in the north, defended promontory forts. Hillforts, however, do not appear to have played an important role in Ireland after about the beginning of the fifth century.

Crannogs occur in Britain, though not as commonly as in Ireland; excavated examples include Buston, Ayrshire and Llangorse, Powys. Souterrains are found in Scotland but, with rare exceptions, do not appear to have outlasted the second century.

A type of fort with a central citadel and outworks joining rocky outcrops was particularly favoured by the Early Christian Celts in Scotland. Although excavation is now showing that the citadels and outworks are not necessarily of one build, these small 'nuclear forts' are found in Dalriada (for example at Dunadd, Argyll) in Pictland (for instance at Dundurn, Perthshire), and among the north Britons (for example at Dalmahoy, Midlothian). Other types of fort found in Scotland include stone built duns, found in both Dalriada and Pictland, and forts with timber-laced ramparts, such as the Pictish example at Burghead, Moray.

The Re-Emergence of Celtic Art

Now free from the restrictions of the Roman presence nearby, the purely Celtic areas were able to interact with each other, with the Anglo-Saxons/Romano-British, with the Mediterranean (especially through Christianity) and eventually, in the ninth century, with the Carolingian world and the Vikings. The results of these wide and diverse influences have, in art, been seen as so dramatic as to be labelled the re-emergence or renaissance of Celtic art. Since it can now be seen never to have died out totally, this seems a slightly extravagant term, but certainly there was a new flowering as a response to external stimuli.

Patrons and Artists

There is a considerable body of evidence relating to patronage in the fifth to ninth centuries.

The kings and high kings of the heroic age needed works of art to display and enhance their status, and for gifts to their peers and their followers, just as they had done in the Iron Age. An early eighth-century law tract, the *Senchus Mór*, provides an insight into why penannular brooches were often superbly crafted in the early medieval period:

> When they are in fosterage, there must be brooches of gold, having crystal inserted in them, with the sons of the king of Erin and of the king of a province, and brooches of silver with the sons of the king of a territory; or the sons of each king is to have a similar brooch as to material, but that the ornamentation of all these should appear in that brooch.

This text makes it clear that brooches were used to distinguish between the various ranks of king – ownership of such a brooch did not in itself prove rank, but clearly for legislation to have been called for, some kings must have been wearing brooches above their station in eighth-century Ireland! The tradition of wearing brooches as a mark of status may stem from the Roman period when they served as indications of rank – gold, crossbow brooches in particular seem to have denoted high-ranking army officers. This tradition survived into the Byzantine era and the sixth-century emperor Justinian legislated on who could wear which kind of jewellery. Only the imperial family was permitted to don elaborately decorated brooches and certain stones could be used by them only, though plain, gold brooches could be worn by other courtiers.

The hierarchy of society reflected in brooches is to be seen in another Irish law tract, the *Críth Gablach*, which stipulates that one of the lowest orders of the nobility was allowed to possess a precious brooch of an ounce. Some scholars have argued that this means 'worth an ounce of silver' rather than merely weighing an ounce. Most of the major brooches of the heroic age exceed this limit. It has been suggested that kings may have controlled the production of brooches and other high-status objects as part of their overall control of the social pyramid – this has been asserted in particular for Dalriada.

The *Book of Rights*, a twelfth-century Irish work, refers to gift exchange, and itemizes such objects as swords, shields, saddles, bridles, drinking

horns, armlets and gaming boards. Brooches also figure in the Irish accounts. According to a life of St Brigid, a lost silver brooch which had been given as payment to a poet by the king of Leinster was miraculously discovered by divine intervention. Brooches were treasured, as shown by the ownership inscriptions on some such as the Ballyspellan brooch which bears an ogham inscription, and the Killamery brooch which asks for a prayer for its (presumed) owner, Cormac.

In Britain, the documentary evidence for works of art as social status symbols is less clear. The *Gododdin* poem by Aneurin is the oldest known poem in British Celtic, and was composed in the late sixth century. It commemorates a disastrous expedition from Scotland to Catterick. In the poem there are indications of brooches, or possibly coronets, as status symbols – the word used is the adjective *kaeawc*, meaning 'wearing a coronet or brooch'. Although there is no evidence for coronets in the Dark Ages, there are crowns from Iron Age and Roman Britain, for example that from Deal in Kent. The same poem makes reference to gold torcs, though this has been dismissed as an archaism since it has been widely believed that torcs did not outlast the pre-Roman Iron Age. But what are probably torcs came from the Pictish hoard from Norrie's Law and one from a Balinderry crannog in Ireland, so these may also have been marks of status in Dark Age society.

The wearing of chains as a mark of royal status is also documented in the heroic age. They were worn by kings in Wales until the time of Rhodri Mawr (d. AD 878), and early Irish literature abounds with references to chains as indicators of rank, divinity or magical power. Massive, silver chains are a feature of Pictish society in the heroic age.

The high-level giving of gifts is well documented in Celtic, as in Anglo-Saxon, society. By giving status objects – swords were particularly suitable – the king strengthened both the loyalty of the recipient and his own prestige. In Taliesin's *Eulogy of Cynan Garwyn*, the king of Powys in Wales is praised for his generous gifts to the poet (which included brooches).

It is not therefore surprising that such secular status symbols as brooches acquired an importance among the status-conscious members of the Church, who also recognized the benefits of adapting pagan and secular tradition to the service of God. Brooches were produced in monastic workshops in Ireland, for example at Nendrum and Armagh, and the *Book of Lecan*, composed about 1400, alludes to the testamentary brooch of the abbots of Iona. Tradition maintained that Columba had acquired it from Pope Gregory and that it was worn by all subsequent abbots of Iona as part of their insignia. Many of the clerics of the Early Christian period were members of the upper orders of society – some kings, indeed, entered the Church. Brooches are shown on ecclesiastical figures in Irish sculpture – the most notable example is that worn by Christ in the Arrest scene on the Cross of Muiredach at Monasterboice. On the Broken Cross at Kells one of the audience for the Baptism of Christ wears a brooch and holds a book – the latter was a symbol used to show that the figure was a cleric. In Pictland, sculptures also depict brooches being worn, notably by high-born ladies, for example on the magnificent slab from Hilton of Cadboll, and on another relief from Monifeith in Angus.

It is a logical corollary to this that penannular brooches often display Christian symbolism, albeit not often readily apparent to the viewer. Perhaps the starting point for this is the brooch from Bath, probably of the fifth century, with its bird and fish iconography indicating Christ seizing the Soul. A small cross appears on a lost penannular brooch of the sixth century from Kenfig Burrows, Glamorgan, and there are several slightly later brooches from Ireland with crosses as the main decorative feature. The attached bird heads that appear on a brooch from Rogart and a number of other Pictish pieces have been seen as reflecting Genesis 1, but a more likely explanation is that they represent doves pecking at the vine of life, or drinking from the fountain of life.

Where art has a religious function or meaning at this period the patron was usually the Church.

The Status of the Artists

It is not surprising that the people who produced high-status art also enjoyed high status. In Irish society they were members of the Aes Dana, the 'Men of Art', a social grouping which was only slightly inferior to that of the warrior nobility. A clue to the prestige enjoyed by the best is perhaps provided by the site of the Mote of Mark, Kirkcudbright, which seems to have been, essentially, the domain of a master since there was little room for anything else but metalworking to have taken place. Presumably, too, the sites which produced the treasure would have been akin to the present-day mint and would have required defending. The site is a small hilltop, defended by a stone-and-timber rampart, the interior of which seems to have been mostly given over to industrial production. There are few indications that farming was part of the daily round of the occupants – there is a notable absence of querns for grinding grain, for example – though the abundant food refuse shows that the occupants ate extremely well of the finest cuts of meat. Ornamental metalworking is also a feature of many of the high-status, presumed-royal, sites that have been excavated extensively. It was a major activity at Dunadd, the seat of the kings of Dalriada, for example, and similarly figured prominently in the activities carried out at Garranes in Co. Cork, claimed to be a major, royal seat. Indeed, although some ornamental metalworking appears to have been carried out on most Early Christian period sites in the Celtic world, the presence of motif pieces (fragments of stone or bone engraved with designs), moulds for decorative objects and materials for inlays point to royal or noble status.

Not all metalworkers were permanently based in courts and monasteries. Some seem to have been peripatetic, and this fact would explain the rapid dissemination of ideas throughout the Celtic areas. In a few cases it is possible to distinguish specific immigrants – a lead die of distinctively Irish type for making brooch moulds was among the finds from Dinas Powys in South Wales. Elsewhere, manufactured objects point only to trade, not necessarily to migrants.

Assessing how far works of art reflect migrating artists rather than the trade of objects is notoriously difficult. It has been pointed out that while patrons are usually responsible for the choice of material, type of object,

possibly overall appearance and iconography, the artist is normally responsible for the technical execution and probably the layout of the patterns. Detail likewise may have been the product of individual artist's training. An analysis of silver, bossed penannular brooches of the Viking Age using these criteria suggested that they were produced by Scandinavians travelling with Viking patrons. They had acquired Pictish traits, possibly from the Northern Isles before taking up residence in Ireland.

The Dark Age Artist at Work

We are fortunate to have a wealth of information about how Dark Age Celtic artists produced their work, since virtually every site of the period of any note has produced clay moulds, crucibles and other materials for ornamental metalworking. We also have the remains of some major workshops, notably those at Mote of Mark, Kirkcudbright, Dunadd, Birsay, Orkney, and Moynagh Lough, Co. Meath, as well as monastic workshops at Nendrum and elsewhere. see p. 115

Raw Materials

It has usually been assumed that the raw materials were initially derived from melted-down Roman scrap, and analysis of one Pictish, silver chain strongly corroborates this. By the end of the fifth century supplies must have been difficult to acquire; certainly later finds of silver, such as those in the treasure from St Ninian's Isle, are sometimes only 50 per cent pure. Nevertheless, it is extremely likely that new sources of metal, particularly of copper, iron and tin were being mined. At the Mote of Mark, Kirkcudbright, iron ore in the form of haematite was readily available, and was found on the site, as well as furnace bottoms (the remains of smelts in bowl furnaces). Copper also came from local sources, and the smiths showed themselves able to adjust alloys suitable for their purpose. Softer tin bronze was used for decorative studs, harder alloys, including brass, for more utilitarian purposes. The metal was smelted in bowl furnaces, the bellows protected by tuyères of clay (which have been found at Garryduff in Co. Cork and elsewhere), then cast in small bar-like ingots in stone moulds (which are relatively common finds).

Gold

Gold has been found at a number of sites, including Dunadd and Moynagh Lough, and a gold rubbing stone was found at Clogher, Co. Tyrone. Gold was detected on crucibles from Buston, Ayrs, Dinas Powys and Dumbarton Rock. Some texts suggest that gold was imported to Ireland. A tradition in the *Book of Leinster* tells how one of the legendary Tuatha de Danann drowned while bringing gold from Spain to Ireland. A seventh-century text, the *Audacht Morainn*, notes that, among other requirements, a king must 'estimate gold by its foreign wonderful ornament'. The meaning of this is ambiguous. By the twelfth century, according to Giraldus Cambrensis, gold was being imported, though he also described Ireland as a 'golden island' and suggested that native gold was very desirable to the Normans. The presence of 3 per cent of copper in

the Ardagh Chalice and in a gold coil from the Mote of Mark has led to suggestions that the gold may have been deliberately alloyed by the Celts. Flat-bottomed, oxidized vessels from Dunadd appear to have been used to separate gold from silver, and it has been suggested that 'heating trays' may have been used to refine gold or silver. One of the heating trays from Knowth, Co. Meath, displayed small golden droplets. Literary sources also indicate a knowledge of refining, alloying and assaying.

Soldering was necessary for affixing filigree to backplates. Analysis of the Derrynaflan paten has shown that various solders were used on the same panel, the different compositions indicating different melting points. It suggests that soldering was done in stages, wires sometimes being joined together before being attached to the base.

Casting

The ingots were melted in small, triangular crucibles, some lidded and some with handles, which were lifted with tongs. A serrated impression from tongs was visible on the outside of one of the crucibles from the Mote of Mark. Casting was done in clay two-piece moulds, which were produced by using a model or die to make an impression and which were then joined together and cased in clay. A former (a piece of wood inserted to form a channel in the mould for the metal to flow in) of wood or some other material was used to make the ingate (entrance to the mould), and the two moulds were keyed together by impressing one with a knife point or sometimes by using wooden pegs. The moulds were set on edge for the process, and then broken to remove the casting. Celtic, metal objects tend to be flattish, and one half of the mould is usually much more deeply impressed than the other (back) portion. Bone pins were used as models see p. 115 in mould making at the Mote of Mark and Dunadd; a lead die was used in brooch making at Dinas Powys in South Wales, and there is a lead brooch-pin model from Clogher. There are several models for making moulds for hinged pins; of lead (e.g. from Dooey, Co. Donegal) and of copper alloy (from Fenagh Crannog, Co. Galway), for instance. Lead was probably favoured because it was easy to carve. An intricate die or design experiment in lead was found at Birsay, Orkney, with a Durrow spiral triskele (p. 208). Silver foils (pressblech) were stamped with metal dies. These are better known from Anglo-Saxon England, but a Celtic design appears on a die from Louth, in Lincolnshire, probably Northumbrian.

Tools for working fine metal have been found on a number of sites – tongs, shears, anvils, hammers and awls.

Glass

Moulds for making glass studs are known, for example from Iona and from Lagore, Co. Meath, where the stud of light green glass was still *in situ*. Glass rods have been found on a number of sites, such as at Armagh and Moynagh Lough, and plates or shallow ladles for melting glass were discovered on several sites. Millefiori glass-working which was in use in Roman Britain, and subsequently appears on hanging bowls, was introduced to Ireland during the formative period of the fifth to sixth centuries. It is much more common in Ireland than in Britain, and was used

as an inlay for penannular brooches and handpins, as well as for later, more complex pieces of metalwork. A millefiori rod, found in the ring-fort of Garranes, Co. Cork, is unlikely to be earlier than the late fifth or early sixth century. While it is possible that millefiori working was developed in Ireland, it is more likely to have been introduced from Britain, where millefiori rods have been found at Luce Sands, Wigtowns and Dinas Powys, Glamorgan. It is notable that one of the most significant groups of millefiori decorated pieces in Ireland comes from the north-east, again perhaps implying a connection with Iona. Pieces of enamel have also been found, for example at Moynagh Lough (yellow). Red and yellow enamel in the early medieval period differed from Roman, in that they often contained high quantities of lead.

Heating trays, perhaps used as crucibles, or to stand crucibles in, are found widely in all parts of the Celtic world.

Until recently, it was believed that glass was not manufactured by the Celts in Ireland. Evidence has now come to light, at Dunmisk, Co. Tyrone, for the making of glass from primary materials – the earliest evidence from medieval Europe. The site appears to have been ecclesiastical, dating from sometime between the sixth and tenth centuries AD, and the range of skills shown by the glass-makers displays considerable expertise.

Techniques

The techniques used were extremely varied. Many of the larger items were assembled from multiple pieces, which involved soldering, rivetting, cementing, and folding. Bolts, rivets and pins were used for joining as appropriate, and plating was in tin (to look like silver) or gold. Mercury gilding (extremely lethal) was practiced. Planishing – beating with a small hammer against a stake – was used for giving plate silver a facetted appearance.

Among the more specialist techniques were those involving the production of gold filigree and granular work. Filigree was produced in a variety of ways, some apparently of ultimately Continental inspiration, some Anglo-Saxon, some purely Celtic. Detailed study of the filigree on the Hunterston and 'Tara' brooches shows that although inspired by see pp. 118–9 Anglo-Saxon work, it was more delicate and complex, displaying a greater technical excellence. Filigree wire work involves different techniques with beaded wire, twined round wires, twined beaded wires, and collared granules. As in Anglo-Saxon work, the fine, filigree, twisted wire was mounted on a foil, edged by a filigree border. An interesting feature in triple wire work is the way in which tiny nicks were cut on the central beaded wires to facilitate levering them forwards to close gaps in intersections. This is found in both Anglo-Saxon and Celtic work. Among the distinctively Celtic techniques were the ways in which alternatives to simple beaded wire were employed in outlining motifs – for example the use of one beaded wire on another, or a beaded wire set on the edge of a ribbon. The use of twined wires to infill animal ornament appears to have been an exclusively Celtic technique. Using such methods, a wide diversity of ornamental schemes was achieved.

Also common in Anglo-Saxon England was the use of polychromy –

Details of filigree. (A) panel Tara
Brooch (B) Hunterston Brooch
(C) Westness Brooch (D) Taplow
Anglo-Saxon buckle, arrow points to
cut in wire (E) Hunterston Brooch,
arrow to cut in wire (Niamh Whitfield)

A

B C

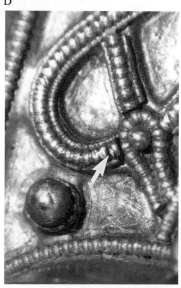

D

E

the setting of different coloured inlays into frames or cloisons. All these
techniques can be seen, for example, on the superb seventh-century,
Anglo-Saxon Kingston Brooch.

Other techniques acquired from Germanic sources include the pro-
duction of die-stamped foils (pressblech), which continued to be popular
in Northumbria after its popularity was waning elsewhere in England.

Artists imported decorative motifs as well as techniques from England.
They include cell-like patterns, sometimes in roundels, which recall the
design of some Anglo-Saxon disc brooches, and the development of
certain types of animal ornament. The bird head with hooked beak which
is so prominent in the treasures from the Anglo-Saxon royal burial at
Sutton Hoo, but which is found in many guises in Anglo-Saxon England,
is one such creature.

Motif pieces are extremely common in Ireland, but less frequent in
Britain. Some may have been preliminary sketches, others used to produce
foils. The designs often show the marks of laying out with compasses and
grids.

Manuscripts and Sculpture

Manuscripts were similarly laid out, using grids and compass patterns –
the guidelines and the marks of compass points are apparent in the Lindis-
farne Gospels and several other manuscripts. The pigments came from a
variety of plants and minerals: lead (white or red), orpiment (yellow),
verdigris (green), lapis lazuli (blue), folium (blue and pink to purple), woad
(blue) and kermes (red). The verdigris was dissolved in vinegar, which
sometimes ate into the vellum. Colours were built up in layers in the Book
of Kells, and glazes were used to change colours. Ultramarine and verdi-
gris were covered with folium rubeum. Ultramarine was sometimes glazed

C

with indigo, and verdigris with ultramarine. Most books show a limited range of pigments, but the artist of the Lindisfarne Gospels was able to produce forty-five pastel shades. Gold was rarely used, except for one letter in the Lindisfarne Gospels, orpiment being used instead. In the Book of Durrow there is no blue. Ultramarine, derived from lapis lazuli, was immensely expensive, and in later times was imported from Afghanistan. Pens and inkwells are depicted in manuscripts. Sometimes text and embellishments were by the same hand, sometimes not.

D

Motif pieces. (A), Nendrum, Co. Down (B) Dunadd, Argyll (C) Ballinderry, Co. Westmeath/Offaly (D) Lagore, Co. Meath (drawings: A,C Lloyd Laing after U. O. Meadhra; B Lloyd Laing from a photo; D from a nineteenth century print)

Sculpture seems to have been produced by artists who went out from their centres (usually monasteries) to carve stones where they were required. There is a sculptor's workshop at Clonmacnois..

A study of the Pictish symbol stones, for example, has suggested that the raw material was usually of local origin, but there is also evidence (for example at Iona) of suitable stone being brought from some distance away. Some of the crosses were carved from a single block of stone, others (less frequently) were made in sections and assembled. An unfinished cross at Kells shows the way in which the work was approached – here the pattern was first sketched out, then blocked out. The background was then deepened and interlace carved. Finally, the detailed figural work was executed. When this was completed, the carving was painted. A cross at Llantwit Major in Glamorgan had traces of black paint in its inscription when first recorded.

Romano-Celtic Art after the Romans

During the fifth and sixth centuries the evidence for Celtic art in the former Britannia, where there was increasing Anglo-Saxon influence, takes the form of metalwork and some incised work on stone. Most of the metalwork comprises a series of hanging bowls with decorated mounts and small items of personal adornment, particularly penannular brooches. Penannular brooches and different types of pin seem to have been produced in the fifth century in the West Country, and more particularly round the Bristol Channel. At Gloucester the remains of a workshop were found on the New Market Hall site, dated by imported Mediterranean pottery to the late fifth century. The finds included part of a bowl with geometric 'cloisons' or cells for the enamel. Another enamelled bowl, in the 'fine-line' style that characterized the early hanging bowls, was found at Bradley Hill, Somerset, in buildings dated to after AD 350.

Unfinished Cross, Kells (Irish Tourist Board)

Hanging Bowls

Hanging bowls are generally small with three, or sometimes four, escutcheons, with hooks for the attachment of suspension chains. They have attracted a great deal of attention since they are essentially Romano-Celtic but were produced in large numbers in Saxon areas. They therefore provide evidence for peaceful interaction between Romano-Celts and Anglo-Saxons. Except for one or two bowls from possibly sixth-century Anglo-Saxon contexts, nearly all are either unprovenanced or from seventh-century, Anglo-Saxon graves. The burying of high-status vessels in graves was a seventh-century custom in England and some of the bowls show signs of being very old when deposited in the graves. In some cases, only the decorated escutcheons were buried, showing that they were prized independently.

Complete hanging bowl, Wilton
(drawing after Praetorius)

Many suggestions have been made concerning the use of the bowls: for washing hands, as lamps, in Christian liturgy or even as water compasses, and that they were suspended from tripods. They probably served a variety of functions, and may even have been ornamental, symbolic 'cauldrons'.

Dark Age examples fall into different groups, which may not, however, be meaningful in terms of date. An important series has openwork escutcheons, usually in the form of a pair of confronted peltas, or sometimes an arrangement of four. Some of these are undecorated, others have decoration with elements derived from Romano-British tradition, such as rosettes, ring-and-dot, or running scrolls. All of these appear on a bowl from Baginton, Warwickshire. The Baginton bowl has a basal print with a marigold – another Roman motif. On this bowl red enamel is set into recesses cut to receive it, in the Roman fashion (later the decoration was in reverse against an enamel field).

The main group of bowls display a triskele of confronted trumpet patterns, in reverse against a red enamelled ground. The stylistically earliest appear in the south-east Midlands (centred on Bedfordshire) with

later types on the periphery. Related bowls have a design with running scrolls, arranged concentrically.

A few bowls, notably the finest of several from the royal Anglo-Saxon ship burial at Sutton Hoo, Suffolk, and one from Ipswich, appear to be the products of the same workshop or group of closely related workshops, and all display the use of millefiori glass floating in a sea of enamel. see p. 122

The pagan Anglo-Saxons never produced millefiori, though they traded pieces of it for inlay from the Celts. Bowls thus adorned may have been produced in Lindsey, the Anglo-Saxon kingdom centred on Lincolnshire, by smiths working in a Celtic tradition.

Some hanging bowls were presumably made by the Anglo-Saxons themselves since they show only a partial understanding of Celtic design. Examples come from Market Rasen, Lincolnshire, and Mildenhall, Suffolk. Others use Anglo-Saxon designs applied to the hanging bowl form, such as are found on a group of bowls with a whorl of animal heads or animals in a circle, such as one from Sutton Hoo.

Penannular Brooches

British penannular brooches of the fifth and sixth centuries are remarkably mundane, and although the main series has terminals in the form of confronted animal heads, these are so stylized that it takes the eye of faith to see that animals are represented at all. The one exception is the fine brooch from Bath with enamelled terminals which displays a bird and salmon on one extremity and what may be a peacock on the other. These are Christian symbols – the eagle and salmon represent Christ seizing the spirit, the peacock Resurrection. Eagle and salmon appear on a bronze from the Roman town of Wroxeter, Shropshire, and the peacock appears on a late Roman buckle plate from Catterick, Yorkshire. They are late Roman creatures, and the form of the brooch suggests a late fourth-century or fifth-century date.

Handpins

In the fourth to fifth century handpins were produced with a characteristic crescentic plate, and initially an arc of stubby 'fingers', subsequently a line of more elongated digits. Fingers and plate can be enamelled, and there are sometimes patterns on the back of the head and on the edge of the now-thickened plate. The most significant examples are of silver – one from Long Sutton, Somerset, and two from a hoard of Pictish silverwork from Norrie's Law, Fife. The hoard included Late Roman silver coins and pieces of Roman silver plate, which are unlikely to have survived much past the fifth century. Whenever the hoard was deposited, the pins are likely to belong to the fifth century, and various features link them with some Irish pieces on the one hand and British pins on the other, including another fine Pictish example from a hoard at Gaulcross in Banff. see p. 123

The emergence of a hybrid Celtic and Anglo-Saxon style in the seventh century can be seen in a bag mount from an Anglo-Saxon burial at Swallowcliffe Down, Wiltshire. Made of openwork, it has die-stamped foils with patterns which are both 'Celtic' (such as peltas) and 'Anglo-Saxon' (such as interlace).

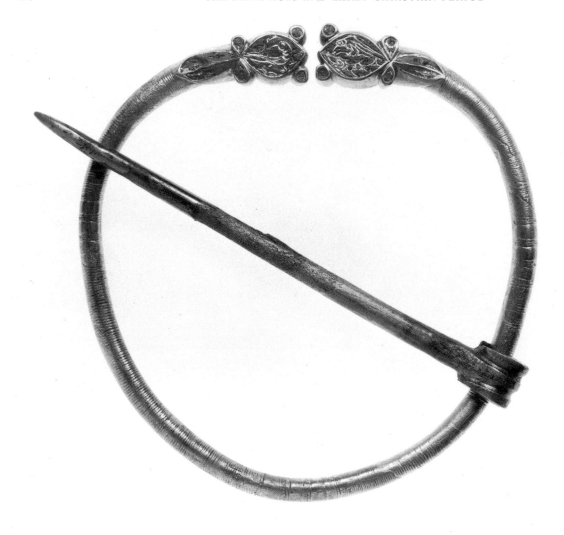

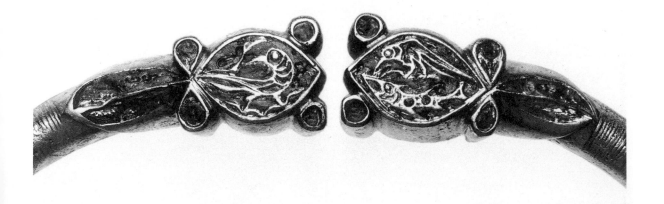

Ireland

In the late-fourth and fifth centuries AD, raiding, settlement and trading brought in manifestations of Romano-British culture. A few penannular brooches, and perhaps some pins, crossed the Irish Sea in the late fourth century. In the fifth, British penannular types were modified in Ireland and decorated with designs which can mostly be matched in late Roman Britain.

'Dodo heads', the 'Durrow' spiral and a variety of other simple decorative elements (p. 208) were combined with enamelling, and sometimes millefiori, in an ever-increasingly complex system of ornament in the later fifth, and more particularly sixth, centuries.

Clear evidence of cultural contacts between the two areas can be seen in two silver, originally enamelled pins with discoidal heads, one in the British Museum and one in the National Museum of Ireland. These have 'dodo' heads and other ornament which link them to British pieces.

OPPOSITE Penannular brooch, Bath (Bath Archaeological Trust)

BELOW Ornate penannular brooch, Ballinderry Crannog, Co. Meath (drawing: H. E. Kildbride-Jones)

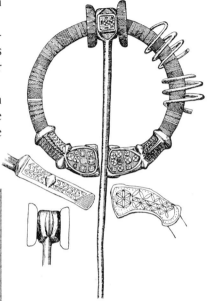

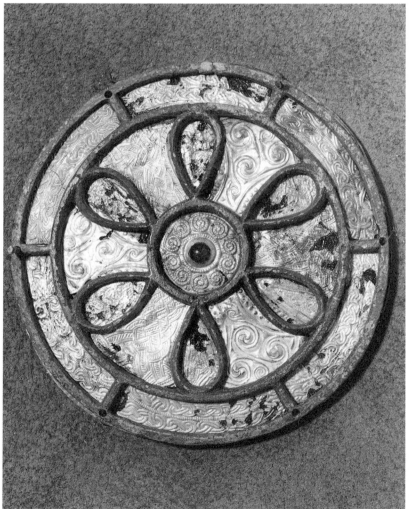

Bag mount, Swallowcliffe Down, Wiltshire (Salisbury and South Wiltshire Museum)

The maker of a mount from Dundrum Castle, Co. Down, chose 'dodo heads' and crested bird heads with trefoil eyes, and trefoil junctions to trumpet patterns, all features found in hanging-bowl art. The Dundrum mount may be Irish, but could have been an import from Dalriada.

Recent finds further demonstrate contacts between artists since hanging-bowl-escutcheon art was assimilated into Irish Dark Age ornament. Perhaps the most significant find comprises two panels from a matchbox sized, house-shaped shrine found in the River Blackwater. Decorated with blue glass studs, it was enhanced with a pattern based on a pelta and confronted trumpets, with hatched infilling.

Clogher

More evidence that artists on either side of the Irish Sea were in contact is provided by the site of Clogher, Co. Tyrone, which is important because it can be securely dated. The first metalworking date is provided by imported east Mediterranean potsherds of the late fifth or early sixth century AD. At this period, penannular brooches were being manufactured on the site, one with 'Durrow spiral' ornament. Among the associated finds was a fragment of a Romano-British bracelet of the type found in large numbers at Lydney in Gloucestershire, perhaps suggesting contacts with the metalworkers of the Bristol Channel region. The end of this phase is radiocarbon dated to the late sixth century AD. After a period of abandonment, or very sparse use, a ringfort was built, presumably in the late sixth or seventh centuries since later types of metalwork and imported pottery from Gaul known as 'E Ware' (which date from this period) are associated with the new building work.

Christianity and Christian Art Patrons

The Christian belief probably reached some of the Celts beyond the frontiers of Roman Britain during the Roman occupation. In particular, it is likely that there were small groups of Christians in southern Scotland and in Wales. Literary sources imply the survival of druids in Wales after the Roman period, and there are some indications, both literary and archaeological, that paganism survived in Pictland, but these are isolated examples.

Christianity was probably introduced to Ireland during the Roman period. St Patrick was abducted from Britannia by Irish raiders at the start of the fifth century and seems to have been converted in Ireland. Two separate figures were actively responsible for the spread of Christianity in Ireland: St Patrick, who seems to have been mainly active in the north, and Palladius, in the south.

In Scotland the first 'missionary' was traditionally St Ninian, who was said to have founded Whithorn in Galloway and to have begun the process of converting the Picts. He is usually regarded as an early fifth-century figure, but there is no firm evidence for the date of his activities. Although the southern Picts may have been converted through Christian communities established on the Firth of Forth, the main phase of their conversion has traditionally been attributed to St Columba, who came from

A

Blackwater shrine (drawing: Priscilla
Wild, photos: by courtesy of the
Trustees of the Ulster Museum)

B

C

Ireland in AD 563 to found a major monastery at Hinba, then one on Iona.

In Wales, the work of conversion is usually attributed to St David and St Illtud in the fifth century; the conversion of Dumnonia may have begun in the Roman period, but was no doubt accelerated by the Irish settlers. During the later fifth and sixth centuries Insular Christianity seems to have been reinforced through contacts with the Continent.

Evidence for this is varied. To begin with, there was trade with the eastern Mediterranean, represented archaeologically by imported pottery, particularly red-slipped vessels from North Africa and sometimes Turkey, and storage vessels (amphorae) from the Greek Argolid and from Cilicia and Antioch in Syria. These imports are concentrated in the period between about AD 475 and 525, and vast numbers of sherds have been found at Tintagel in Cornwall, which is presumed to be a trading base. The Byzantine Empire was probably responsible for the trade, and the commodity sought in return may have been tin. These pottery imports were taken northwards through the Irish Sea to Wales, Ireland and even Scotland, and a later trade brought other imported pottery from the Bordeaux region of France, presumably connected with a wine trade.

Inscriptions on tombstones suggest that the trade was just one facet of wide contacts between the Celts and the Continent. One from Penmachno in Gwynedd states that it was set up 'in tempore Justini consulis' (in the time of the consul Justinus), who is known to have been in office around AD 540, but who had no authority outside the Mediterranean. Some other tombstones employ Latin formulae which originated in North Africa and Gaul.

Such contacts probably involved a reinforcement of Christian beliefs and values, and the importation of works of art from different parts of the Christian world.

In early Dark Age Britain church organization was probably diocesan, as inscriptions on Welsh stones suggest, but in Ireland there were no urban centres to form the foci of the dioceses.

Christian Artists

Christian artworks were produced by monks or by laymen employed by the monastery. Adomnan, Columba's biographer, informs us that the saint was copying a psalter on the last day of his life. He also reports that Columba copied a book of hymns for the week in his own hand, and mentions a third 'written by the dear and holy fingers of St Columba'. We have detailed information about the production of the Lindisfarne Gospels, since in the tenth century a priest called Aldred added a colophon on the last page naming the four men responsible for it. The inscription reads:

> Eadfrith, Bishop of Lindisfarne Church, originally wrote this book, for God and for Saint Cuthbert and – jointly – for all the saints whose relics are in the Island. And Ethelwald, Bishop of the Lindisfarne islanders, impressed it on the outside and covered it – as he well knew how to do. And Billfrith, the anchorite, forged the ornaments which are on it on the outside, and adorned it with gold and with gems and also with gilded-over silver – pure

metal. And Aldred, unworthy and most miserable priest, glossed it in English between the lines with the help of God and St Cuthbert.

Scribes and Patrons

Manuscripts, metalwork and sculpture occasionally provide information about the patrons and the people who produced the work. A few examples may suffice. The manuscripts seem to have been mostly the work of clerics, though the name of the scribe may have been falsified on occasion for political ends. Thus the Book of Dimma has a false inscription attributing the work to a scribe who was a contemporary with Saint Cronan. Virgilius, a Latinization of the Irish Fergus, is named in an Echternach manuscript and is probably authentic. The Book of Armagh was the work of Ferdomnagh, a scribe who is known to have died in AD 846 and who was working under the direction of Torbach, abbot of Armagh in AD 807–808. The Book of Mac Durnan is named after Maelbrigte Mac Durnan, abbot of Armagh (AD 888–927), and the psalter of Ricemarch or Rhigyfach was executed by the son of a Welsh scribe of that name who had lived for many years in Ireland.

Major pieces of ecclesiastical metalwork from eleventh- and twelfth-century Ireland have inscriptions which tell us about their makers and the milieu in which they worked. They appear to have belonged to families of laymen attached to major monasteries, such as the MacAeda family at Kells and Cúduilig and his sons who worked at Armagh. Thus the inscription on the shrine for the Cathach of St Columba asks us to 'Pray for Cathbarr Ua Domnaill who caused this shrine to be made; for Sitic Mac Meic Aeda who made it and for Domnall Mac Robartaig coarb of Kells who caused this shrine to be made.'

It is known from documentary sources that Domnall Mac Robartaig was abbot of Kells in the late eleventh century and Mac Aeda, father of Sitric the metalsmith, is recorded as a craftsman (ceard) in one of the Kells charters.

Some High Crosses carry inscriptions which name the patrons – the most famous is the Cross of Muiredach at Monasterboice. These were sometimes abbots (as in this case), or kings. Royal patronage for crosses appears to be particularly a tenth-century phenomenon. Dedications were often inscribed on the cross-shafts low down (to facilitate reading, it has been suggested, when kneeling in prayer), usually calling for prayers to be said for the dedicator. One of the most remarkable is the Pillar of Eliseg, at Valle Crucis, near Llangollen, Powys, now truncated and illegible, but fortunately read by the antiquary Edward Lhuyd in 1696. It was originally composed of at least thirty-one lines; the text explains how it was set up by Concenn (who died in AD 854), great-grandson of Eliseg, in the latter's honour. The inscription is remarkable for providing a royal genealogy back to the Roman usurper Magnus Maximus, and mentions other historical figures such as St Germanus and Vortigern. The inscription also records the name of the scribe who carved it – 'Conmarch painted this text at the command of his king.' The Carew Cross, in memory of Maredudd ap Edwin, King of Deheubarth, was probably erected after his death in 1035. In Pictland, dedicatory inscriptions are notably lacking –

OPPOSITE ABOVE The Gallarus
Oratory, Co. Cork (Caroline Bevan)

OPPOSITE BELOW St Kevin's Church,
Glendalough (Caroline Bevan)

there is a solitary one on the 'Drosten Stone' from St Vigeans, Angus,
naming two otherwise unknown Picts – but in Ireland the sculptural dedi-
cations are more informative. As far as can be ascertained, kings began
dedicating crosses in the middle of the ninth century – the earliest
monarch to do so appears to have been the High King Maelsechnaill mac
Maelrruanaidh (AD 846–862) who may have erected the Kinnitty Cross,
the Durrow Cross and the South Cross at Clonmacnois. The erection of
these crosses may have been to bolster the royal image, in partnership
with the Church, for political ends. It might be noted in passing that the
Kinnitty Cross and the Cross of the Scriptures at Clonmacnois both bear
the name of one Colman, who could have been the master sculptor re-
sponsible for them.

Archaeology and the Church in Celtic Lands

A variety of ecclesiastical sites range from simple, undeveloped cemeteries,
sometimes set within a circular or curvilinear *vallum monasterii* or en-
closure, through to elaborate monasteries that were the pre-Viking
equivalents of towns.

Prior to the Viking Age, building was mostly in timber, and churches
were simple edifices, usually of a 3:2 proportion, with a doorway set in
the short side. A few timber churches have been found in excavation,
though none is conclusively pre-Viking in date. The classic sites are
Ardwall Isle, Kirkcudbright, Church Island, Co. Kerry and Burryholms,
Glamorgan. The churchyards contain simple dug graves and typical long-
cist burials, in which the bodies were laid in coffins made of slabs of stone,
though burials in hollowed-out tree trunks are known, notably at
Whithorn in Dumfries and Galloway.

The graves of particularly holy men were sometimes specially de-
marcated by a rectilinear enclosure, usually indicated by a setting of stones,
and perhaps a cross-marked stone. The cult of relics developed from the
sixth century onwards, so the corporeal remains of saints were often trans-
lated to above-ground shrines. These take different forms – corner-post
or corner-block shrines have slabs slotted into upright corner posts or
slabs, and flat or more often hipped roofs, to imitate a chapel. In some
cases only the roof element is present, and occasionally these slab-shrines
as they are called, had an opening through which the devout could touch
the saintly remains. A few of these shrines were sculpted – the finest is
that from St Andrews. Another outdoor feature was the *leacht* – a kind of
altar, perhaps located above a special grave, at which prayers could be
said. These are mostly confined to Ireland, and a good collection can be
seen on the island monastic site of Inishmurray, Co. Sligo. A good out-
lying example, known as St Patrick's Chair, now lies in a field at Marown,
Isle of Man. Other churchyard features are crosses and cross slabs.

Monasticism spread from the Mediterranean in the late-fifth to mid-
sixth century. It originated with the Desert Fathers, who eschewed the
growing opulence of the Church and sought solitude in remote situations,
initially as hermits but later in communities. The first was St Anthony
(d. AD 355). From the east Mediterranean monasticism spread to southern
Gaul, where St Martin founded monasteries at Liguge, near Poitiers and

The Pictish fort at Dundurn, Perthshire (David Longley)

ABOVE Mote of Mark, Kirkcudbright (Lloyd Laing). See p. 99

LEFT Interlace mould, Mote of Mark, Kirkcudbright

Marmoutier near Tours. Later foundations were the work of John Cassian and Victor. From southern Gaul, Aquitaine and perhaps Spain, monasticism spread to Britain, the first monasteries probably arriving in the last years of the fifth century. Celtic monasteries take many forms, from isolated hermitages and occupied caves to small communities in remote situations such as at Skellig Michael, a rock off the coast of Kerry, to large complexes extending to many hectares with large communities of monks, several churches, and dependent lay communities. The earliest major monasteries tended to have a rectilinear enclosing vallum, as for example at Iona and Clonmacnois. Later and smaller communities were enclosed within curvilinear valla.

Ideas from the Mediterranean

By the sixth century Irish monks were travelling to Gaul, Italy and, soon after, to Germany. Reciprocally, Continental clerics came to Ireland to study, and through both agencies no doubt books and works of ecclesiastical art reached the Celtic west, to give rise to an indigenous tradition. A seventh-century life of St Patrick by Tírechán records that the saint brought 'fifty bells, fifty patens, fifty chalices, altar-stones, books of the law, books of the Gospels' across the Shannon. While it is unlikely that there was a flourishing tradition of Christian art as early as the time of Patrick, clearly such a tradition was already so well established by the seventh century that it is likely to have begun well before, possibly as early as the fifth century. Irish monks at Bobbio in northern Italy had access to a range of source material which included three North African manuscripts of the fourth/fifth century, one of which was apparently carried by St Columbanus (Bobbio's Irish founder) in his book satchel.

A few of the items described in preceding pages have been Christian either in purpose or in the content of their ornament. Like Christianity itself, some of this ornament owed a debt to a Romano-British past, but increasingly owed more to Mediterranean sources. Some of the Mediterranean pottery (namely North African, red-slipped vessels), bore decorative stamps which could have been a source of stimulus for Celtic artists. Among the possible design elements that could have been borrowed from the ceramics are double outline crosses, alpha and omega combinations, chi-rhos, peacocks, dolphins, felines, facing humans and more abstract patterns, which include one which looks not unlike the Pictish so-called 'swimming elephant' symbol.

The trade represented by imported pottery is well documented. From the fifth century onwards the Atlantic ports of Aquitaine traded with Spain, Britain and northern Gaul, while the Garonne and Loire ports operated on a trade route extending from Iberia to Dalriada. Along such well-established routes the cult of St Martin, and with it monasticism, was probably disseminated. Adomnan, Columba's biographer, tells of Gaulish sailors visiting Iona, and other documentary sources lend supporting weight to his evidence.

Manuscripts produced by Irish monks in Italy are further evidence of how Mediterranean art was assimilated. These include some made at Bobbio soon after the death of St Columbanus. The Codex Usserianus

Primus is one such, a manuscript in bad condition, now in Dublin, which may have been brought to Ireland by returning monks. The only notable decoration is a chi-rho outlined with red dots between alpha and omega, the use of red dots being perhaps an Irish device.

The Beginnings of Sculpture

One of the arts stimulated by Christianity was sculpture, and both the Irish and Pictish artists embraced it, producing fine results in Irish High Crosses and what are known as Pictish symbol stones. It is extremely difficult to determine the origins of sculpture among the Early Christian Celts, and it is important to distinguish between incised designs on stones and true relief. There is reason to suppose that a tradition of engraving on stone was current in Britain during the Roman centuries, and that this continued into the post-Roman period. From engravings on rock surfaces to engravings on free-standing stone monuments is not a major leap, and some at least of the Pictish symbol stones of Scotland described below probably belong to the sixth century, if not the fifth, if the idea of erecting carved stones was a legacy from Roman Britain. Some inscribed stones which served as memorials to the dead can be dated to the later fifth century, such as the 'Latinus' stone at Whithorn. Others show that the tradition of commemorating the dead with inscriptions was well established in early sixth-century Wales and Cornwall, as well as in Scotland.

Pictish Symbol Stones

What are probably the earliest sculptures found in the post-Roman Celtic world are apparently secular in origin. Pictish symbols appear incised on free-standing, undressed blocks of stone, on cave walls, and on small portable objects throughout Pictland. Forty to fifty different symbols have been recognized, appearing on about 160 stones. Since their recognition in the nineteenth century, they have prompted fierce debate – what date are they and what do they mean? The symbols fall into two groups: abstract and animal. There are about eighty examples of the latter; all were creatures to be found in historical Pictland, with the exception of the commonest, the 'swimming elephant', and a second creature which is clearly derived from a classical hippocamp (seahorse) that appears on only a few late, relief-decorated stones. The animal symbols appear singly, in combination with abstract. The abstract symbols appear in combinations. They are given names such as 'Z-rod and crescent', 'double disc', 'notched rectangle', 'V-rod and crescent' and so on, as what they represent, if anything, is not readily discernible.

As a whole, the art of the Pictish incised symbol stones is very distinctive, and does not fall into the mainstream of Early Christian period Celtic art. Although on later, relief-decorated stones, where symbols are combined with Christian and other imagery, the symbols sometimes acquire more complex decorative features, the abstract designs are simple. Such features as triskeles and confronted trumpets are absent, though peltas and leaf patterns are to be found. The likeliest explanation for this art is that it is a separate tradition from the mainstream of Celtic art,

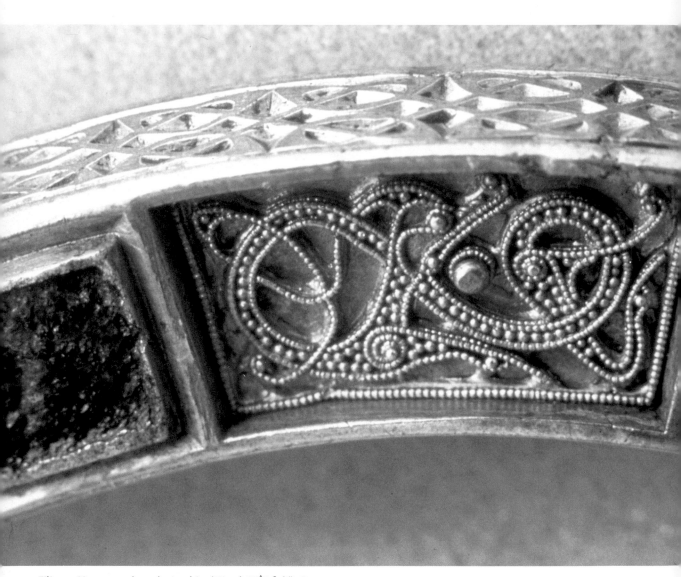

Filigree, Hunterston brooch, Ayrshire (Niamh Whitfield). See p. 101

OPPOSITE Filigree, 'Tara' brooch (Niamh Whitfield). See p. 101

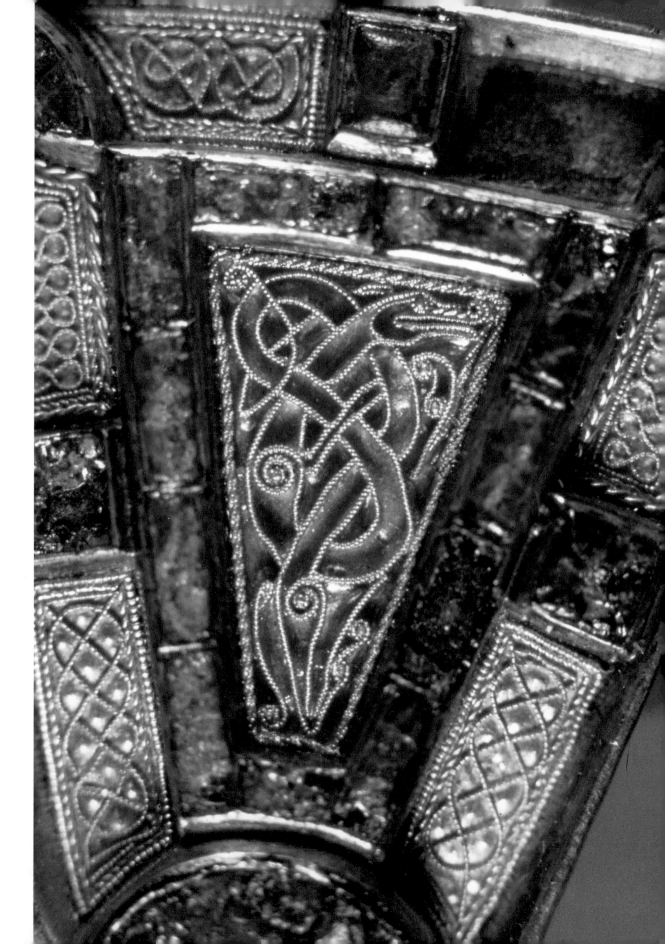

Pictish symbol stone, Newton,
Aberdeenshire (Catherine O'Donnell)

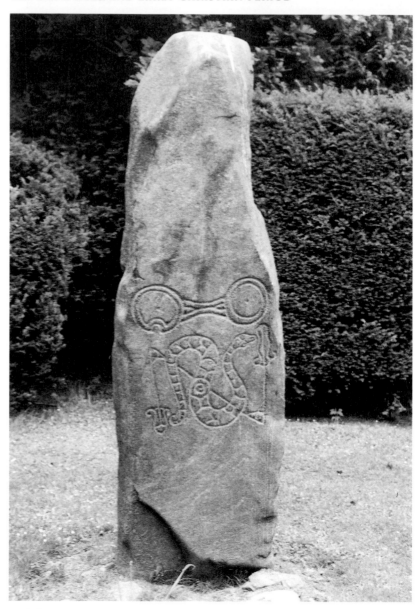

a folk art which may have been originally developed on perishable
materials. In the past, much emphasis has been put on shoulder-and-hip
spirals, but it is conspicuous that only one horse and one deer bear these
features, hardly making them a major element of Pictish design.

There is no particular regional grouping for any one symbol, so a
territorial explanation is difficult to support. Despite many ingenious
theories as to their interpretation, the likeliest explanation for the symbols
is that they are personal badges – heraldic. This would explain why they
are found on portable objects as well as stones, some of which were prob-
ably funerary. Such an explanation does not rule out their use as tattoos,
nor that the symbol combinations record dynastic marriage alliances, as
has been suggested.

The question of date is controversial, since the symbols in some cases at least may have been in use before they were engraved on stone. Simple forms of some symbols appear on cave walls, notably at Covesea, Moray, where there is no evidence for use of the cave after the fourth century AD. More informative perhaps is the fact that proto-symbols were found in an archaeological context at Pool, Orkney, where it was apparent that they were in use by the sixth century AD. The most intensely debated piece of dating evidence, however, is the Norrie's Law hoard from Fife, a find of silverwork which came to light in the early nineteenth century and most of which was dispersed before it could be recorded. The surviving pieces include two leaf-shaped plaques with enamelled symbols, and a pair of hand-pins, one with a symbol on the back. The hoard contained Roman silver, and the plaques are similar to Roman votive examples. Some other items in the hoard also have Roman parallels and the likeliest date for many of the pieces lies in the fourth to fifth centuries AD, though of course the hoard could have been deposited later.

Interesting examples of incised patterns have been found on slabs probably from a box-shaped shrine at Carrowntemple, Co. Sligo. One of these has a 'Durrow spiral' triskele of confronted trumpets, and another has a pattern of running 'Durrow spirals'. Both these designs can be found on hanging-bowl escutcheons, and although they could be later, they may belong to the seventh century.

With these few exceptions, the only ornamental device found on the earliest decorated stones is the cross; figural work is absent. Individual crosses cannot be dated precisely, and although certain forms may be detectable as having been used at particular dates, the same form could have been used for centuries.

Certainly the earliest form of the cross found among the Celts appears to be the chi-rho – a cross with a vestigial hook on the top, formed from the monogram of the first two letters of Christ's name in Greek. On occasions it is found in combination with alpha and omega. The chi-rho cross is certainly found in Roman and later contexts in the Mediterranean. It may have been introduced to Britain and Ireland in the fifth century, but there is no reason to believe that any surviving examples pre-date the sixth or seventh century. An Irish Sea distribution might suggest that the appearance of the motif was connected with trade in this zone in the later sixth century.

A cross in a circle can be dated to the sixth century in Wales, where it appears on the memorial stone of a known historical personnage, Vortepor, at Castell Dwyran, Carmarthen, who is mentioned in the writings of Gildas, c. AD 540. A great diversity of crosses appear on recumbent cross slabs in Ireland, but although many carry inscriptions, none can be dated with any confidence before the seventh century.

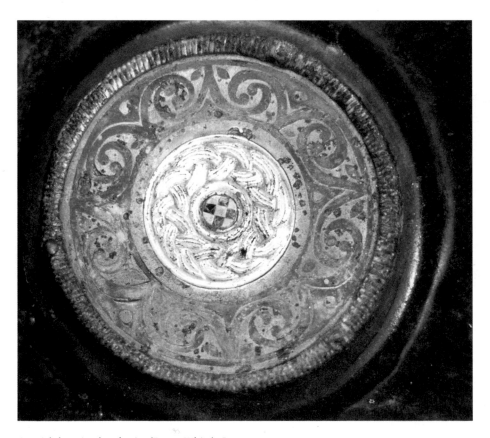

Ipswich hanging bowl print (Roger White). See p. 105

OPPOSITE Norrie's Law, Fife, Pictish silver and Pictish chain from Newmachar, Aberdeenshire (National Museums of Scotland). See p. 105

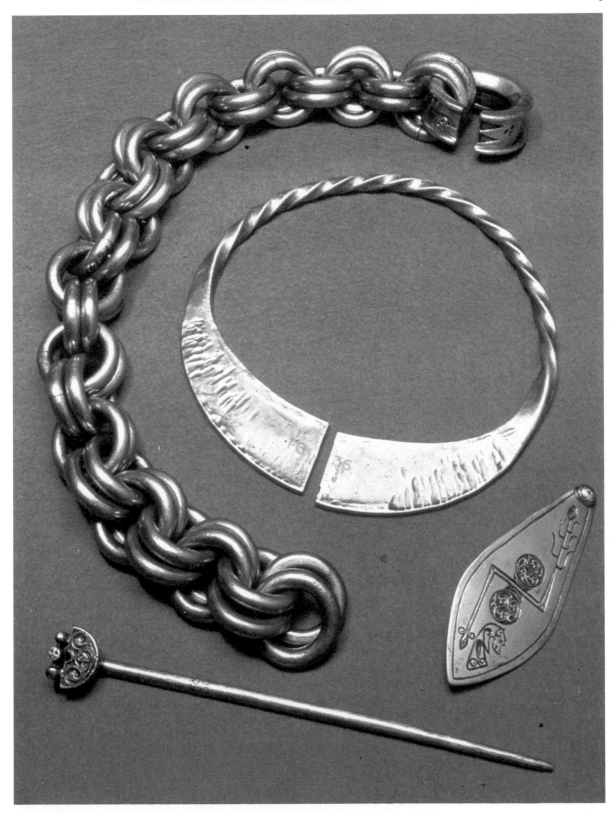

The Golden Age

THE SEVENTH AND EIGHTH CENTURIES were dominated by Christianity in Ireland, Dalriada and Pictland. Archaeological evidence for Ireland is good, but for Wales, most of Scotland and the south-west peninsula it is generally sparse. It contrasts with the comparatively plentiful evidence from Anglo-Saxon England. The dearth in Celtic areas may in part be explained by the fact that from the seventh century AD onwards hillforts were increasingly abandoned, and more open sites favoured, especially in Wales. These are difficult to recognize and may also have been obliterated by later settlements. The plague mentioned in the Dark Ages in Wales may also have depleted the population.

Although it is clear in Scotland that some forts, such as Dumbarton Rock in Strathclyde or Dunadd in Dalriada, continued to be occupied down to the Viking Age, much of the evidence for lifestyle comes from sites in the Northern and Western Isles at this period. In Wales, the current excavations at Llangorse crannog are beginning to fill out the picture, but Welsh life from the eighth to the eleventh centuries can only partially be pieced together from such sources as law codes. Artistic and architectural remains are very few in number.

In the area as a whole, settlement patterns, everyday life and technological skills remained very similar to those in the previous centuries. As far as archaeological and historical sources reveal, at present, standard of living and lifestyles had been therefore relatively unchanged since before the Romans created Britannia. The major change had been the adoption of Christianity with attendant new types of site such as monasteries and churches.

The Golden Age

The end of the sixth century heralds the beginning of two centuries that are known as 'The Golden Age' in Ireland and Scotland. The Irish settlements of Dalriada also participated in the extraordinary artistic and cultural flowering, which was stimulated through Christianity, with the apogee during the eighth century. Throughout this period Ireland was intellectually and spiritually unparalleled throughout the rest of Europe.

Contacts were forged between Ireland and the Mediterranean, Egypt, Italy and Spain, Anglo-Saxon England and, increasingly, with first the Merovingian and then the Carolingian Empires of Frankish Gaul. The Venerable Bede, writing from the Anglo-Saxon monastery at Jarrow, noted how important Irish missionary work was in Northumbria, and how Englishmen were educated in seventh-century Irish schools. Some Irishmen held important offices in the Anglo-Saxon Church. Among the key

monasteries of the period were Durrow, Kildare and Clonmacnois in Ireland; and Lindisfarne in England.

It has been suggested that the catalyst that brought about the eighth-century renaissance may have been a plague which swept through Ireland in the years AD 663–667; we are told by Adomnan that the Picts and Dalriadic Scots were spared, which might account for the pre-eminence of these peoples in the artistic world at this time. Conscious perhaps of the fragility of life, monks in Ireland started recording Irish traditions, sagas, law, genealogies and poetry. Latin became fully assimilated into the culture of the Irish clergy, and a tradition of Latin literature, as well as Irish, became established. However, an additional factor will surely have been the stimulus from other cultures. As will be seen, manuscripts in particular often show a bewildering diversity of influences, so that scholars often argue over where a scribe was trained or where a document was produced, sometimes suggesting highly complicated historical backgrounds.

Dalriada

In AD 563 or thereabouts, St Columba left Ireland with a few followers and went to western Scotland, where he established a monastery at Hinba (possibly Jura) before making his base at Ey, an island which was later named Iona after him (the Latin for dove). The monastic foundation on Iona was perhaps the most influential cultural centre in the Early Christian Celtic world, and it was here that many artistic traditions merged, to flow outwards to Northumbria, Pictland and Ireland.

The role of Iona in ecclesiastical affairs has long overshadowed its role as an artistic centre, almost certainly because the monastery was a prime target for Viking raiders who are first recorded as attacking the island in the eighth century. In the early ninth the community was transferred to Kells in eastern Ireland, with only a small brotherhood left behind to maintain the monastery, until a Benedictine house was built there in the twelfth century. This episode explains why very little, apart from sculpture, remains in Iona or western Scotland to attest the island's artistic greatness – much would have been looted by the Vikings, and what remained would have been taken to Kells by the refugee monks.

It is likely that from the outset Iona was an important cultural centre. The library was extremely fine, and included many major texts, both pagan and Christian. The monastery lay in the kingdom of Dalriada, an area coinciding roughly with present-day Argyll and some of the adjacent islands. It had been colonized by the Irish from the region of County Antrim known as Dal Riada, probably around the end of the fifth century AD, though there are some clues which also point to an earlier settlement. The first settlers may have been Christians – certainly there were Christian communities in Dalriada in the time of Domangart (who died in AD 507), the son of the first colonist, Fergus.

More of the evidence for the art of Iona that still survives on the island comprises a body of sculpture which shows how the Iona community took the lead in developing free-standing crosses in the eighth-century Celtic world. Prior to these developments, however, there is evidence for

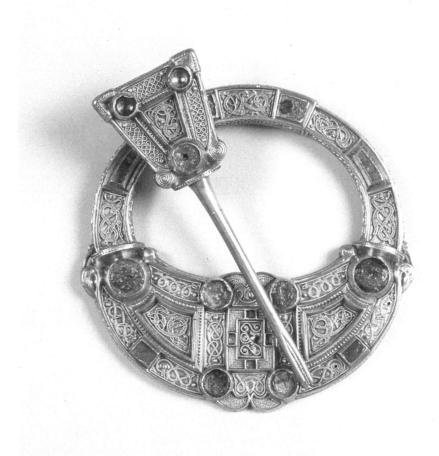

Hunterston brooch, Ayrshire (National Museums of Scotland)

OPPOSITE The Book of Durrow, fol. 192v (Trinity College Library). See p. 129

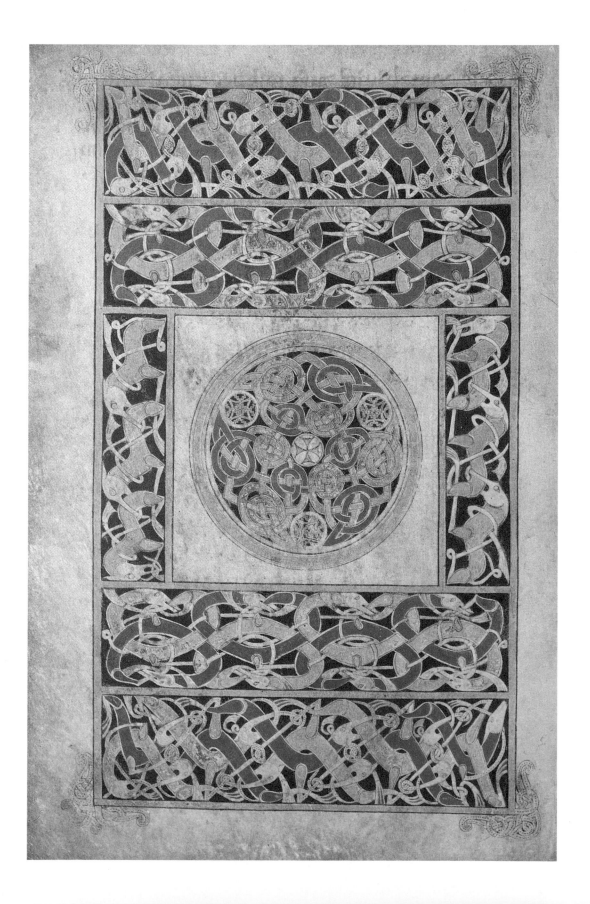

Dunadd metalwork and the Book of Durrow. (A) enamelled roundel, Dunadd (B) detail from the Book of Durrow (C) enamelled disc, Dunadd (D) detail from the Book of Durrow (E) design on a die-stamped bronze plate, Dunadd (F) animal from the Book of Durrow (drawings: Lloyd Laing)

a flourishing art in other media such as metalwork and manuscripts in Dalriada. Only a few treasures are extant but they show features which imply that they could only have been made there since it was subject to influences from a variety of areas.

Metalworking

There is some archaeological evidence that metalworking was carried out on Iona, for example a miniature, bronze casting of a head, and clay moulds for casting decorated glass studs for ornamenting metal. However, Iona is known to have been in contact with the mainland site of Dunadd (probably the capital of Dalriada) so the technological expertise would have been available from this source.

Dunadd

The Dunadd remains include large numbers of clay moulds for ornamental castings, crucibles (which were used for gold and copper alloys), and a few important finds of metalwork, including an enamelled roundel with interlace patterns and another enamelled roundel with small bosses, confronted trumpets and 'Durrow' spirals (p. 208), reminiscent of hanging-bowl escutcheons. The finds also included a gold and garnet stud from an Anglo-Saxon object, perhaps a disc brooch, and a die-stamped bronze mount, possibly from a buckle, with a type of long-snouted animal found in Insular manuscripts. These last two pieces, and the fact that Anglo-Saxon-style buckles were being cast at Dunadd, show that Dalriada had contacts with Anglo-Saxon England, probably Northumbria. Other moulds from Dunadd show us that brooches of types found in Pictland were also being made there, suggesting that Dalriada was a melting pot of traditions. A series of radiocarbon dates assign the metalworking at Dunadd to the seventh century.

The Hunterston Brooch

The metalworkers of Dalriada may well have been commissioned to produce the splendid Hunterston brooch from Ayrshire that has been subject to debate. In silver, amber and gold, it is regarded as the earliest of the richly decorated penannulars and has a pin with a 'keystone' head that matches the terminals, inlaid with gold filigree animals. It shows considerable affinities with art from other areas. For example, hooked-beak bird heads face one another on the terminals, their beaks inlaid with filigree cables – these birds recall the eagle Evangelist symbol in the Book of Durrow and also the heads on bird-headed brooches represented in the moulds from Dunadd. The distinctive filigree animals, infilled with granular work and with convoluted hindquarters, are reminiscent of creatures seen later in Pictland. The filigree snakes have heads composed of a loop, containing a bead of gold for an eye – they are best matched in Anglo-Saxon England, though somewhat cruder versions appear on a cave wall on Arran. The fact that the filigree owes a lot to Anglo-Saxon models has given rise to the suggestion that the brooch was the work of a Celtic smith trained in an Anglo-Saxon workshop, or even of an Anglo-Saxon working for a Celtic patron. Everything about the Hunterston

Brooch points to Dalriada, and it may well have been made for ecclesi-see p. 126 astical purposes on Iona, subsequent to the Viking lootings. Some other decorative brooches, such as one found on Mull, were probably made in Dalriada.

Manuscripts

With the advent of Christianity came a new type of artist. The manuscript illuminators employed new techniques and materials and were able to use colour to an extent not previously possible. There is good reason to suppose that three of the most important Insular manuscripts were produced in the Iona scriptorium. The Cathach of St Columba was, according to tradition, written by Columba himself. Many pages are missing from this badly damaged psalm book, but it is of great significance as it appears to be the earliest of the decorated Insular manuscripts. The style of the calligraphy has been dated by experts to the late sixth or early seventh century, and it employs the device of diminution, that is the letters get progressively smaller from the initial as they merge into the text. It has been suggested that it is a copy made secretly from a text by St Jerome, that Columba's teacher Finnian brought to Ireland. If this is true, it would have been in Ireland prior to the saint's departure for Scotland, but it is extremely likely that it was written at Iona, and very possibly inspired copies itself. The red and yellow ornament is extremely simple, and confined to decorative letters which have spirals, peltas, stemmed crosses and the occasional fish or animal head. No doubt it originally began with a decorative page. It was enshrined in Ireland, probably at Kells in the eleventh century, its shrine being further embellished in the fourteenth.

The Book of Durrow is a small volume, a mere 24.5 centimetres see p. 127 (9½ inches) by 14.5 centimetres (5 ½ inches). The decoration is restricted to evangelist symbols prefacing each of the gospels, decorated initials, and a few full-page embellishments. In some respects, however, its restraint makes it a more pleasing work than the technically far more accomplished later manuscripts. Debate has surrounded its provenance, with claims that it is Anglo-Saxon (written perhaps on Lindisfarne), Irish (written at Durrow) or Dalriadic (executed on Iona). The style of the script does not help, so the debates centre on the decoration which is ecclectic, showing the extent of interaction between Celtic peoples and their neighbours. Some elements are Anglo-Saxon, some Pictish, some seem to reflect the art of Dalriada as it is seen at Dunadd.

A number of textual features, in particular the arrangement of the order of the books, are distinctive in Durrow, and these have been seen to link it to the Book of Kells. The arrangement of all four evangelist symbols on one page is unusual, but was followed by Irenaeus, Bishop of Lyons. A copy of this (or models like it) was not available either in Northumbria or Ireland, but from what is known of Iona's library a copy could have been there. All in all, it seems probable that the Book of Durrow was produced on Iona and taken to Durrow at a later date.

The date at which the Book of Durrow was produced has been hotly debated, but most would agree with a point somewhere in the mid- to later-seventh century.

LEFT Cathach of St Columba, fol. 40 (Royal Irish Academy)

OPPOSITE The Book of Durrow, fol. 197v (Trinity College Library, Dublin). See p. 128

Kilnave Cross, Islay (Jenny Laing)

Sculpture in Dalriada

The sculpture of Iona and the outlying islands of Dalriada, is of paramount importance for understanding the achievements of the artists of Iona, and is generally regarded as incorporating the earliest free-standing crosses in the Celtic world.

Since the techniques used on many sculptures are demonstrably those of carpentry and metalwork, it seems likely that sculptors were carpenters and smiths, adapting their career structures to the new demands. Of the 'Iona School' of sculpture, the earliest surviving examples are two from Islay. The better of the two is the Kilnave Cross. The sculptor used intricate 'Durrow-spiral' ornament and, stylistically, the cross shows that its maker was familiar with elements in that manuscript. Next in date are two fragmentary crosses on Iona itself, St Oran's and St John's. St Oran's Cross is carved from a hard, local stone. The decoration, however, includes figural work – a Virgin and Child not unlike those that appear in a full-page illustration in the Book of Kells, and a man – possibly Daniel – with a quadruped. There is also a pair of rampant beasts with their heads turned to face one another, and these, like the other animals on the cross, have distinctive snub snouts of a type found on the cross-slabs of Pictland. St Oran's Cross also introduces another feature of the Iona school – birds' nest bosses, probably modelled on metalwork; similar bosses can be seen on the Ardagh Chalice for example.

A change of plan by the sculptor can be seen on the more sophisticated St John's Cross (p. 145). Apart from the curvilinear abstract ornament and birds' nest bosses, the sculptor introduced a ring which was originally employed as an afterthought to strengthen the head, which had been damaged during an early fall. The techniques used in slotting the ring into the head were those of carpentry, reminding us that free-standing crosses in stone were probably preceded by wooden ones, which are documented though none survive. Once introduced, the wheel became an important feature of Celtic crosses. St John's Cross also has a cabled border which, like the bosses, is borrowed from metalwork. The ornament also employs bosses made with snakes, a device with symbolic undertones which was taken up in Pictland and in Ireland.

Two further, better-preserved crosses make up the catalogue of the main survivals of Iona-school cross sculpture. St Martin's Cross displays figural work which is very much more complex than any seen before, and includes a Virgin and Child on the crossing, David and the sacrifice of Abraham on the shaft.

The cross on Kildalton, Islay (p. 148), is generally similar, though bosses are less prominent, except in the centre of the crossing where a birds' nest boss is surrounded by interlace. Again, however, there are snake bosses, and the figural ornament includes a Virgin and Child, a sacrifice of Abraham, and Pictish-headed beasts.

The Golden Age in Scotland and Ireland

By the eighth century Celtic art blossomed, stimulated perhaps by the Columban monasteries of Scotland and Ireland.

A description of the monastic centre of Kildare is preserved in Cogitosus's *Life of St Brigit*, written around the middle of the seventh century:

> On account of the growing number of the faithful of both sexes, a new reality is born in an age-old setting, that is church with its spacious site and its awesome height towering upwards. It is adorned with painted pictures and inside there are three chapels which are spacious and divided by board walls under the single roof of the cathedral church. The first of these walls, which is painted with pictures and covered with wall hangings, stretches widthwise in the east part of the church from one wall to the other ... This church contains many windows and one finely wrought portal on the right side through which the priests and the faithful of the male sex enter the church.

Writing of the settlement outside the church, Cogitosus commented:

> Who can describe in words the exceeding beauty of this church and the countless wonders of that monastic city we are speaking of, if one may call it a city, since it is not encircled by a surrounding wall ... In its suburbs, which Saint Brigit had marked out by a definite boundary, no human foe nor enemy attack is feared; on the contrary, together with all its suburbs it is the safest city of refuge in the whole land of the Irish for all fugitives and the treasures of kings are kept there. (tr. M. Richter, *Ireland: The Enduring Tradition*, London, 1983, p. 79–80)

As yet, clearly nobody had heard of the Vikings.

Ecclesiastical Arts in Ireland and Pictland

In the seventh and eighth centuries Irish and Pictish monasteries grew very rich, and were able to provide the patronage necessary for the production of church treasures. These comprised liturgical plate – chalices to hold the wine in Mass, and patens (essentially plates) to hold the Host, initially a loaf which was broken, later wafers. In addition, there were book bindings, and various reliquaries or shrines (in the sense of containers for holy material rather than cult centres) and sculpture.

Manuscripts

Books were highly prized, and great care was taken by monks in their embellishment to the glory of God. Nunneries in both Anglo-Saxon and Celtic lands are known, but seem to have been afforded less prominence at the time and subsequently in later studies. A number of twin houses are known – St Brigit's in Kildare was one such. St Patrick wrote that he was 'unable to enumerate' the monks and 'Virgins of Christ' in his own time. It is always assumed that the scribes were male (because all the names known are of men and depictions in manuscripts show male illustrators and scribes), but it is theoretically possible that some manuscripts were produced by women. As was seen in the case of the Book of Durrow, it

is extremely difficult to attribute individual manuscripts to particular scriptoria, since the art they display seems to draw upon a common pool of decorative devices and models which was shared by monasteries in Northumbria, Ireland, Scotland and on the Continent. Attempting to attribute individual books to particular centres all too easily becomes merely an academic exercise that detracts from the universal nature of the art at the time. There was considerable communication between the monasteries and churches in Anglo-Saxon England, the Celtic world and the Continent, and there was no copyright on motifs or art styles.

From the Lindisfarne library comes the Durham Cathedral A II 10, which consists of twelve surviving pages of a Gospel book. This is important as it lies, stylistically, somewhere between the Cathach of St Columba and the Book of Durrow. The script is strongly Irish, indicating that the book was produced either by an Irish scribe or one who had spent time training in an Irish tradition. The surviving decoration is limited – the only ornamented pages we have belong to the end of Matthew and the beginning of Mark, of which the first word is wrongly spelt (INITITIUM instead of INITIUM). This, however, includes the earliest known interlace in a manuscript and an elaborate initial letter with double-headed snakes. The treatment of their jaws is like that on such pieces as the Anglo-Saxon, Faversham, hanging-bowl escutcheons.

The Book of Dimma and the Book of Mulling represent two small manuscripts, of the family known as 'pocket gospels'. Dimma is particularly appealing for its rich colours, and was probably produced at Roscrea, Tipperary, since it has a forged colophon attributing its production to a contemporary of Roscrea's saint, Cronan. It is the work of several hands. Perhaps its best ornament is the eagle evangelist symbol. The Book of Mulling is more homogeneous, its three evangelist portraits having, however, been taken out and bound in at the back.

Four manuscripts called the Echternach and Durham Gospels and the Otho Cv and Corpus Christi 197 may have been produced under the direction of a monk called Egbert, who had been at Iona and was active both among the Picts and in Northumbria around AD 700.

The Echternach Gospels, now in the Bibliothèque Nationale in Paris, could have been made for the foundation of Echternach in Germany in AD 698. They are related to two manuscripts, one badly damaged by fire (only one small fragment survives), the Cotton Otho Cv in the British Library, the other the Corpus Christi 197 in Cambridge, which is remarkably well preserved. All three gospels mark a departure from the text of the books followed in Durrow – they adhere to the order in the Vulgate (the accepted version of the New Testament by St Jerome), and appear to copy the text of a south Italian manuscript. The Echternach Gospels has an evangelist with lobed draperies and a tonsure similar to that worn by St Peter on the wooden coffin of St Cuthbert, which has been dated to c. AD 698.

The Durham Gospels (Durham A II 17) shows signs of having been produced by the same scribe responsible for the Echternach Gospels and is consequently known as the Echternach-Durham Calligrapher. The Durham Gospels is important since it was originally a work of comparable

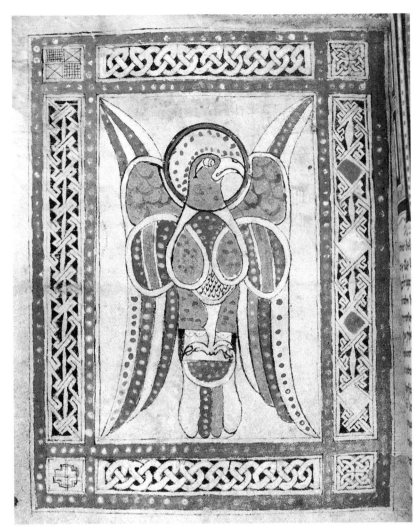

The Book of Dimma (Trinity College Library, Dublin)

magnificence to the Lindisfarne Gospels. Among the surviving pages is a fine Crucifixion.

The St Gall Gospels is an eighth-century book, probably produced in Ireland, then subsequently taken to St Gall in Switzerland. It is distinguished by having a Last Judgement and a Crucifixion page. It has one carpet page (i.e. totally covered with ornamentation). The colours are unusually bright – blue, red, yellow and green, and the decoration tends to the abstract. It provides a foretaste of the complex figural work of the Book of Kells.

The Book of Kells

The Book of Kells is the most famous of all the Insular manuscripts, and is a *tour de force* of Celtic draughtsmanship. It is the work of several hands and, in addition, apprentices probably filled in details. Some of the full-page decorations are separate from the main text and inserted, suggesting that artists worked on separate sheets of vellum so that only satisfactorily

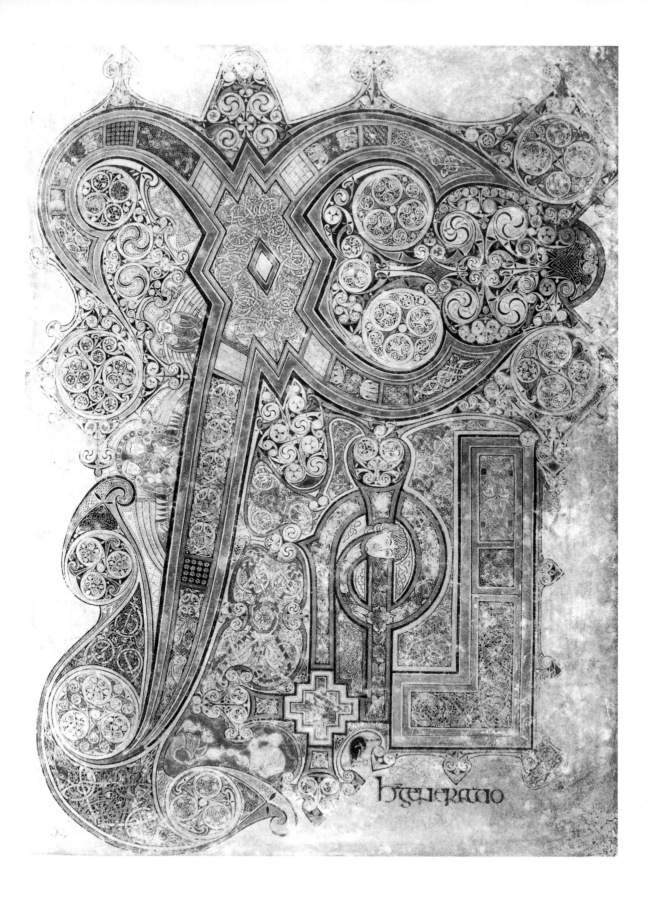

generatio

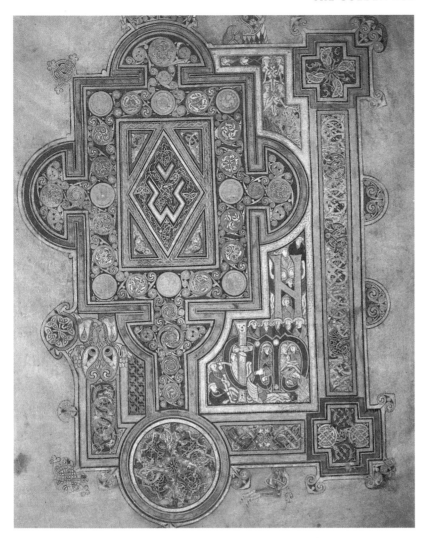

OPPOSITE Book of Kells, *Christi Autem* page fol. 35 recto (Trinity College Library, Dublin)

LEFT Book of Kells, decorative page, fol. 188 recto. *Quoniam* page from Luke. (Trinity College Library, Dublin)

completed work was incorporated into the book. It is a large volume, measuring 33 centimetres (13 inches) by 25 centimetres (10 inches) (it was even larger originally, before the pages were trimmed by the nineteenth-century binder) and originally comprised about 350 pages. Of these, 340 survive. The book was at Kells in 1007, where it was described in the Annals of Ulster as 'The great Gospel of Columkille, the chief relic of the Western World'. This records how it was stolen for its shrine but was found some months later, stripped of its gold and buried in the ground.

Whether Kells was begun on Iona and finished at Kells by the monks who had transferred there after the Viking attacks, or whether it was completed on Iona, hardly detracts from the fact that it was a product of the Iona scriptorium. The word 'Iona' (here referring to Columba, not the island) appears on one folio of Kells. This fact explains why it shares the same arrangement of the Gospels as the Book of Durrow, and why, like Durrow, a number of features in its ornament are matched in the art of Pictland. Three 'styles' are apparent in both Pictish art and the Book of

Kells. It has been suggested that the Book of Kells was produced in honour of the enshrinement of St Columba, sometime between AD 752 and 767, and that it was illuminated under the patronage of Oengus mac Fergus, a Pictish king who for a while controlled Dalriada and who also came into contact with the Anglo-Saxon kings of Northumbria, Wessex and Mercia. It is likely that if this is the case the book was taken to Ireland (along with Durrow) after a Viking raid in AD 878.

The work of individual artists is clearly recognizable in this manuscript, showing that illumination could be a team effort, e.g. the 'goldsmith' who was responsible for the chi-rho page, the cruciform carpet page known as the 'page of the eight circles' and the initial pages of each gospel (except that of Luke). His work is by far the most intricate, with minute, inter-locked spirals, intertwined animals and tiny men twisted to fit circles (a feature also found in Pictland). His work is asymmetrical, but never confused. His figures are always ornamented, never naturalistic.

The 'portraitist' was responsible for the two surviving evangelist portraits, the full-length facing figure of Christ and some of the symbols in square frames. He also decorated the initial page for Luke. In contrast to the goldsmith, he uses vegetal scrolls as well as the traditional patterns employed by his fellow monk. He uses little figures of humans as orna-mental details, but with greater naturalism than the goldsmith.

Much less conservative is the 'illustrator', who was responsible for the full-page illustrations of the Arrest, the Temptation, the Virgin and Child, the 'Tunc crucifixerant' page and the symbols at the start of St John's Gospel. His concern is not for ornamental detail, but for the drama of the main scene he is depicting. His colours are strong, even garish – a com-bination of purple and green, sometimes combined with strong red, is a favourite device.

A fourth illuminator was responsible for the 'Nativitas Christi' page and one of the canon pages – his work is graceful and precise, and he is skilled at representing movement. It may be that he was responsible for much of the naturalistic animal ornament in the book – cats, cocks, hens, a goat, a greyhound, a cormorant and some figures. His work can be seen, for example, on the Christi Autem page, otherwise decorated by the gold-smith. He is the artist who is perhaps the most versed in Pictish art. Indeed, he might have been a Pict.

Giraldus Cambrensis, a twelfth-century monk who travelled in Ireland, described a manuscript which he saw in Kildare. It is unlikely to have been the Book of Kells, but his description shows that it was a closely-related work, and it is informative for showing us just how such books were viewed by their contemporaries:

> This book contains the harmony of the first four Evangelists according to Jerome, where for almost every page there are different designs, dis-tinguished by varied colours. Here you may see the face of majesty, divinely drawn, here the mystical symbols of the Evangelists, each with wings, now six, now four, now two; here the Eagle, there the Calf, here the Man and there the Lion, and other forms almost infinite. Look at them superficially with the ordinary casual glance, and you would think it an erasure, and not

tracery. Fine craftsmanship is all about you, but you might not notice it. Look more keenly at it, and you will penetrate to the very shrine of art. You will make out intricacies, so delicate and subtle, so exact and compact, so full of knots and links, with colours so fresh and vivid, that you might say that all this was the work of an angel, and not of a man. For my part the oftener I see the book, and the more carefully I study it, the more I am lost in ever fresh amazement, and I see more and more wonders in the Book.

(tr. E. H. Alton, in *Evangeliorum Quattuor Codex Cenannensis*, 1950–1951, 15)

The layout of the Book of Kells involved three fully illuminated pages at the beginning of each Gospel – the Evangelist symbols, an Evangelist portrait appropriate to the Gospel that followed, and an opening page for the start of the Gospel. The Gospel of St Matthew was seen as having two beginnings, the 'Book of the Generation' and 'The Birth of Christ'. For the second beginning the Book of Kells employed a full-page portrait of Christ, a full-page of ornament and the famous Christi Autem page, which marks the beginning of verse 18. In addition, full-page decorations were employed to emphasise key events – the Arrest of Christ (in Matthew), the Crucifixion (in Mark), the Temptation (in Luke) and the Resurrection (in Luke). In addition, there are canon pages which provide a concordance for the Gospels. Evangelist symbols reappear throughout in various contexts.

The Lindisfarne and Lichfield Gospels
Apart from the Book of Kells, undoubtedly the finest of all the Insular manuscripts is the Lindisfarne Gospels. Probably made to commemorate the enshrinement of St Cuthbert, alterations in it are made in the same hand as is found in the Durham Gospels, showing either that both were in the same place (Lindisfarne) at one time or, alternatively, that the scribe was peripatetic.

The manuscript was written by Eadfrith, Bishop of Lindisfarne, and since we know the date of elevation to the bishopric, the date of the manuscript can be fixed at, or around, AD 698. It employs Evangelist portraits with their symbols above them, the iconography copying classical models. The colours are rich and very varied, and the ornament comprises carpet pages, elaborate opening pages for each Gospel, canon pages and decorated initials.

The Lichfield Gospels (or Gospels of St Chad) is closely related to the Lindisfarne Gospels, now in Lichfield Cathedral, Staffordshire. Two Evangelist portrait pages survive, very different in style from Lindisfarne, and each by a different hand. Mark is attended by a lion with an outraged expression, similar to that in the Otho Cv. The figure of Luke is almost entirely composed of curves, and a Mediterranean model has been sought. The Lindisfarne style of long-legged and long-beaked birds appears in profusion in the Lichfield Gospels, particularly on a cruciform carpet page. It may have been produced in south Wales or in Mercia in the first half of the eighth century, though all that is known for certain is that it was taken to Lichfield in the tenth century, having previously been at Llandaff in Wales.

Church Plate – Hoards

Metalwork was in many cases produced in monastic workshops, and no doubt making objects for liturgical use was in itself an act of devotion. Some monastic workshops have been discovered, most recently that at Armagh, though earlier discoveries include those at Nendrum and Movilla, both in Co. Down. Lay craftsmen, too, were probably attached to monasteries.

Three major hoards together comprise the finest masterpieces of Irish ecclesiastical metalwork.

The Derrynaflan hoard from Co. Tipperary is one of the most notable discoveries of recent years. The hoard came to light in 1980 on the site of a monastery, and comprised a chalice, silver paten, its stand and a liturgical ladle, all covered by a plain, copper-alloy bowl. The hoard was deposited in the late ninth or tenth century, but the objects were of different dates. The earliest item is the paten (diameter: 36.8 centimetres [14½ inches] max.), which is a superb piece of workmanship. It comprises a hammered silver plate with flattened rim which had been turned on a lathe, and was attached by soldering, stitching, and locking pins to a double-walled hoop of copper alloy, with applied decorative ornaments. On the upper surface of the rim are twelve frames, each of which had two panels of filigree. In the centre of each frame is a cast enamel stud, and

The Derrynaflan, Co. Tipperary, hoard (National Museum of Ireland)

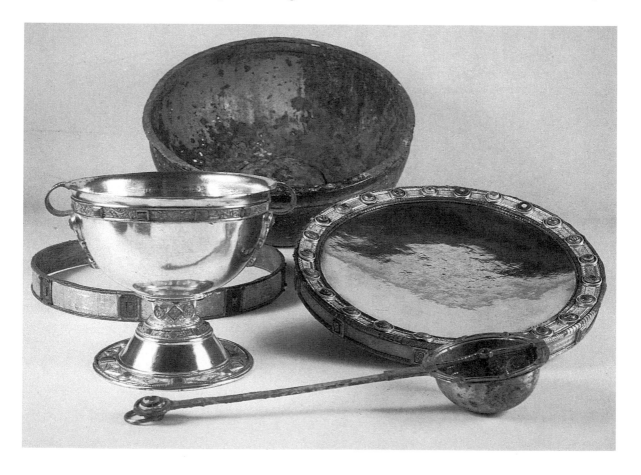

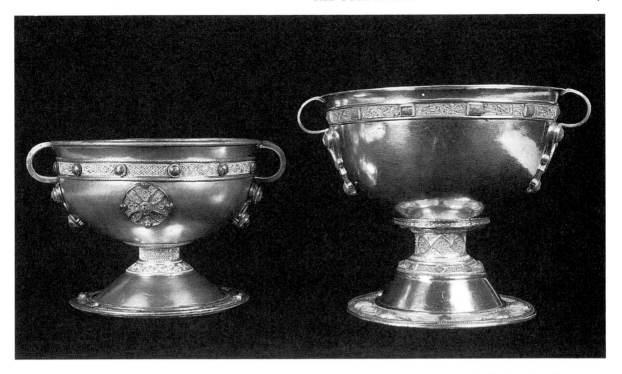

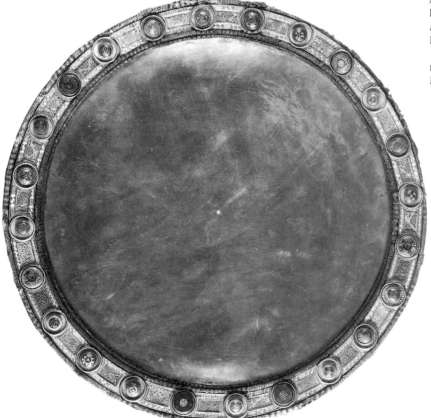

ABOVE The chalices from the
Derrynaflan (Co. Tipperary) and
Ardagh (Co. Meath) finds (National
Museum of Ireland)

LEFT Derrynaflan paten (National
Museum of Ireland)

where the frames touch there are twelve smaller studs covering the locking pins of the assembly. There are twelve, gold, pressblech foils with trumpet scrolls and spirals inside, and double outline, billeted interlace appear on the outer face of the hoop. Other decorative features include trichinopoly (knitted silver wire) work and polychrome inlays.

The filigree panels are of great interest and variety. They are ornamented with kneeling men back to back (four panels), fanged beasts (ten panels), interlaced snakes (two panels), an eagle (one panel), pairs of confronted beasts (three panels), stags (two panels) and thin quadrupeds with crossed necks (one panel). A panel with plain interlace and two with spiral patterns make up the list. Some of the creatures are reminiscent of Pictish art; Anglo-Saxon influence is also apparent, and an Iona connection is not out of the question. The symbolism is complex and is discussed below.

A very interesting feature of the paten is the tiny letters and symbols which were engraved, and are a key to its assembly. Apart from the fact that the form of the letters helps to provide a date in the eighth century for the piece (it has been argued as being late in the century), they also shed light on workshop practice. A further inscription is even more noteworthy, as the letters are only one millimetre high, and thus very difficult to see. The scribe who engraved them paid attention to details of the lettering, such as wedges, but unfortunately he blundered or omitted some letters so the inscription (which was on the rim under the ornament), cannot be deciphered precisely. It may have been a dedication and prayer of thanks on completion of the work. Assembly letters appear on other pieces of Celtic metalwork, notably on the Ardagh Chalice and less certainly on the 'Tara' brooch.

The stand for the paten may have been made later, and has die-stamped silver foils among its ornamental details.

The origin of the paten lies in the late Roman and Byzantine world. Such large patens were replaced by smaller ones in the later Middle Ages, when the loaf was replaced by wafers. It is unlikely that the paten would ever have been used.

The strainer-ladle has coloured studs, silver foils and millefiori plaques, suggesting that it too was a product of the eighth century, though not made to go with the paten.

The Derrynaflan chalice, 19.2 centimetres (7½ inches) high, has eighty-four filigree panels, fifty-seven gem-set amber studs, cast interlace and animal patterns, which provide additional ornament. The decorative scheme is symbolic.

The Ardagh Hoard
The second of the great hoards provides us with the Ardagh Chalice, arguably one of the finest pieces of early medieval metalwork to survive. Smaller and finer than that from Derrynaflan, it was found by a boy digging for potatoes in a ringfort known as Reerasta Rath near Ardagh, Co. Limerick, in September 1868. With it was a plain, copper-alloy chalice and four sumptuous brooches: three Irish, the fourth a Viking-silver penannular of the type known as a 'thistle' brooch on account of its terminals. The objects were buried about a metre (about three feet) under

ground, and marked by a stone. As with Derrynaflan, the items are of different dates, and the hoard was buried perhaps in the tenth century.

The Ardagh Chalice stands 17.8 centimetres (seven inches) high, and is an indigenous Irish version of a type of liturgical chalice common in Byzantine silver hoards of the sixth century. The bowl and foot are made of beaten lathe-polished silver, to which cast silver handles were added. The stem, which hides a split pin, is made from cast gilt-bronze, as is the basal ring and the setting, underneath which the pin reaches the surface, to be covered by a polished, conical crystal. Filigree of exceptional quality, and glass, decorate the escutcheons for the handles, which are themselves inlaid with enamel. Some polychrome glass studs have inset metal grilles, to create the effect of cloisonné Anglo-Saxon, or other Germanic, jewellery. Germanic too is the device of employing paillons (silver foils) under some of the studs on the base. On the handle escutcheons the studs are bordered by thin amber ornaments, fastened with a glue mixed with malachite. Sheets of mica, also used on the Moylough Belt Shrine, appear on the base.

Church Fittings

The Donore Hoard, found in Co. Meath in 1985, illustrates another facet of ecclesiastical metalworking. This comprises what appear to be items of door or shrine furniture, presumably from a major church – Dulane or

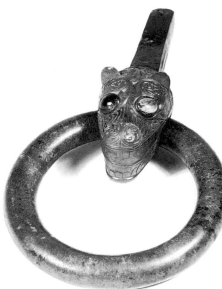

ABOVE Donore ring handle (National Museum of Ireland)

LEFT Donore, Co. Meath, plate for ring handle (National Museum of Ireland)

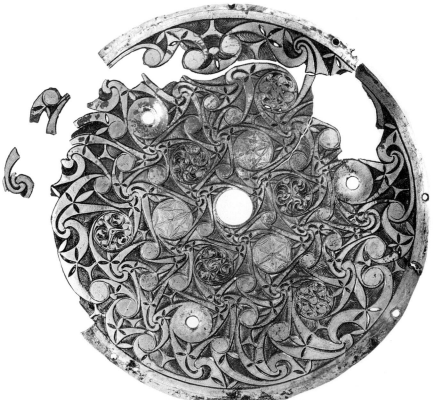

OPPOSITE St Johns Cross, Iona (David Longley). See p. 132

Kells have both been suggested. The important feature of the objects is that they show the way in which the 'Lindisfarne' style of ornament was being assimilated in the east midlands of Ireland at the beginning of the eighth century, and also the way that not only church plate was richly decorated. The main element is a handle assembly with a lion head with the ring handle in its teeth. Such lion-head ring handles were a feature of the classical world.

Reliquaries and Shrines

The idea of venerating the corporeal remains of saints, or objects that had been closely associated with them, was very popular in the Golden Age. It is likely that this was because of the sense of 'family' in the early Irish monasteries. Saints were seen as heroes, and founder saints were revered in the way that the head of a family line might be honoured. Relics established a visible link with the founder by attracting pilgrims, and with them money, to the monasteries concerned. Obviously, the more important the saint, the more valued the relic. Thus, St Patrick's relics were highly esteemed, and were used on occasion to solemnize major political agreements. They were carried into battle, and were even used to call down curses.

There is a great diversity of types of reliquaries, most notably for such incorporeal relics as books, though also for corporeal relics, which were frequently encased in house-shaped shrines, intended to represent miniature churches or chapels. These were based on Continental models. Much larger shrines are also known, and although none survive from the eighth century, there are mounts which may have come from them. Important relics were similarly housed in richly decorated shrines.

Probably belonging to the beginning of the eighth century, or even

Belt shrine, Moylough, Co. Sligo (National Museum of Ireland)

the end of the seventh, is the Moylough Belt Shrine, found in a peat bog at Tubbercurry, Co. Sligo in 1945. Much debate has surrounded the date of this strange object, since much earlier models seem to lie behind it, both Frankish and Anglo-Saxon models having been suggested. It still contains the leather strap of a belt, and the buckle is skeuomorphic (decorative rather than functional). To fasten the belt around a person (perhaps to effect a miraculous cure) it is necessary to remove the pin of the back hinge. It is in four sections, with bronze plates with round

Monymusk Reliquary (National
Museums of Scotland)

Monymusk Reliquary (National Museums of Scotland)

mouldings, each one with a cross-shaped mount in the centre. The buckle has a pair of bird heads facing one another on the loop, and two silver panels of pressblech with spirals and trumpet patterns. Geometric cells contain enamel and millefiori, and there are, in addition, decorative glass studs.

The Monymusk reliquary is the only example of a small, house-shaped shrine to survive more or less intact in Britain. It was fashioned from a block of wood, encased in metal plates, and furnished with a pair of enamelled hinges to which a strap was attached so that the casket could be carried around the neck. It is known as the Brecbennoch of Columba, and contained an important relic of the saint. It was carried before the successful Scottish army at the Battle of Bannockburn in 1314. The decoration, with alternating round and rectangular settings with gilt interlace, is similar to that on a shrine in Bologna, Italy. The crest with beaked birds is in keeping with Irish pieces. The animal ornament on the silver plates covering the shrine and the background of punched dots is reminiscent of Pictish work, though not totally dissimilar to the creatures that cavort on the Iona crosses. It is likely, however, that the reliquary, for a major relic of Columba, was made on Iona rather than Pictland, perhaps at the time of the enshrinement of the saint in the eighth century.

Probably earlier is the recently-discovered Lough Kinale Book Shrine from Co. Longford, found in the water near a small crannog in 1986. It consisted of a wooden box onto which metal plates had been fastened, which then had binding strips attached along the sides and corners. The main element on the front is a cross with lobed arms, reminiscent of a

carpet page or the Iona crosses. The border decoration uses a pair of similar designs for the long sides and another pair for the short. The bosses recall those on the Iona crosses too, and employ decorative studs. Around the same time a processional cross was found at Tully Lough, Co. Roscommon and this has cusped arms and also employs bosses.

Croziers, Plaques and Bells

Stylistically the earliest of the eighth-century pieces of ecclesiastical metalwork is perhaps the Ekerö Crozier, found in the Swedish trading base of Helgö, which has produced other exotic trade objects, such as a bronze Buddha. The head is in the form of a monster with a human head in its jaws, probably representing Jonah and the Whale. It is decorated with herringbone pattern, and a further animal head projects from the back. The socket is decorated with enamel in geometric cells.

The Rinnigan, or Athlone Crucifixion Plaque, is larger and in a different style from a group of later plaques, but shares with them a Crucifixion, with Christ in a long eastern robe flanked by Stephaton and Longinus. Above are two angels. Its function is not known – it could be

Book Shrine, Lough Kinale, Co. Longford (National Museum of Ireland)

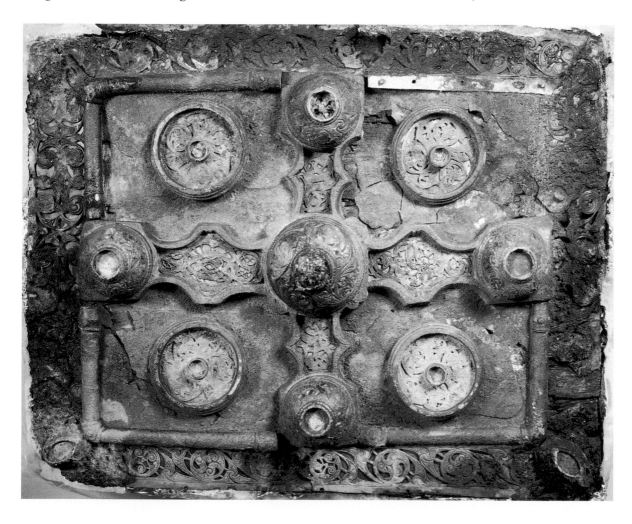

Kildalton Cross, Islay (Jenny Laing).
See p. 132

OPPOSITE Cross slab with Jonah,
Gallen Priory, Co. Offaly (Green
Studio). See p. 151

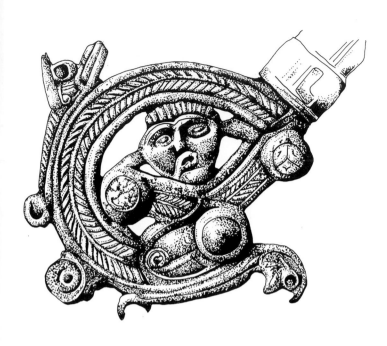

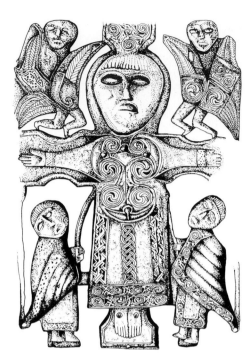

LEFT Ekero crozier, from a trading site in Sweden (drawing: Priscilla Wild)

RIGHT 'Athlone' Crucifixion plaque, St John's. Rinnagan, Co. Roscommon (drawing: Priscilla Wild)

from a book cover or some large reliquary. Christ's robe is embroidered with interlace and Durrow scrolls as well as with other patterns.

Bells were important relics of particular saints – what was believed to be St Patrick's bell was enshrined – and a number of bells have survived, not only in Ireland but in Scotland and Wales. These were seldom decorated, and because they lacked clappers were clearly intended to be struck. They were often made from folded sheet iron. It must not be forgotten that although not surviving, there must also have been items of altar furniture such as candlesticks, and the churches themselves would have been adorned with panel paintings and carvings, probably many in wood.

Sculpture in Pictland

There is good reason to believe that the Church in Pictland in the eighth century was extremely prosperous. There were many important monasteries (though little survives of them) such as Applecross in Ross. The eighth century in Pictland was marked by the career of Nechton mac Derelei, who became king in AD 706 and who opened up Pictland to Northumbrian influence. Pictish ecclesiastical artistry was responsible for the production of a major series of relief sculptures. The Picts favoured cross-slabs. These are distinguished by having a cross as the main element of the design, combined with Pictish symbols (which were originally incised, but by this period were executed in relief) and diverse subject matter, both religious and secular. Although the idea of a cross slab and relief decoration may have been imported, the Pictish cross slabs are totally distinctive and innovatory. Although the Crucifixion is absent, the central decorative pattern probably represented Christ and, as a whole,

the cross was symbolic of the Resurrection – there are sometimes seraphim or worshippers flanking.

There is strong reason to suppose that the Pictish cross-slabs are the earliest relief sculptures in the Celtic Christian world. The inspiration may well have been, at least partly, Northumbrian, where sculpture perhaps inspired in turn by Gaulish precedents, appeared on the churches at Monkwearmouth and Jarrow before the end of the seventh century. At this period too, the Northumbrians may have begun making memorial stones with a cross and a personal name, sometimes combined with alpha and omega. Some may have been recumbent, others set upright.

The tradition may have spread to Pictland around the end of the seventh, or more probably beginning of the eighth, century, perhaps when king Nechton sent to Northumbria for guidance and imported Northumbrian masons, around AD 710. This may be the date of the Aberlemno Churchyard Cross, a magnificent cross-slab with Northumbrian animals on the front and Pictish symbols on the back (p. 152). The battle of Nechtansmere fought nearby in AD 685, when the Pictish king Bridei mac Bili defeated the Anglo-Saxons and killed King Ecgfrith, may be the subject of the stirring low-relief scene on the back.

Also probably of early-eighth-century date, are a few other low-relief cross slabs, such as the Glamis Manse Stone, Angus, which has incised Pictish symbols on the back, in the traditional manner, combined with a relief cross and figural work on the front. This includes more Pictish symbols, a contest between two axemen, and what appear to be figures which are being dropped into a cauldron. Could this be human sacrifice or a symbol of rebirth?

There are a few other low-relief slabs, probably of the earlier eighth century. They include the more sophisticated Rossie Priory Stone, from Perth and Kinross. It has a richly decorated cross on both faces, with complex figural work, some of which may be derived from a manuscript source, the *Marvels of the East*, known to have been available in Northumbria. Other monuments in southern Pictland also appear to have images taken from this work. The Rossie Priory stone also has riders and the ubiquitous Pictish symbols. On the Eassie Priory Stone, Angus, the iconography includes what appears to be a tree set in a base. From its branches human heads are suspended: a survival of Pictish paganism?

A slab which serves as a stylistic link between these low-relief, eighth-century monuments and the 'Boss Style' of the ninth is the stone from Dunfallandy, Perthshire. This has prominent bosses on the cross, reminiscent of those on metalwork and those on the Iona crosses. The designs on the reverse include no fewer than eight Pictish symbols, a cloaked rider, two seated figures, probably the hermit saints Paul and Anthony, and a small cross. The whole is framed, as was the back of the Aberlemno cross, by two serpents, this time with a human head between them, perhaps representing Jonah.

Sculpture in the Eighth Century in Man and Ireland
Relief sculpture is not well represented in the Celtic world of the eighth century outside Scotland. In the Isle of Man the incised slab tradition is

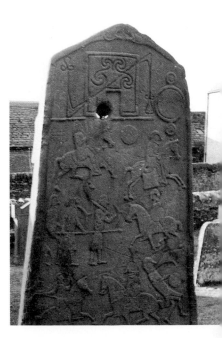

Aberlemno Churchyard stone back (Lloyd Laing)

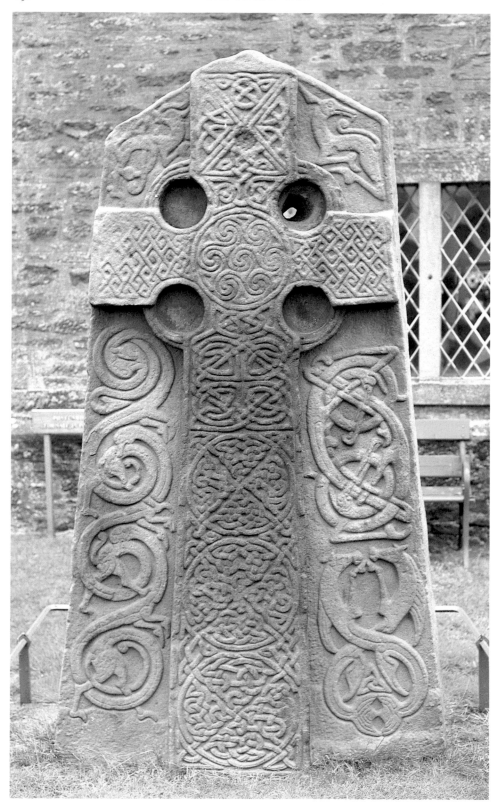

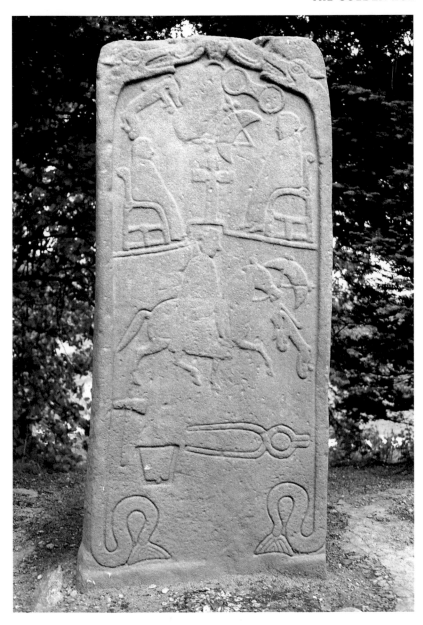

OPPOSITE Aberlemno, Angus, Pictish Churchyard Stone front (James Kenworthy). See p. 151

LEFT Dunfallandy, Perthshire, Pictish stone (James Kenworthy). See p. 151

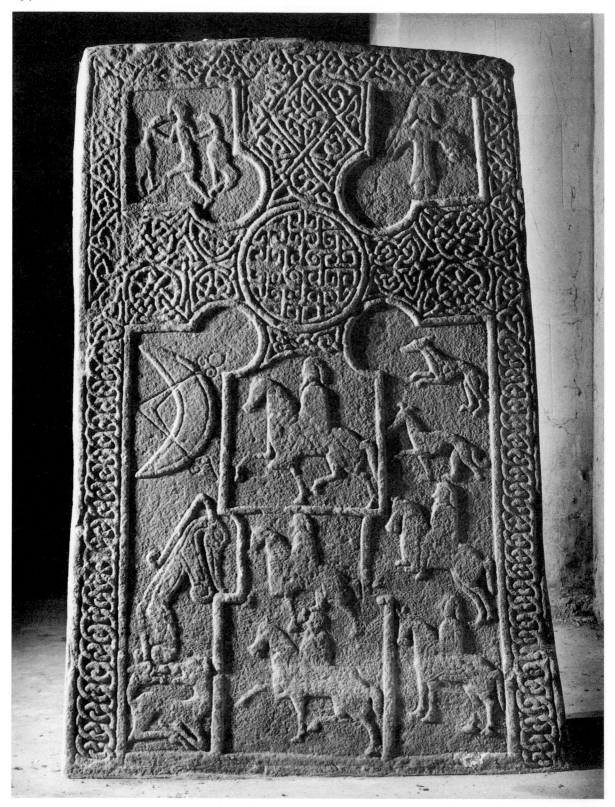

well represented by the late seventh-century Irneit's Cross, with a fine marigold pattern and chi-rhos. From a tiny island off the Manx coast has come the Calf of Man Crucifixion Slab, probably an altar frontal or the panel from a stone composite shrine. The Calf of Man slab recalls the Rinnigan (Athlone) Crucifixion Plaque, with Christ in a long robe, flanked by Longinus and Stephaton, though only one of the two survives. The ornament includes double-strand interlace in a roundel in the centre of Christ's robe. The bifurcated treatment of Christ's beard is notable.

Of the Irish monuments, apart from a small group of High Crosses that may belong to the end of the eighth century (though this has been disputed), the main sculptures of the period comprise a series of incised slabs. The earliest is perhaps one from Ballyvourney, Co. Cork, with a cross in a circle and a small cleric bearing a crozier – he appears to have the same kind of tonsure as found in the Book of Durrow, and could be of the late-seventh century. Next perhaps come a few slabs with Crucifixion scenes engraved on them, such as the crude monument from Duvillaun, Co. Mayo, and the slightly less crude slab from Inishkea North in the same county, perhaps pointing to a tradition of incised Crucifixions in this part of Ireland. Slightly later is a fine slab from Gallen Priory, Co. Offaly, in low relief, which has Jonah and the whale on a cross head with a snake-boss whirl and heads in the extremities of the cross arms and head.

The Secular Arts

All the techniques acquired by Celtic artists from their neighbours at the beginning of the eighth century were also directed towards secular markets. Almost all the secular metalwork comprises penannular brooches and dress pins, though there are also some buckles, mounts for harnesses and a few metal or metal-decorated vessels.

Penannular Brooches
As far as can be judged from representations, the penannular brooches were worn at the shoulder, with the pin pointing vertically down or diagonally, as is shown for example on the Cross of Muiredach at Monasterboice, or a carving of a warrior from White Island, Co. Fermanagh. A stone from Monifeith, Angus, and the Hilton of Cadboll stone show Pictish women wearing brooches at the breast. Artists fashioned penannular brooches of various materials, commonly of bronze, less commonly of silver, rarely of iron. The only solid-gold brooch found is from Loughan, Co. Derry. It is a true penannular, and for long was associated with Irish Dalriada, though in fact it was found outside the territory.

The 'Tara' Brooch
The finest of the eighth-century brooches are made of silver with inlays of gold, amber and other materials. The most famous of them all is the consummate 'Tara' brooch, which was found at Bettystown, Co. Meath, in the nineteenth century. It was given its name by a Dublin jeweller, who acquired it to make replicas, and deemed 'Tara' more romantic a title than the 'Bettystown Brooch'. The 'Tara' Brooch is a museum of early-eighth-

OPPOSITE Rossie Priory, Perth and Kinross, Pictish stone (Tom Gray)

Calf of Man slab, Isle of Man (Roger White)

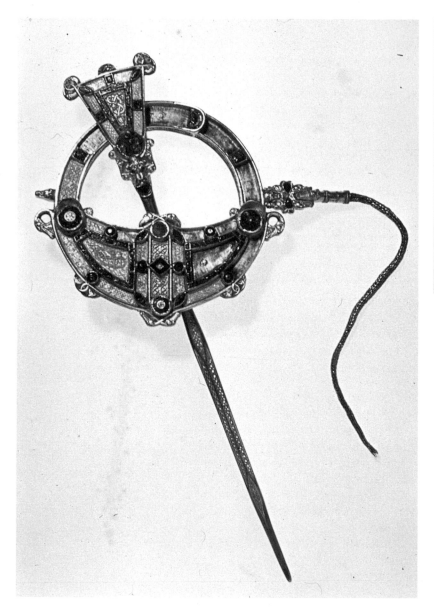

LEFT AND ABOVE 'Tara brooch', Bettystown, Co. Meath (National Museum of Ireland)

OPPOSITE St Ninian's Isle Shetland, hoard, silver objects (National Museums of Scotland). See p. 158

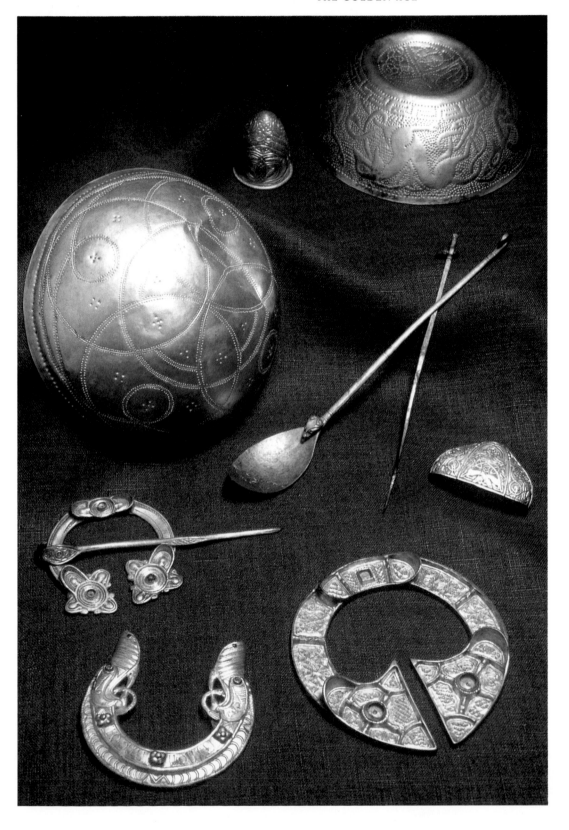

century techniques and styles. Made of cast silver-gilt, its ring is 8.7 centimetres (3½ inches) in diameter, its pin 32 centimetres (12½ inches) long. It is inlaid with gold filigree, amber and coloured glass. Every available surface is decorated. It is a pseudo-penannular brooch, in so far as the terminals are joined together, and attachment was by means of the detachable pin, further security being provided by a knitted-wire (trichinopoly) safety chain, presumably connected to a pin or miniature brooch. This was fastened to the hoop by means of an animal head on a hinged tab, which itself is furnished with four beast heads and two tiny glass human heads. The filigree is confined to the front of the brooch, as it might snag on the cloth.

Its maker was highly skilled in two types of decoration. On the front he employed animal interlace and plain interlace in filigree, with cast bird and animal heads. The settings are filled mostly with cut amber, though there is also some glass. The back has ornament in the abstract traditional style, though there are also birds and animals and some interlace. The back is mostly done in imitation chip carving, and the creatures show the influence of the Lindisfarne Gospel style.

One of the most remarkable features of the back are the two silver panels with traditional Celtic designs, made by polishing away a thin film of silver, applied to a copper plate on which the design had been embossed. The result was that the colour of the copper showed through the silver in the areas of the relief design. Its date has been much debated, but it is usually assigned to the early-eighth century.

Of the many brooches of the eighth and ninth centuries is the County Cavan Brooch, which belongs to the end of the eighth century. It is also known as the 'Queen's Brooch', in honour of Queen Victoria. Of silver, it has tiny heads forming bridges between the terminals: two human, the third bridge being formed of an interlace panel connecting with back-to-back animal heads. The lobed pattern on the terminals with animal heads, in the junctions of the lobes, echoes the design of some Pictish penannular brooches of the late-eighth century. The pin head matches the terminals.

Penannular brooches also occur in hoards of Pictish silverwork of the later eighth and ninth centuries, the deposition of which may be connected with Viking raids. The hoard from Rogart, Sutherland, was dispersed on its discovery in the late-nineteenth century, but three of the eleven brooches have survived, and two others in Oxford are probably from the same find. The two finest (the Cadboll brooches) are silver-gilt, probably belong to the end of the eighth century, and display characteristic features of Pictish penannulars.

The St Ninian's Isle Treasure

see p. 157 The St Ninian's Isle Treasure, discovered during excavation in 1958, is the finest assemblage of Celtic early-medieval metalwork found in Britain. This Pictish hoard was buried around AD 800, probably in the face of Viking raids. There has been some debate as to whether the hoard was primarily secular or ecclesiastical, but the likeliest explanation for the objects in it is that they represent the treasures of a Pictish chief. His possessions comprised a silver hanging bowl, a series of seven silver

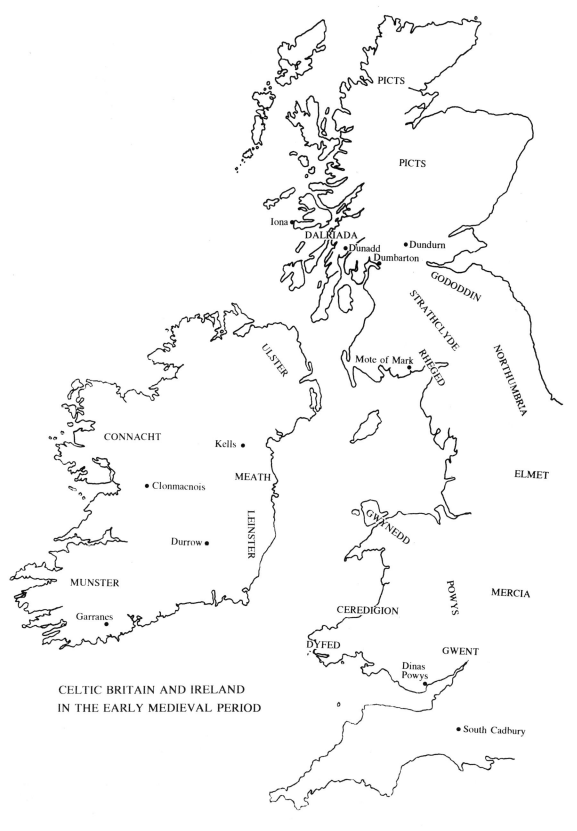

PICTS

PICTS

Iona ●

DALRIADA

● Dundurn
●Dunadd
Dumbarton●

GODODDIN

STRATHCLYDE

NORTHUMBRIA

ULSTER

Mote of Mark ●

RHEGED

CONNACHT

Kells ●

MEATH

ELMET

● Clonmacnois

LEINSTER

GWYNEDD

Durrow ●

POWYS

MERCIA

MUNSTER

CEREDIGION

DYFED

GWENT

Garranes ●

Dinas
Powys ●

**CELTIC BRITAIN AND IRELAND
IN THE EARLY MEDIEVAL PERIOD**

● South Cadbury

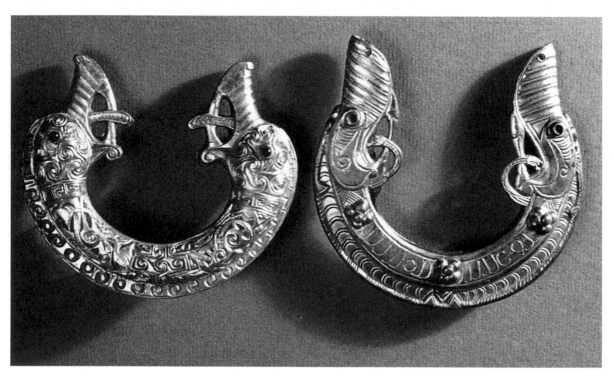

Two silver sword chapes from the St Ninian's Isle hoard, one inscribed (National Museums of Scotland)

bowls, twelve penannular brooches, three pepperpot-shaped objects, a sword pommel, two sword chapes, a spoon and a pronged implement. Anglo-Saxon influence has led to suggestions that several of the objects were made in England. If that were so, it points to high-level gift exchange. Given, however, that all the penannular brooches are of types found only in Pictland (with the exception of a few exports), this seems most unlikely. A serious contender for an Anglo-Saxon provenance is the hanging bowl, the only silver example to survive (though a lost silver bowl is known from the River Witham in Lincolnshire). The St Ninian's Isle bowl has the distinctive feature of three ribs in the form of boars, terminating in the suspension loops. The bowl is the oldest object in the hoard, and is unlikely to post-date AD 750.

The two silver sword chapes are distinguished by the fact that one carries an inscription. Originally read as naming two Picts, Resad and Spusscio, there has been a more recent suggestion that in fact this part of the inscription is an abbreviated rendering of 'property of the Son of the Holy Spirit'. The first part is clear enough, as it begins 'In the name of God ...'. Such dedications on items of weaponry were not unknown at this period; there is a similar inscription on an Anglo-Saxon helmet from York.

The three pepperpot-shaped objects, which have slits in their bases, have defied explanation, though it is generally assumed that a strap passed through the base and they were used for adjustment, after the manner of a car seat belt. An alternative suggestion is that they were attachments for a processional fan – this has also been used to provide an alternative explanation for the 'sword pommel'.

The artist or artists who made the objects were familiar with a very fine and varied repertoire of designs, typical of the period. These artistic developments were both disrupted and enhanced by the arrival of the Vikings.

The Viking Age

VERY LITTLE IS KNOWN from archaeology about settlement sites of the ninth to twelfth centuries in Celtic Britain or Ireland, but the few sites of the period that have been excavated, such as Beal Boru, Co. Clare, occupied in the eleventh century, show a continuing Iron Age lifestyle. This dearth is compensated for in two unexpected phenomena – Irish High Crosses and Pictish sculptural stones. Across these, process numerous charming little figures wearing a wide variety of clothes and showing us musical instruments and carved furniture.

The period between the ninth and the twelfth centuries, both Scotland and Ireland, and to a lesser extent Wales, saw two major incursions by invaders, first the Vikings, then the Norman English.

Viking Raids and Settlement

In AD 793 Lindisfarne was subject to a Viking attack, though the community survived until AD 875. The Anglo-Saxon Chronicle reports that Vikings raided southern England in AD 787. In Ireland, a church on Rathlin Island was reputedly burnt in AD 795. The early raids were of the tip-and-run variety, probably relatively slight in their impact, but progressively they grew more concerted and led to a period of settlement.

The first area to be colonized, as opposed to raided, by Viking seafarers was Scotland. The earliest Scandinavian settlements in this region began in the Northern Isles in the early ninth century, where characteristic Viking longhouses, with stone foundations and slightly bowed walls, have been encountered at such sites as Jarlshof, Shetland and Birsay, Orkney. Some were substantial structures, up to 20 metres (65½ feet) or more in length, and were the homes of farmers who may have gained excitement, and a second income, by raiding, as evidence (in the form of loot) from Jarlshof suggests. These settlements were open, but a small stone-built fort has been discovered at the Udal on North Uist dating to the mid-ninth century.

The Northern Isles were relatively sparsely populated, the inhabitants being predominantly Pictish with some Irish clergy from Dalriada. The same may be said for the Hebrides and those parts of the north Scottish mainland (mainly Caithness) that were settled by Scandinavians.

The Hebrides served as a base for further raids and settlements in the Irish Sea area, and the Isle of Man was extensively colonized. Further south, there was some settlement in Galloway, and Viking timber houses, well-preserved by waterlogging, have been found at Whithorn, Wigtownshire, dating from around AD 1000.

Wales was raided, and the Viking-age finds include a magnificent

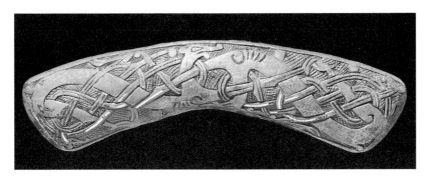

Viking bronze sword guard, found off the coast of Pembroke at Smalls (National Museum of Wales)

recently-discovered sword hilt-guard from Smalls, Pembroke. Made of bronze, it is richly decorated with Viking ornament, and is one of the finest examples of Viking art from Britain. As yet, however, there is no evidence for Viking settlement in Wales or the south-west of England.

After AD 820, raids became more frequent in Ireland, and in AD 841 the first permanent settlements were established, one at Dublin and one at a place usually identified as Annagassan in Co. Louth. The raids and settlements are documented in the Irish Annals. Secondary settlement brought Norse-Irish to the Wirral and other parts of the north-west of England.

Hoards

The earliest Viking hoards are of the ninth century, those in Scotland have been dated to the tenth, and only five of the 120 or so hoards from Ireland have been dated to before AD 900. They comprise Anglo-Saxon, and occasionally Frankish or Arab, coins, armlets, rings, ingots, brooches and what is termed 'hacksilver' (pieces of silver intended for the melting pot). Some hoards may have been buried in fear of Viking raids, but most were deposited by the Vikings themselves. In the absence of a Viking coinage in Scotland at this period, armlets seem to have doubled as a kind of currency. The hoards contain various types of brooch, including penannulars with brambled terminals, known as 'Thistle' brooches, and large silver penannulars with expanded terminals and bosses which are often termed 'Hiberno-Viking' as they were mostly made in Ireland in the period AD 850–950.

The Impact of the Vikings on the Celts

The Vikings had their own social structure which gradually impinged on Celtic society.

Outside the Northern and Western Isles and north Scottish mainland, the impact of the Vikings was not great in Scotland, and no towns, for example, were founded. There were, however, political changes of some importance. In the years following AD 840, Kenneth mac Alpin, king of the Dalriadic Scots, became king of a united kingdom embracing both Picts and Scots, henceforward to be known as Alba. Although some of the finest Pictish sculpture was produced in the first half of the ninth century, gradually the identity of the Picts was eclipsed and their language replaced with Scots Gaelic. The Picts are last mentioned in an Irish source

in the early tenth century. Probably the Viking threat helped to unite Picts and Scots and, in addition, English influence increasingly made itself felt.

In Wales, the early kingdoms were progressively reduced in number and united by marriage alliances. This had begun long before the Viking period, and by the time of Rhodri Mawr, in the ninth century, much of Wales was united under one ruler. It enjoyed something of a cultural revival, with links extending to the Carolingian court. Rhodri's grandson, Hywel Dda, became virtually sole ruler of Wales in AD 942, but he allied with Aethelstan of England, and seems to have been a client king. Henceforward, Wales increasingly looked to England.

Like that in much of Europe at the time of the Viking raids, Irish society was somewhat unstable. The extent of the Viking raids and settlement has probably been exaggerated, but at the same time it must not be under-estimated. Vikings certainly had an enormous impact on the Church. Among other things, they caused monks to flee to Carolingian France, which resulted in a two-way opening up of Ireland to Continental learning and art, and of the Continent to Irish. For fear of Viking fire, churches were built of stone in increasing numbers, and round towers were built, perhaps as much for treasuries as for bells. By this time, monasteries were normally under the control of a layman who could provide the military support necessary for their protection. The focus of learning in Ireland also moved westwards, from the vulnerable east coast, and Clonmacnois became the major centre of learning between the ninth and the twelfth centuries.

There were some social changes. The lowest rank of kings became less important, and there was a shift from the emphasis from the *derbfine* to the nuclear family. Through the Vikings, slavery became widespread in Ireland. Through the Vikings too, new techniques of seamanship were acquired. Society appears to have become more brutal. Viking words were assimilated into the language. Towns were established for the first time in Ireland, and these opened up new networks of contacts, at first with Scandinavia, later with England and Carolingian France. Much has been learned about Viking urbanism in Ireland from the excavations in relatively recent years, in Dublin. Other towns that the Vikings founded (all in the later ninth century) were Limerick, Waterford, Wexford and Cork, though comparatively little is known about them from archaeology. Each town was the centre of a small Norse kingdom, and in eastern Ireland these came into conflict with Danish raiders. After a brief period under Danish control, Dublin was regained by the Norse in AD 870 by Olaf the White, who used it as a base for Irish Sea raiding. The Irish allied with Norse or Danes, according to the passing inclination of particular groups, but under Brian Boru the Irish rose against the Scandinavians, and at the battle of Clontarf in 1014 Scandinavian power was effectively eclipsed. Although, politically, the Vikings were henceforward of lesser importance, culturally their impact was to increase, through intermarriage.

Viking Dublin

Quite a lot of evidence for art in Ireland in the tenth and early eleventh century takes the form of carvings in wood and, more rarely, bone. Much

of this has recently come to light in the excavation of the Viking town of Dublin. Dublin was clearly a rich manufacturing and trading port. Through the finds it is possible to see the introduction of Scandinavian styles into the Celtic areas, and the way in which they may have become gradually assimilated into native Celtic art. All the styles are quite closely related, and seem to have evolved out of each other. They are named after Scandinavian finds, and the most significant are the Borre, Mammen/ Jellinge, Ringerike and Urnes.

There are over 150 pieces of carved woodwork spanning the period from the tenth to the twelfth century from Dublin, some no more than sketches and hardly Celtic art at all, some outstanding pieces of Irish Viking art. These include a number of pieces which show some contribution from southern England as well as Scandinavia – for example in the Ringerike creature that adorns a spatula from Christ Church Place, which has a foliate fetter and a knot, which seem to be similar to ornament in some English manuscripts. A fine plank from Christ Church Place is in a type of Ringerike found on the famous St Paul's Churchyard stone in London, also indicating a southern British origin for the Viking styles

ABOVE Chair pommel, Fishamble St, Dublin (drawing: Priscilla Wild, after James Lang)

BELOW Spatula, Christ Church Place (drawing: Priscilla Wild, after James Lang)

encountered in Dublin. From Fishamble Street have come a considerable diversity of wooden objects in local Viking style, including small hollow cylinders, a bucket stave, a stylus handle, a dog and ball model, weaving swords, a yarn winder and a small house-shaped shrine, as well as a knife handle and a strange wooden crest with two cocks' heads.

Art in the Viking Age

The Book of Kells was taken from Iona to Ireland at the time of the Viking raids at the beginning of the ninth century, and in a sense it marks the end of not only the Golden Age but of Celtic art as it is usually perceived. That is not to say that fine works of art were not produced by Celts, but so strong were the other influences: Viking, Carolingian, English and Continental Romanesque, upon the artists that the traditional Celtic elements became subordinated in an organic whole. It was often as if the artists strove to recreate the art of the past by consciously reviving traditional design elements, but somehow only succeeded in producing a Celtic version of the art forms of the day.

The impact of Viking art and culture on the Celts was not felt fully until the twelfth century. There is far less ninth-century metalwork and manuscript art than there is of the eighth. This may be partly due to Viking raiding, which resulted in objects being taken to Scandinavia, where they are frequently found in Viking graves. It is also probable that less was being produced.

Although there is a growing conviction among scholars that Irish art continued to flourish in the ninth and tenth centuries, it was revitalized by new imagery from the Carolingian world, and by new styles from Anglo-Saxon England.

The art was both secular and ecclesiastical. The former consists mostly of metalwork, especially brooches. The church art includes manuscripts, sculptures and metal pieces such as croziers. Ireland and Scotland are particularly prominent artistically, both notably open to Viking influence.

The Secular Arts

Ninth-century metalwork is surrounded by controversies since it is often difficult to distinguish it from that of the eighth century.

A large number of Celtic treasures have been found in Viking graves in Scandinavia. Pieces of Celtic metalwork were sometimes remodelled – there is for example a brooch from Jarlshof made out of a Celtic harness mount, and a pair of brooches from a Viking burial at Carn a'Bharraich on Oronsay that have been made from the strap hinges from a house-shaped shrine. In some cases, pieces of Celtic metalwork were even set in Viking weights – for example at Kiloran Bay, Colonsay. Celtic artists seeing opportunities for new markets may even have produced horse gear and other items for Scandinavian patrons, such as the fine set of harness mounts from Balladoole, Isle of Man, which may have been made in a Hebridean workshop.

Virtually all the metalwork which survives in the Celtic world from

later than the eighth century comes from Ireland and the north of
Scotland. There are one or two brooches from Wales, of the eighth to
ninth centuries, which may have been made in Wales, but could just as
easily be imports. The most ornate is a gilt-bronze pseudo-penannular
from Llys Awel, Clwyd, with amber and glass studs.

Penannular Brooches

Some penannulars can be assigned with a degree of certainty to the ninth
century in Ireland. There are two main series – in the north, silver
brooches with prominent bosses as part of their design are to be found.
These bosses are joined by lines creating irregular fields occupied by
animals. The closest parallels for this kind of ornament are to be found in
Anglo-Saxon silverwork, and the immediate models were probably silver
brooches. Among the finest is the Ballyspellan Brooch from Co. Kilkenny,
which has openwork panels between the bosses, which were made sepa-
rately and riveted on, holding the openwork in place. Such brooches were
probably being made in the last years of the ninth century, or even the
beginning of the tenth. They turn up in early tenth-century hoards in
Britain and Ireland, and are probably partly to be accounted for by the
sudden increase in silver introduced by the Vikings.

In southern Ireland, the traditional type of pseudo-penannular con-
tinued to be made in the ninth century, though now they were slightly
different in character. Animals were used as borders for the terminals, glass
disappeared, and the only inlays were amber studs. Filigree, as on the
Derrynaflan paten, became coarser. Of the many examples, the best are
perhaps those from Roscrea, Co. Tipperary, Killamery, Co. Kilkenny,
Ardagh (found with the chalice) and Loughmoe (the 'Tipperary' brooch).
Of these, the Ardagh and Loughmoe examples lack the characteristic
animal borders.

Kite Brooches

Alongside the ornate penannulars, a variety of more modest but often
quite pleasing brooches were produced, as well as hinged pins.

A curious type of tenth-century silver artefact which is represented in
Ireland by a mere six examples is the kite brooch. Brooches of this type
have kite-shaped heads, with a hinge attaching them to the pin, from
which the heads are made to project. One from Clonmacnois, now lost,
had a head not unlike the famous Anglo-Saxon Alfred Jewel (which has
a beaded boar on its socket of Irish character), but they show Viking
influence in their design, and in some animal ornament.

Ecclesiastical Arts of the Viking Age

By far the most examples of ecclesiastical art of the Viking Age come from
Ireland and Scotland. A lost shrine in the form of a hipped roof was
drawn by the antiquary Edward Lhuyd in the late seventeenth century at
Gwytherin in Gwynedd, but although the form of the shrine is in keep-
ing with Irish examples (such as the later shrine of St Manchan) the orna-
ments on it are more Anglo-Saxon in character. A few stray pieces found see p.177

ABOVE Book of Armagh (drawing: Lloyd Laing)

RIGHT Book of MacRegol (Bodleian Library Oxford)

in Britain are more likely to be imports from Ireland than indigenous.

The artistic remains consist in particular of manuscripts, Irish High Crosses, Pictish sculpture and some metalwork pieces. The Carolingian world had a special influence on High Crosses.

Manuscripts

After the Book of Kells, relatively few notable manuscripts survive from the later ninth and tenth centuries. Belonging to the early ninth century is the Book of Armagh, which is notable for its lack of colour but accomplished drawing. An inscription proves it to have been executed at Armagh around AD 807. Unlike most of the other manuscripts from this period, it is a volume put together from several books: including a Life of St Patrick, a New Testament and a Life of St Martin of Tours.

The Gospel of MacRegol is a richly decorated Gospel Book, named after the scribe, who died in AD 822. It was made at Birr, and is slightly

heavy handed, produced as it was in a relatively minor monastery. It is
nonetheless reasonably competent. It has an Evangelist page and an initial
page at the start of each Gospel, simply coloured in orange, yellow, green,
black and a shade of brown. The colours are applied thickly, and there
is a corresponding lack of finesse about the ornamental details, which
include interlace, fret and animal patterns.

During the later ninth and tenth centuries, the manuscripts tend to be
small and continue the traditions of the style of ornament that appeared
in the 'pocket gospels' of the eighth century. The Book of MacDurnan is
a good example of these later works. It is named after the abbot of Armagh
(AD 888–927). It passed into the hands of the English king, Aethelstan,

and thence went to Christ Church, Canterbury. There is a tendency in the book to concentrate on linear rather than painterly ornament – a feature of contemporary English art also, though the effect in the Irish manuscript is very different. Colour is thick, but not liberal in terms of area – red, orange, yellow and green are used. It has four Evangelist pages, only St Mark has his symbol, and decorative initial pages to each gospel. Interlace is crude, as are the fret and animal patterns.

Of the early tenth century is the fragmentary Cotton Psalter (Cotton Vitellius F XI), which was badly damaged in an eighteenth-century fire that destroyed many priceless manuscripts. Two full-page decorations survive, one of David and Goliath, the other David as Harpist, and there are also two pages from the beginnings of sections (elaborated with borders), and decorated initials from the beginnings of each psalm.

The Southampton Psalter belongs to the late tenth, or even early eleventh, century. It has three surviving miniatures, of David and the Lion, the Crucifixion, and David with the felled Goliath. The style of the latter can be compared with the similar miniature in the Cotton Psalter. Goliath is shown upside down. The drawing is simple, the colours limited to purple, brown and yellow. There are some interlaced animals making up initials, with coloured infill, but many initials are simply executed in black. Spirals and step patterns are absent, though frets continue. Some of the animal ornament is reminiscent of that to be found on metalwork.

The Book of Deer is a Pictish manuscript, much treasured by monks in the eleventh and twelfth centuries at Deer Abbey, near Elgin, in the Highland region. It is a small volume, after the manner of the 'pocket gospels'. It has fret interlace and animal patterns, and a crude Evangelist portrait with dotted background. Elements of the style recall a Pictish stone at Elgin, and it dates probably from the ninth century. It has been suggested that it was executed from memory by a scribe who was familiar with Gospel books, but did not have one in front of him to copy. The Edinburgh Psalter, produced in the early years of the eleventh century, may also be a Scottish product.

Sculpture in Ireland – the High Crosses

The Irish High crosses, of which there are about 300, not all equally well preserved, represent a major corpus of Dark Age sculpture. Essentially, they comprise a Latin cross, to which may be added the optional features of a capstone, a ring on the head, and a separately carved base, though not all these features are by any means universal. While it cannot be doubted that the vast majority of the Irish High Crosses belong to the ninth and tenth centuries, there is some disagreement over whether some groups of Irish crosses may belong to the eighth. The origin of the crosses is equally obscure; connections with Northumbria and Iona are claimed, but the question is complex, embraces art-historical considerations and is subject to much debate.

Why did the Irish (either in Scotland or in Ireland) begin erecting stone crosses? It has been suggested that they were stone translations of earlier timber crosses. The documentary sources show that crosses were erected over graves in the seventh century, but it is not usually clear whether they

were of timber or another material. Not until the ninth century, in Ireland, is there a firm allusion to a timber cross (of hazel). Documentary sources suggest that crosses were used to mark burials, commemorate events, mark boundaries, provide a focus for prayer, and as fit places for solemn events: one source refers to a baby being left at one for fosterage!

Although it has been suggested that some features of free-standing crosses are skeuomorphic of the wooden prototypes, it is much more likely that the models were metal crosses. The design of the early Iona crosses and some of the Irish for example, clearly copies features of metalwork, with its bosses and the cabled edges imitating the binding strips on reliquaries, and in some cases filigree. There are in addition a couple of crosses in metal with profiles that recall High Crosses in stone – the Tully Lough Cross and the Anglo-Saxon Rupertus Cross are two examples.

'Early Crosses'

Two groups of crosses may predate the beginning of the ninth century.

One group is found in the area known as Ossory, and comprises the two fine crosses at Ahenny in Co. Tipperary, and the crosses at Kilkieran. The crosses of this group are notable for displaying ornament which is closely matched in eighth-century metalwork, have large heads compared to their shafts, and employ a wheel on the cross head. In some cases they have conical capstones (though whether they are an original feature has been questioned), and bases like truncated pyramids. Rope or filigree-like mouldings occur, and they also have prominent bosses. Abstract ornament predominates; the only figural ornament is on the bases, and comprises a mixture of scriptural, non-scriptural but religious, and secular subjects. One scene on the base of the North Cross at Ahenny is of particular interest, since it appears to depict a beheaded warrior being carried on the back of a horse, his body pecked by ravens, while a figure walks behind carrying his head. Two clerics, one with a processional cross, the other a crozier, precede him. The meaning is lost, but it is a vivid version of a scene that must have been not too uncommon in early Ireland. Another scene on the base of the same cross appears to represent the Mission of the Apostles, while yet another shows a man under a palm tree surrounded by animals who seem to ignore him.

The second 'early' group of monuments is at Clonmacnois and includes the South Cross. In keeping with the Ahenny monuments, the South Cross has prominent mouldings and bosses, and predominantly abstract decor- see p. 180 ation. Here can be seen the first introduction of figural ornament on the cross itself – a low relief Crucifixion on one side of the shaft. The remaining crosses probably post-date AD 800.

Figural Work on Crosses

The first cross to have a complex system of figural work is probably the see p. 185 South Cross at Kells, also known as the Cross of Patrick and Columba, after an inscription on it. Similar is the Cross of Duleek, Co. Meath. This has, in the centre of the head, on its west face, Christ in Majesty, with the four Evangelist symbols, and Matthew holding the Lamb of God. Below is the Crucifixion, the appearance of which may be due to growing

Ahenny Cross, Co. Tipperary (Gavin Williams)

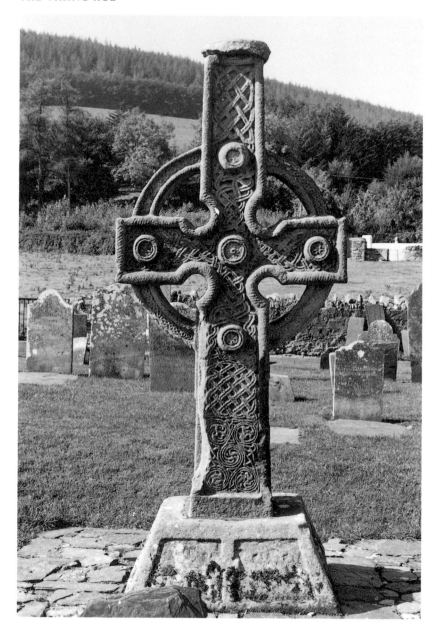

see p. 181

Carolingian influence. It is clear that, as yet, the layout of the iconography has not yet been formalized. The base has a chariot and two horsemen, a composition reminiscent of designs in Pictland, which is hardly surprising given that Kells was an offshoot of the Columban house of Iona.

Clothing, Furniture and Musical Instruments on Crosses

Most of the scenes depicted on High Crosses are conventional renderings of Scriptural subjects, which in general terms are faithful to their models, frequently Continental. However, there is good reason to suppose that details of dress, weaponry and so forth are accurately copied from con-

temporary life in Ireland. Thus the crosses provide an interesting fashion gallery of the ninth and tenth centuries.

The West Cross at Clonmacnois (Cross of the Scriptures) shows two men, each dressed in an ankle-length linen robe (known in texts as a *leine*), and a woollen cloak (*brat*) fastened at the shoulder with a brooch. Their belts are clearly visible, and one has a sword which, though weathered, appears to have a Viking-style hilt. Both have beards and moustaches, but of different style – one neatly trimmed to a point, the other bifurcated. These figures appear to be watching two in profile underneath holding a staff. One of these has a short tunic, the other a long robe and upper garment. Both garments have embroidered borders, perhaps produced by tablet weaving, otherwise attested in archaeology. The secular figure may be King Flann, the other Abbot Colman. Some figures appear to be shown wearing trousers, for example on the Tower Cross of Patrick and Columba at Kells. In the Arrest of Christ on the Cross of Muiredach, Monasterboice, the figure of Christ wears a suitably embroidered robe and a fine penannular brooch. The soldiers have Viking-style swords and what appear to be short breeches, cut off just above the knee. One seems to have a diamond-shaped brooch or insignia on his chest, not readily matched in archaeology – a diamond-shaped brooch is worn by the Virgin in the Book of Kells.

Some figures on the Cross of Muiredach have small round shields, similar to those found in Pictish art and in the Book of Kells, and a few have conical helmets with nose guards reminiscent of the Anglo-Saxon example from York. Hair is worn shoulder-length, and sometimes in a pigtail. Apart from swords and shields, spears are represented. Horsemen use bridles, for example on the Market Cross at Kells. Chariots appear on the cross at Ahenny and the Cross of the Scriptures at Clonmacnois. These have prompted vigorous debate, since chariots do not appear to have been widely used by the Celts at this period, yet these seem to be indigenous, not copied from manuscripts or other models.

Among other details, mention may be made of chairs with animal carvings on their backs, and animal-prowed ships representing Noah's Ark. These sometimes have windows in the side, for example on the Broken Cross at Kells. Musical instruments include harps and horns, similar to those on Pictish monuments. Clerics are shown with croziers, books and sometimes bells, frequently with a clapper which extant bells lack. An interesting pillar from Banagher, Co. Offaly, shows a deer caught by its foot in a trap.

Ninth-Century Crosses

One group of crosses is usually termed the Bealin Group, after an example from Bealin, Co. Westmeath. This cross is distinguished by its lack of figural ornament on one face, linking it with the Ahenny group. It bears an inscription requesting the viewer to 'Pray for Tuathgall who caused this cross to be made'. He has been identified with an Abbot of Clonmacnois who died in AD 810 or 811. The ornament is cruder than on the Ahenny Crosses, but it still has a family resemblance to them.

The cross at Moone, Co. Kildare, is carved of granite, and displays a see p. 184

forceful crudity in its ornament. Tall and slender, the iconography is concerned with both Old and New Testament subjects. Bodies are square and small, detail is kept to a minimum. Current opinion dates it to the mid-ninth century.

Cross-Slabs

One group of slabs was often, in the past, seen to be of the seventh or eighth century, but is now thought more likely to be a ninth-century archaism. These are all found in Co. Donegal and comprise the interlace-decorated cross-slab from Fahan Mura and the slab from Carndonagh, where the cross seems to have just escaped from its slab. The Fahan slab has projecting tenons and pointed top – two features encountered in Pictish sculpture – and flanking low-relief figures. Similar relief work decorates the Carndonagh monument, which depicts Christ in Majesty on the shaft.

The richly decorated crosses of the tenth century are heralded by the cross at Durrow which may be of the ninth. It has a large figure of Christ in the centre, an angel blowing a trumpet, and a human head, perhaps symbolizing the human race, below. David the harpist appears on one arm.

Tenth-Century Crosses

The finest of all the High Crosses comprise two at Monasterboice, the South and West (the South Cross is also known as the Cross of Muiredach), and the Cross of the Scriptures at Clonmacnois (p. 188). They bear inscriptions which point to a tenth-century date.

The Cross of the Scriptures, Clonmacnois, is a complex monument, with a shrine-shaped capstone and truncated pyramid base, which bears depictions of charioteers. The figural work is in high relief, and includes the now mandatory Christ on the centre of the crossing.

The finest of them all, however, is the Cross of Muiredach at Monasterboice (p. 189). It displays the Last Judgement, with St Michael weighing the souls while being harassed by a devil; the Mass of the Saved; the Adoration of the Magi, and a variety of other scenes. At the base of the shaft two cats swallow birds and frogs.

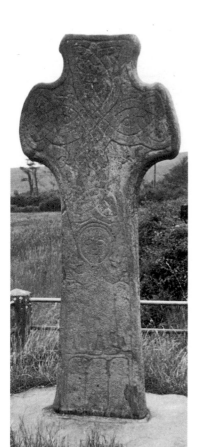

Cross slab, Carndonagh, Co. Donegal (Green Studio)

The Carolingian Dimension

The Holy Roman Empire was founded when the Frankish king, Charles (Charlemagne), was crowned emperor on Christmas day, AD 800. The Carolingian court became a focus for a classical revival. The imperial palace at Aachen was modelled on classical buildings, and Charlemagne gathered about him men of learning from all over Europe, among them English monks such as Alcuin. Artists turned to Antique manuscripts, ivories and sculpture for inspiration. One of the several schools of Carolingian art, the Court School, began by producing manuscripts strongly influenced by Insular traditions, but gradually, as the Carolingian renaissance advanced, Carolingian art became increasingly classical.

Ireland kept in fairly regular contact with the Carolingian world in the early ninth century. Irish annals record both the death of Charlemagne

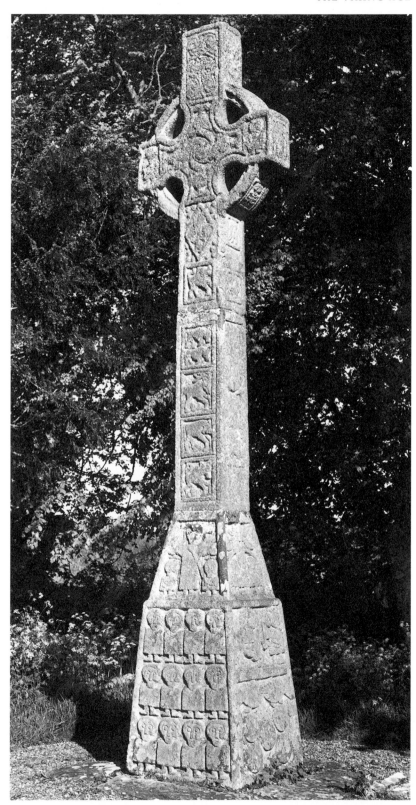

Moone Cross, Co. Kildare (Irish Tourist Board)

and his successor, Louis the Pious. Charlemagne's artists did not make extensive use of biblical cycles, but these became prominent in the time of Louis the Pious. Their use was prompted by a council held in Paris in AD 825, probably following a revival in the use of biblical narrative iconography in Rome under Pope Pascal I (AD 817–824). Biblical fresco cycles were painted in Louis's chapel at Ingelheim (they have not survived) and inspired others at St Gall and Liège. The only surviving cycle of biblical frescoes is at Müstair, Switzerland, where it probably dates from around AD 834.

It was through contact with the Carolingian world that Irish artists began assimilating biblical narrative scenes in the ninth century. Although human figures occur in metalwork and in manuscript art, the area in which this narrative art really makes its impact is on Irish High Crosses, where Old and New Testament scenes, as well as episodes from the Apocrypha, figure, along with more abstract art and subjects from other sources.

About ninety different scenes appear on the Irish High Crosses, ranging from the favoured episodes from Genesis and Exodus, through the later less popular books. The Life of Christ also figures prominently (though, strangely, not the Nativity), and there are sometimes several different renderings of particular episodes, such as the Adoration of the Magi or the Miracle of Loaves and Fishes. In many cases, the iconography can be matched up with representations in the Müstair frescoes, or in descriptions of lost representations. At Müstair for example, can be found the counterpart for the Flight into Egypt that appears on the cross at Moone, or the *Traditio Clavium* that appears on the Cross of the Scriptures at Clonmacnois.

Clearly there were common models behind the Irish High Crosses and the Carolingian cycles. They are unlikely to have been sculptured crosses, since they do not occur in Carolingian Europe, and could hardly have inspired Irish artists so extensively at that remove. Manuscript sources also seem unlikely, given their absence in Ireland. In any case, the relief modelling of the crosses represents work in a different form from the two-dimensional art of frescoes or manuscripts, and a three-dimensional model is more likely. Carolingian ivories were famous, and though few have survived (and none from Ireland) some show sufficient similarities to High Crosses to suggest they may have been one source of inspiration. Dr Peter Harbison, who has made a particular study of Carolingian models for Irish High Crosses, has suggested that stucco work may in fact lie behind the dissemination of the scenes, though again none has survived from Ireland or Britain at this period. He has suggested that stucco crosses may have been carved in Ireland before the stone versions.

Sculpture in Scotland in the Ninth and Tenth Centuries

Pictland remained the dominant region for sculpture in Scotland in the ninth century. Until the Picts were conquered by Kenneth mac Alpin of Dalriada after AD 840 they continued to produce cross slabs with Pictish symbols in relief. After the conquest, the symbols may have disappeared, but a number of notable works of sculpture were still produced.

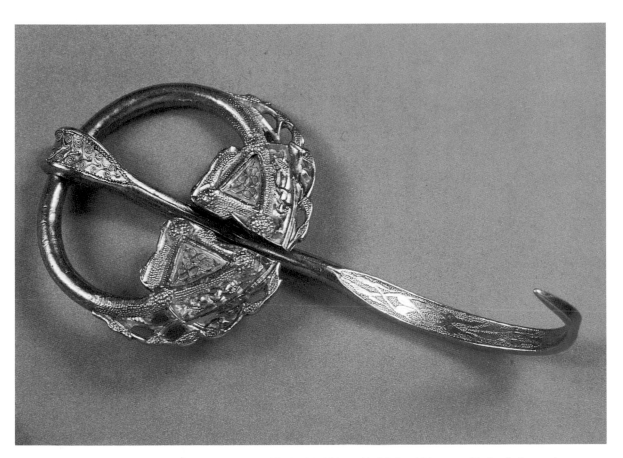

Gold penannular brooch from Loughan, Co. Tipperary (the 'Dalriada' brooch). (National Museum of Ireland). See p. 167

Pictish Life from Sculpture

These Pictish slabs (and the earlier examples of the eighth century) are a
treasure house of information about Pictish life. In contrast to the Irish
crosses, the scriptural ornament is less dominant and formalized, and there
is a wealth of local detail. As with the Irish crosses, however, the most
useful information relates to costume, which is generally not unlike that
found in Ireland, though the breeches are absent, perhaps because they
did not become fashionable until after the Pictish slabs had all but ceased
to be put up. In contrast, Pictish figures sometimes wear hooded cloaks.
Although rare, Pictish women appear on a slab at Monifeith and on the
Hilton of Cadboll monument. They wear long skirts and cloaks or over-
mantles, fastened with penannular brooches. One is shown riding side-
saddle (at Hilton of Cadboll). Their hair is worn shoulder-length, the
Monifeith woman having side bunches. Pictish men have moustaches and
beards, and figures on a probably eighth-century slab from Birsay, Orkney,
have long robes and their hair tied back. Hair can be either long or short.

Horsemen are sometimes shown with saddle cloths and ornate bridles,
though no stirrups. Some warriors seem to be wearing stiff leather jerkins
or in one case chain mail. The weaponry and shields are for the most part
like those on Irish monuments, though a small square shield is found as
well as a round, and they are sometimes shown carried on a strap round
the neck. There is, in addition, a cross-bow depicted on several stones (it
appears to have been used for hunting) as well as long bows and battle-
axes. Sword scabbards are sometimes shown with chapes. Helmets have
nose-guards, and in one case what appears to be a vizor.

Other subjects which appear on the Pictish stones include animal-
backed chairs, cauldrons, hammers, shears, a two-wheeled vehicle with
canopy, and an open boat. This is depicted on a stone known as St Orlands
as Cossans, Angus. On it are a series of figures, apparently transporting
an object similar to a cross-slab. The ship appears to be plank built with
a high prow and rudder; traces of oars can also be discerned. Musical
instruments include blast horns, a barrel drum and what may be a terminal
horn. One Pictish warrior drinks from a drinking horn with bird-headed
terminal.

Pictish Sculptures after the Golden Age

A series of monuments is grouped together as the 'Boss Style'. As the name
suggests, these monuments employ the bosses first seen on the Iona High
Crosses. The monuments are in much higher relief than the eighth-
century works, and are far more richly decorated. The series probably
starts in the late eighth century, and developed from monuments of the
type represented by the Dunfallandy stone. As before, the central subject
is a cross with armpits, flanked by a diversity of human and animal figures.
Where Biblical sources were used, Old Testament scenes were favoured,
particularly episodes relating to Jonah, Daniel and Samson; themes of
salvation were particularly popular, as with other early medieval societies.
In addition, the hermit saints, Paul and Anthony, make not infrequent
appearances. The sources for the figural work were very varied – manu-

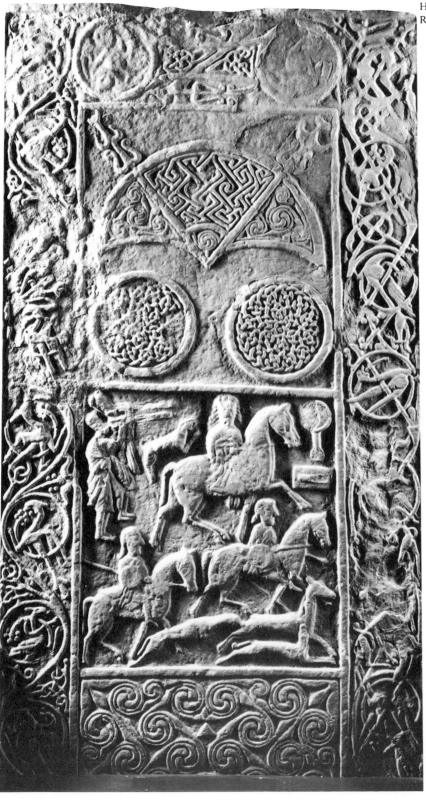

OPPOSITE South Cross, Clonmacnois, Co. Offaly (Green Studio, Dublin). See p. 171

RIGHT South Cross of Patrick and Columba, Kells, Co. Meath (Green Studio). See p. 171

scripts certainly were the main inspiration, but ivories may also have contributed. Some of the subject matter, such as hunt scenes seems, however, to have been a Pictish speciality, and details appear to be derived from contemporaneous Pictish life, not from the imported models. Influence has been discerned from Northumbria and Mercia in the art of these cross slabs, though other influences show that the tradition was in the mainstream of contemporaneous European art. The figures for the most part float in space with no real attempt at background – stacked or 'cavalier' perspective (figures put higher up to indicate that they are further from the viewer) may have been employed on occasion.

No fewer than thirteen types of cross are found on these slabs, some peculiarly Pictish. The interlace is similarly varied, with some indication that there were local 'pattern books' for regional centres of carving.

One monument, St Vigeans No. 7, Angus, of the late eighth or early ninth century, illustrates the characteristics of what is known as the 'Early' Boss Style. It has unfortunately been cut down at some stage, damaging the rich overall decorative scheme, but it still displays an interlace cross with running scrolls, each a Durrow spiral of alternating animal and human heads. The figural work includes an intriguing depiction of a man being dropped head first into a cauldron, the hermit saints and a figure apparently about to sacrifice a bovine.

The later Boss Style is well represented by three very large slabs, all probably of the early ninth century. The first, over 3 metres (10 feet) high, is now located beside a road at Aberlemno, adjacent to an early incised symbol stone. The Aberlemno Roadside Cross, as it is therefore called (to distinguish it from the earlier Aberlemno Churchyard stone), has a cross on the front with square bosses, rather like the mounts on the Monymusk reliquary, and is flanked by two hovering angels with books. On the back are scenes from the story of David, including a hunt and trumpeters.

Related in style, and apparently drawing on the same iconography, is the Hilton of Cadboll stone. This is perhaps the finest of the Boss Style slabs, and is slightly smaller, 2.5 metres (8 feet) high. Given the similarities to Aberlemno Roadside, it was rather surprisingly found many miles to the north, in Easter Ross. The cross side is badly defaced, but the back has a frame of vinescroll inhabited by Mercian-looking birds, with an intricate panel of interlocked Durrow spirals at the bottom and ornate symbols (double disc, crescent-and-V-rod) with two interlaced circles beneath. In a panel is a hunt scene with a lady accompanied by her partner (whose nose and beard are just discernible in the background). The symbols are those found on the Aberlemno Roadside slab, and there are once again the trumpeters from David iconography.

These are not the only fine early ninth-century monuments. The Nigg slab from Ross has snake bosses with a scene at the top taken from the story of Paul and Anthony. On the back is David iconography. Some of the patterning on the cross recalls Mercian work. The Nigg cross also displays features shared with the Book of Kells.

Displaying equally deep carving, the St Andrews Sarcophagus or Shrine has claims to be one of the finest sculptures from early medieval Europe. It belongs to a family of stone slab-shrines, some of which had

Nigg slab, Ross and Cromarty (Tom Gray)

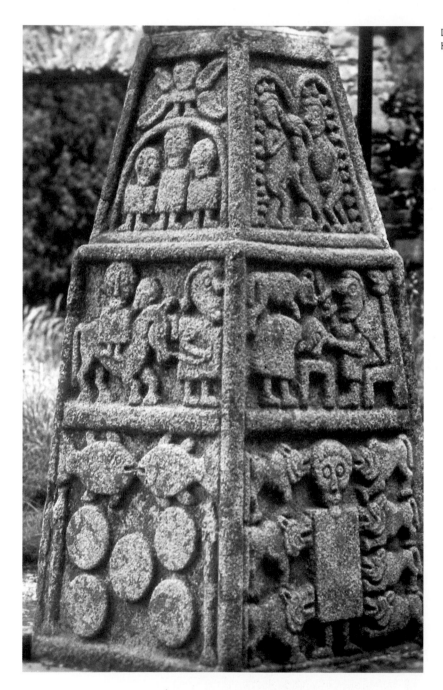

Detail of base of the Moone Cross, Co. Kildare (Green Studio). See p. 173

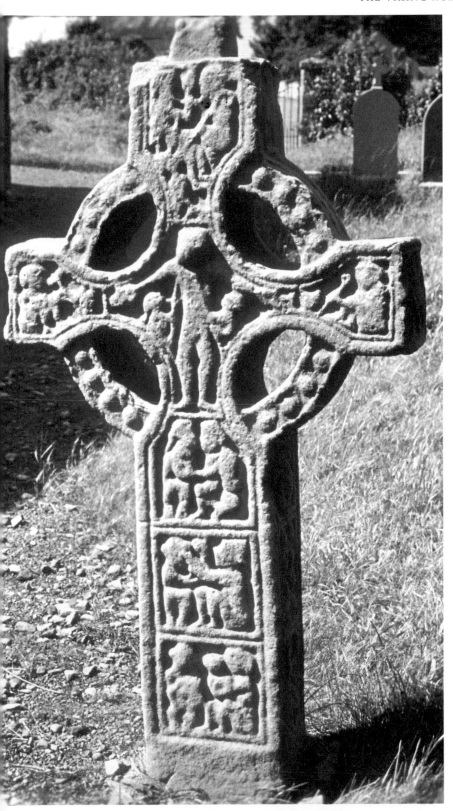

High Cross, Duleek, Co. Meath (Green Studio)

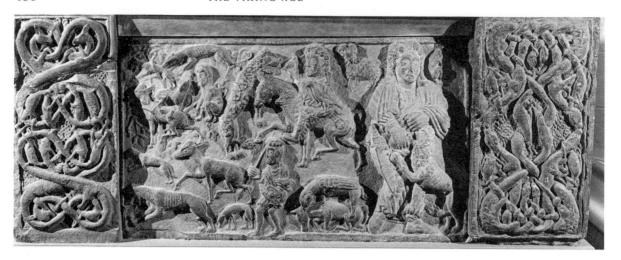

St Andrews sarcophagus, St Andrews, Fife (Tom Gray)

gabled roofs, that are found particularly in Scotland and Ireland, though they were also used in Northumbria. It was probably made for a relic of St Andrew. It was found buried in the churchyard in 1833, where it had probably been deposited during the Scottish Reformation. Originally it had four panels slotted into rectangular corner posts. The front panel survives, with complex David imagery and some foliage 'landscape'. The corner posts are decorated with intertwined animals, and one of the end slabs has snake bosses and oriental-looking monkeys.

An extremely tall slab 6.5 metres high (21 feet), known as Sueno's Stone, covered on the back with figural work, stands near Forres, Elgin. The front has a cross covered in tight interlace, the back seems to record a battle, perhaps that in which the Scottish king Dubh was killed by the men of Forres in AD 966. The date seems appropriate, as the cross shows features in common with the Cross of Muiredach at Monasterboice. The iconography of this monument is complex to decipher, but seems to include the representation of a broch tower, current in the northern Scottish Iron Age and rows of beheaded prisoners.

Galloway can boast a group of crosses with wheel heads known as the Whithorn School Crosses – the best are the Kirkinner Cross and one from Whithorn itself. They probably date from the tenth century, and have monotonous interlace, often two-strand. They are related to comparable Viking-age monuments in the Isle of Man.

Ninth and Tenth Century Sculpture in Wales and the Isle of Man

Although the Norse sculpture of the Isle of Man is generally better known than the pre-Norse, it has already been noted that fine sculpture was produced in Man in the eighth century, and there are some notable examples of the ninth or tenth. Of these, mention may be made of the cross at Lonan just outside Douglas, which has a wheel-head in a general style not unlike some Welsh monuments of the late ninth or early tenth century. A Welsh connection is perhaps implied by the inscription on the 'Crux Guriat'

stone from Maughold, a monastery with an impressive array of stones. Guriat is probably Gwriad, a Welsh prince who came to Man around AD 825. Like most of the Manx monuments, it is a relatively simple cross-slab.

There is a considerable diversity in Welsh ninth- and tenth-century monuments. Both cross-slabs and freestanding crosses are found in Wales at this period, and regional variations can be found. Although there are a large number of monuments, the quality of most is not high, though there are a few notable works. As a whole, Welsh sculpture is very ecclectic, and influences can be detected on individual stones from Irish, Mercian, Northumbrian and Scandinavian traditions.

It is possible to distinguish schools of sculpture, based on particular monasteries. Particularly noteworthy is the Carew School, based in Pembroke, which was operating in the tenth to eleventh centuries and specialized in tall, wheel-headed crosses with tall, splayed shafts, the head connected to the shaft with a tenon joint. Also noteworthy, though it is more a style than a school, is that centred on Margam, Glamorgan. The Margam crosses (there are eleven) are disc-headed with wide shafts, six coming from Glamorgan.

In general terms, the ornament on the Welsh sculptures is limited in its range. Interlace, key and fret patterns predominate. Animals are rare – the best appear on a broken cross-shaft from Penally, Pembroke, where pairs of confronted creatures seem derived from Northumbrian ninth-century tradition. Human figures are not unduly common, either. The commonest subject is the Crucifixion, though the Visitation can also be found, as well as the Temptation of St Anthony, the Meeting of Paul and Anthony, angels and praying figures – orantes – with uplifted hands.

A couple of examples can serve to illustrate the range of Welsh sculpture. Conbelin's Cross at Margam has an inscription explaining that he set it up. It is a disc-headed cross, not unlike that at Lonan, with a cross head with double-square armpits, a type common in Pictland. At the base of the shaft are two figures, probably St John and the Virgin, and it stands on a carved, rectangular base. A date in the tenth century is likely. The Cross of Hywel ap Rhys at Llantwit Major is interesting both for the high quality of its key patterns and for the inscription which shows it was set up by this king of Glywysing, who died in AD 886 and was a client king of Alfred the Great. It may have been the work of an immigrant Irish sculptor. The Carew Cross can also be dated by an inscription, recording that it was set up in honour of Margiteut – King Maredudd who was killed in 1035. It is a tall, composite monument, with a small wheel head and weak interlace and other patterns.

Ecclesiastical Metalwork

Among the pieces of ninth-century ecclesiastical metalwork is a group of openwork crucifixion plaques, of which the best is that from Clonmacnois.

The ninth-century Prosperous Crozier from Co. Kildare is typical of Irish croziers generally, in that it was furnished with knops and a straight drop. The top knop is asymmetrical and it employs yellow enamel in a chequer pattern, not unlike patterns in the Book of Kells. The knops have

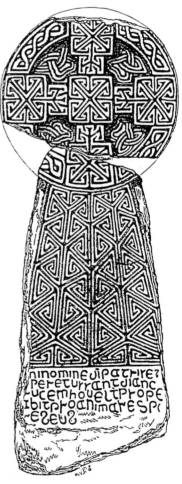

Cross of Hywel ap Rhys, Llantwit Major (drawing, prepared for J. Romilly Allen)

OPPOSITE Cross of Scriptures, Clonmacnois, Co. Offaly (Green Studio). See p. 174

LEFT Cross of Muiredach, Monasterboice, Co. Louth (Green Studio). See p. 174

inset panels with false-relief meander pattern. There is interlace, and the crest takes the form of eleven birds in procession, ending with a creature with a fish in its jaws. There is also a human head with 'horns' just before the drop.

To the end of the ninth century can be assigned the so-called 'Kells' or British Museum Crozier and the Croziers of St Dympna and St Mel.

The 'Kells' Crozier (better known as the British Museum Crozier, as 'Kells' is a fanciful invention), can be taken along with the Croziers of St Dympna and St Mel as examples of a new style of ornament which began to make itself established in Ireland in the ninth century. This involved using small squashed animals in irregularly-shaped fields. Although the device has been seen as an Anglo-Saxon contribution to Irish art of the ninth century, it is likely that it developed out of earlier animal ornament in Ireland, though there may have been some contribution from England.

'Kells' crozier (Copyright British Museum)

Epilogue

BY THE ELEVENTH CENTURY, the political arena of western Europe had changed considerably. The Vikings had made onslaughts in France (settling in Normandy) and in England, as well as the Celtic world, and eventually the Danelaw was established in northern England. In 1066, however, the former Vikings of Normandy invaded in their guise as Normans, and Anglo-Saxon England became Norman-French.

Malcolm III of Scotland (which was now a unified force), married an English princess (later St Margaret), and the process of anglicization began. David I, who came to the Scottish throne in 1124, introduced Anglo-Norman nobles into Scotland, giving them most of the high offices of state, and Norman motte towers spread through the land. Feudalism became the basis of society.

In Wales, the process of Normanization began with William I, who introduced Norman lords at Chester and Shrewsbury to control the Marches. The Normans gradually infiltrated the coast of South Wales, and along the north as far as Rhuddlan. A pattern of villages grew up in South Wales on the English model, and gradually Norman penetration was effected inland by way of the river valleys of central Wales. As in Scotland, mottes spread across the face of the land. Independent Wales came finally to an end with Edward I's defeat and the death of the native king, Llewellyn Fawr, in 1283.

In Ireland, the Norman-English became increasingly involved in Irish affairs from the start of the twelfth century, at which time, as the excavations in Dublin have shown, the focus of Irish trade became directed increasingly towards England and France. At the same time, major reforms were put underway in the Irish Church, which again were partly driven by contacts with England and France.

The Norman-English invaded Ireland in the year of 1169. The invasion was not like the Norman Conquest of England, for the social structure in Ireland did not lend itself to the same kind of takeover, but nevertheless the impact was immense. Having landed in Wexford, by 1200 the Normans had captured much of the south and east of the country, and the military conquest went hand-in-hand with the building of mottes, and, from 1200 onwards, stone castles. Between 1170 and 1300 approximately two-thirds of Ireland was divided up on an English manorial basis.

There is very little Celtic art in Scotland after the tenth century, and

Kildalton, Islay, West Highland cross (Jenny Laing)

equally little in Wales, though both areas produced some dreary sculpture with loose interlace. In Scotland it was not extinguished for ever, however, for in the Western Isles in the later Middle Ages it enjoyed a distinctive revival.

In Ireland, somewhat surprisingly, there was a 'twelfth-century renaissance' in art, during which the Viking styles, particularly Ringerike, became assimilated into the Irish repertoire, along with various elements derived from England. This hybrid art can be seen in metalwork, sculptures and manuscripts.

For the first time in Celtic art, dates are available for particular works of art in Ireland, and sufficient material survives for it to be possible to group it into regional schools. The inscriptions that provide the dates also provide the names of patrons, and sometimes even of artists.

A few examples may suffice to illustrate the trends at work in twelfth-century Irish art. It seems likely that the custom of erecting stone crosses may have died out in parts of Ireland, at least in the eleventh century; in the late eleventh and twelfth there was a revival of the tradition in the western part of the country. Inscriptions provide information about the patrons, who were both kings and clerics. The Dysert O Dea cross, Co. Clare, is typical of the monuments of this period. It lacks a ring, and bears in high relief a representation of the crucified Christ in a long robe. Beneath is a mitred bishop with a crozier with a curled crook. Both the mitre and the crozier show the influence of contemporary European trends, and the high-relief modelling recalls Romanesque metalwork.

In metalwork, there are a number of major works of which the Lismore Crozier, the Shrine of St Patrick's Bell, the Shrine of St Lachtin's Arm and the Cross of Cong are the most significant. A number of techniques distinguish the metalwork of the period – a popular device was the setting of plaits of red copper and silver wire into grooves, which were polished to give a two-colour, rope effect. It was a device developed in Gaul and in Scandinavia, and came late to Ireland. Another technique involved setting silver ribbons into grooves with bands of niello (a black silver-sulphide paste) on either side. It may have been a Byzantine technique originally, and can be seen on the Shrine of St Lachtin's Arm. Enamelling continued, red on yellow being favoured. Filigree was still employed, but was coarser.

The Lismore Crozier (1090–1113), which was found walled up in Lismore Castle, has a magnificent crest in the form of openwork animals, with a further animal head. The shaft of the crozier is smooth, but there is also decoration on the knops, which have lattice-like, openwork bronze, and circular settings for enamel at the crossings, in red, blue and white. The animal ornament betrays Viking origins, with elements of Ringerike and, more particularly, Urnes (a later style with pronounced tendrils).

The Shrine of St Lachtin's Arm (1118–1121) is one of two arm shrines from Ireland, and comes from Donaghmore, Co. Cork. It takes the form of a forearm with a clenched fist, and comprises a wooden core with sheets of metal fastened with binding strips. Apart from the fingernails, every available space is covered with ornament, mostly a type of interlace derived from the Viking Urnes style.

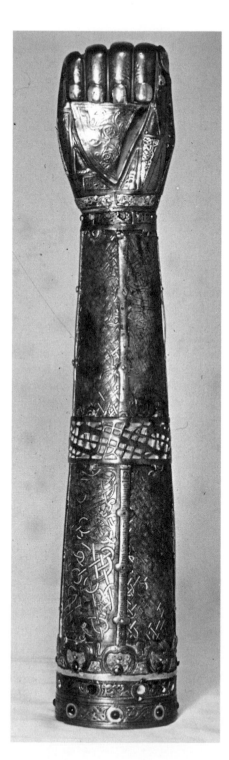

LEFT Shrine of St Lachtin's Arm
(National Museum of Ireland)

OPPOSITE Cross of Cong (National
Museum of Ireland)

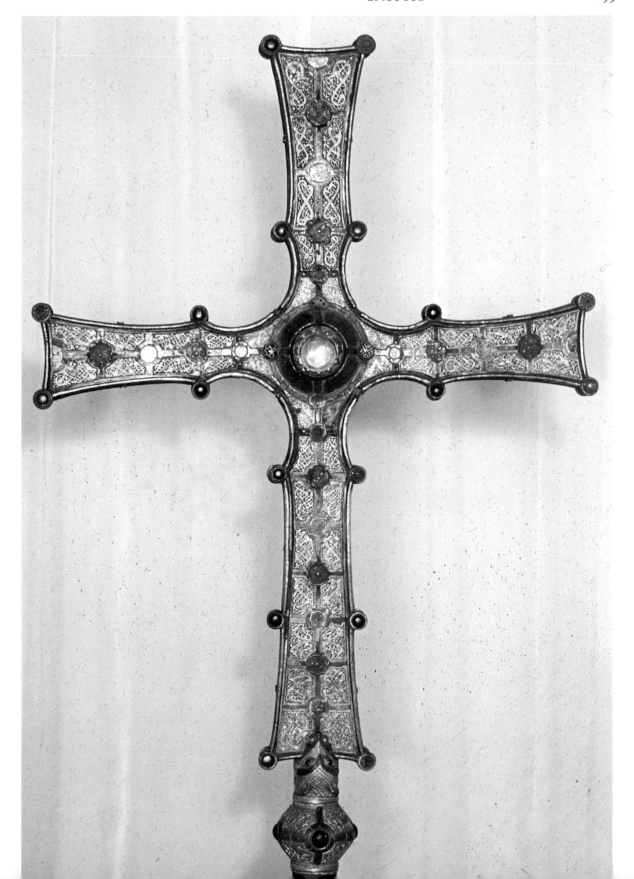

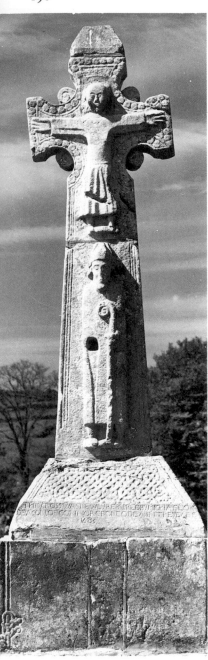

Dysert O Dea Cross, Co. Clare
(Commissioners of Public Works,
Ireland)

The Cross of Cong is a processional cross of the type found in Romanesque Spain. It was made to house a relic of the True Cross, preserved under a rock crystal dome on the crossing. It takes its name from Cong in Co. Mayo. It is made out of bronze plates, and is covered with Urnesstyle interlace.

Many pieces of metalwork were remodelled at various periods in the Middle Ages, and tend to be a pastiche of styles. The Shrine of St Patrick's Bell (1094–1105), is perhaps the most visually satisfying of these multi-period works. It was made in the late eleventh century to contain an iron bell, traditionally associated with the saint (the bell survives), and comprises a box made of bronze plates held together with binding strips. Once again Urnes-style ornament predominates, with a fine Urnes crest. The filigree is elaborate. Later in the Middle Ages it was embellished with tasteless cabochon jewel settings.

Several Irish manuscripts of the twelfth century survive, but although the colours are bright the ornament is often uninspiring, showing both Viking and English influence. Two are of exceptional interest, however, the Corpus Missal and Cormac's Psalter, the latter named after the scribe who produced it. This tiny manuscript is a superb late flowering of Celtic art, and with its occasional use of a rich, dark-red background and intricate interlace, looks back from the shadow of the Norman conquest to a more Golden Age.

Wales was the setting for the production of the Psalter of Rhigyfach (Ricemarch). This book was produced by the son of a Welsh scribe who had been trained in Ireland, where he had lived for several years, and had mastered the Irish version of Scandinavian Urnes ornament. The book dates from the end of the eleventh century, and is interesting for the light it sheds on intellectual life in Wales at this period.

After the Normans

The impact of the Normans had irrevocable effects on both England and the Celtic lands. Possibly the greatest challenge the Celts had ever had was to give up what the Romans referred to as barbarian ways (an Iron Age society with all its trappings). The process was not easy.

> The inhabitants stick close to their ancient and idle way of life; retain their barbarous customs and maxims; depend generally on their chiefs as their sovereign lords and masters; and (are) accustomed to the use of arms, and inured to hard living ...

Those words could have been penned by any commentator writing about the Iron Age or Dark Age Celts, but they are in fact the words of Duncan Forbes, writing of his fellow Scottish Highlanders in 1745.

In the west Highlands and islands of Scotland, divorced from and in opposition to the kings of Scotland, there flourished in the later Middle Ages the Lordships of the Isles. From their island stronghold, at a loch at Finlaggan on Islay, they ruled as Celtic chiefs had done at the head of their tribes in centuries gone by. They were Christian chiefs who

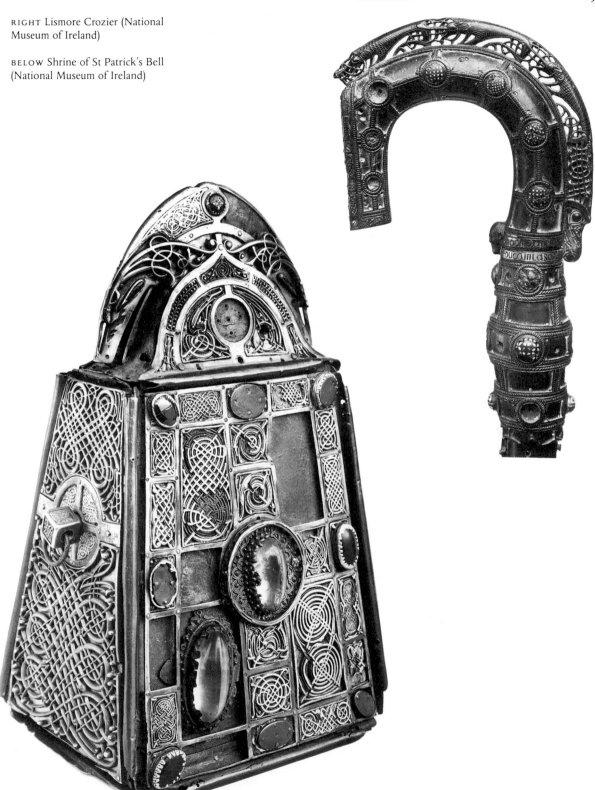

Cormac's Psalter
(The British
Library).
See p. 196

OPPOSITE Psalter of Ricemarch
(Trinity College Library, Dublin)

maintained their own fleet, and when they died they and their followers were commemorated with magnificently-carved tombstones.

In the art of these west Highland monuments, elements came together of both the traditions of medieval, feudal, funereal effigies and the native Scottish past. Free-standing crosses carry on the tradition begun at Kilnave, their heads intricately adorned with complex interlace patterns, and their shafts displaying foliage designs which echo the vinescroll of Dark Age monuments. They are scattered through the Western Isles from Islay to Lewis, and along the mainland from the Mull of Kintyre to Inverie in Knoydart. Over eighty of the sculptures can be found on Iona, but there are other major concentrations, for example at Kilchoman on Islay, or at Oronsay priory.

They are the products of different schools of sculptors who travelled from their centres to carve works in their own traditions when and as they were needed, though local sculptors also produced their own versions of the art. They span the fourteenth, fifteenth and sixteenth centuries and depict local costumes and armour, and on occasion details of ships or everyday objects. Inscriptions help to identify the deceased, and date the monuments.

Apart from these sculptures, there is little else to suggest a flourishing art in the later Middle Ages in the west of Scotland, though whalebone, ivory caskets (the Eglinton and Fife caskets) and some ornament on 'Queen Mary's Harp' show that the sculptures cannot have been the only works in the tradition. In Ireland there were similar echoes in the Late Middle Ages and post-medieval centuries of Celtic tradition, though nothing that could be regarded as a truly Celtic Art.

So why has Celtic art exerted a fascination over modern minds? In every tourist shop from Penzance to Kirkwall, and Cork to Rhyll, we are offered delectable goods with the unmistakable Celtic flavour. Part is simply nostalgia, but there is a further factor which may be playing a part. The Celtic lands are once more part of a widespread and dynamic European network in the European Community, just as they were in their first Iron Age flourishing. The routes to commerce and trade are open as they were after the Roman period and during the Golden Age. Perhaps the sudden flourishing of Celtic art is simply the Celtic artistic spirit responding, as so often in the past, to outside challenges.

Gold stater of Dubnovellaunus of the Catuvellauni, with design explained (photo: Chris Rudd; drawing: Lloyd Laing). See p. 214

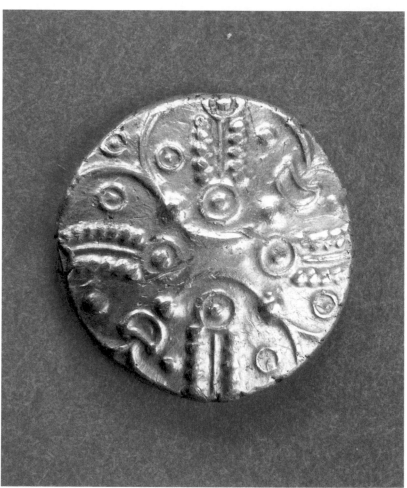

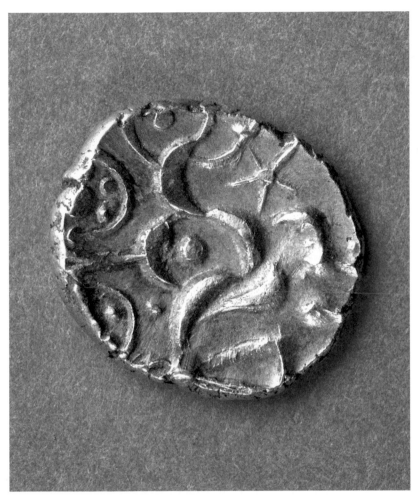

Gold stater of Corieltauvi, with design explained (photo: Chris Rudd; drawing: Lloyd Laing). See p. 214

The Language of Celtic Art

Abstract Celtic Art

Peculiar to the Early Iron Age is the use of the lotus bud and the palmette. Originating in Greek art (where it had been borrowed from Oriental art), it was assimilated into the Celtic repertoire on the Continent and thence reached Britain. Formal **lotus-buds** appear in the fifth-century BC art of the Continental Celts and by the fourth century BC had acquired lateral tendrils. In Britain, lotus-bud ornament is comparatively free-flowing and innovative. As the motif evolved, it became a lop-sided mushroom, with curling ends which sometimes look like snail shells, sometimes fleshy bulbs. In one form they can appear like bird heads, for example on the Torrs pony cap (p. 45).

The **palmette**, again of classical origin, was probably introduced to Continental Europe on imported, Etruscan wine flagons: part of one has been found in Britain, at Minster, Kent. In its most typical form the palmette in Celtic art is enclosed by two S-scrolls (an arrangement termed a lyre scroll). The design became simplified, and turned into what has been called the 'decapitated palmette', seen for example on the Brentford 'horn cap' (p. 44). In Celtic art, palmettes and lotus-buds are often closely related, and stylistically can merge with trumpet patterns.

In its classic form the **trumpet pattern** tapers to the 'mouthpiece' which is curled around a boss. Trumpet patterns can be found 'confronted', that is to say, joined mouth to mouth, or can be linked – joined at the mouthpiece ends. Some have domed 'caps'.

A fourth element is a swollen leaf with a stem ending in a scroll; sometimes it is termed a **comma** motif or **lobe pattern**. It sometimes looks like a bird head, and probably gave rise to the 'dodo' heads of Dark Age art.

One other major element completes the repertoire of basic motifs in Early Iron Age art – the **triskele**, a motif which has three arms springing from a common centre. It is fairly ubiquitous in the Iron Age, and very much more so in the Dark Ages; in both periods it can be simple, or elaborated in a number of ways – the legs, for example, can acquire animal heads for 'feet'. A related pattern is the four-legged version, the 'swastika'.

A variety of lesser elements occur – voids, circles and sub-triangular forms, and occasional devices such as the 'berried rosette' and 'swash-N', both of which appear at the end of the pre-Roman Iron Age. The **swash-N** is the most distinctive. It is found predominantly on casket mounts and related pieces of the Early Roman period. It also occurs, for example, engraved on ritual spoons from Ireland, where it may have been inspired by imported 'casket' pieces. It can be seen in the decoration of seal box lids of Roman origin, of which the best example, with enamelling, comes from Lincoln. In pure, casket form the Swash-N can be found on an armlet

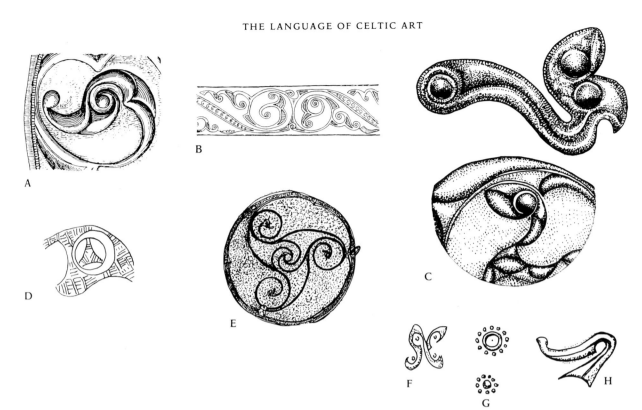

from Plunton Castle, Kirkcudbright, where it is combined with punched dots, and on the Stichill collar from Roxburghshire.

A minor element, used for infilling, is the strangely named **spherical triangle**. In Britain it is comparatively rare in Iron Age art (tending to be mostly late in the period), but it is much more common in the Dark Age/early medieval period.

In Dark Age/early medieval Celtic art, many of the old elements can be found in slightly new guises in addition to new elements. The palmette and lotus-bud motifs became the simple symmetrically balanced **pelta**. Trumpets and confronted trumpets continued, and spirals, which were relatively rare in the Iron Age except in the earliest engraved work, became common, with the appearance of a new type of spiral, the '**Durrow spiral**', which is essentially a whorl converging on a common centre, and the '**yin-yang**', which is found only as part of a more complex design in Iron Age art. The 'dodo' head is a lobe with an eye, often found in the centre of a spiral or flanking a pelta.

A feature of Dark Age Celtic art is the use of complex **linked spiral ornament**. Romilly Allen (d. 1907) was the first to study Celtic ornament in any detail. He pointed out that there were only two elements in all Dark Age spiral ornament – they were based on the C-scroll and the S-scroll, which joined adjacent spirals and could be used separately or together as part of the same design. The result was a great diversity of ornamental schemes, in which spirals could be in borders; in panels with two or more rows of spirals; in square panel patterns; in roundels; in mirror-image arrangements and in semi-circular, crescent-shaped and triangular spaces.

Design elements in Iron Age Celtic art (A–B) lotus bud motif (A) on Torrs, Kirkcudbright, pony cap (B) on Toome scabbard, Co. Antrim (C) petal-and-boss on Tooley St, London, horse trapping and detail from Llyn Cerrig Bach, Anglesey, roundel (D) concave-sided triangle, Trelan Bahow, Cornwall, mirror (E) triskele, Bann Disc (F) swash-N, Plunton Castle armlet, Kirkcudbright (G) berried rosette, Elmswell, Humberside, mount (H) broken-backed scroll, Moel Hirradug, Clwyd, plaque (drawings: A, B, D, H. E. Kilbride-Jones; C, Priscilla Wild; E, Tasha Guest; F, G, H, Lloyd Laing).

Gold 'Cheriton' stater of Durotriges,
with design explained (photo: Chris
Rudd; drawing Lloyd Laing). See
p. 214

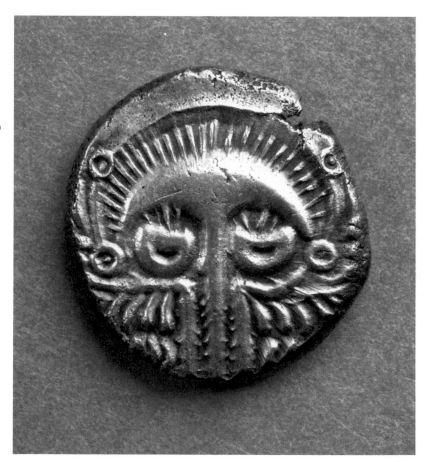

Battersea Shield (Copyright British Museum)

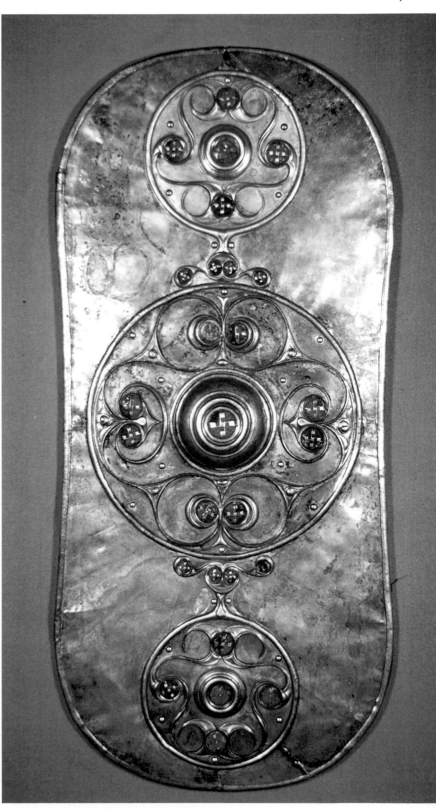

Design elements in Early Christian
Celtic art. (A) method of making
breaks in interlace (B) regular plait-
work without breaks (C) eight-cord
plait employing Allen's knot type 7
(D) fret patterns from Gattonside,
Roxburgh and St Andrews, Fife
(E) circular knotwork, Monasterboice,
Co. Louth (F) Durrow spiral patterns,
Book of Durrow (drawings: after
J. Romilly Allen)

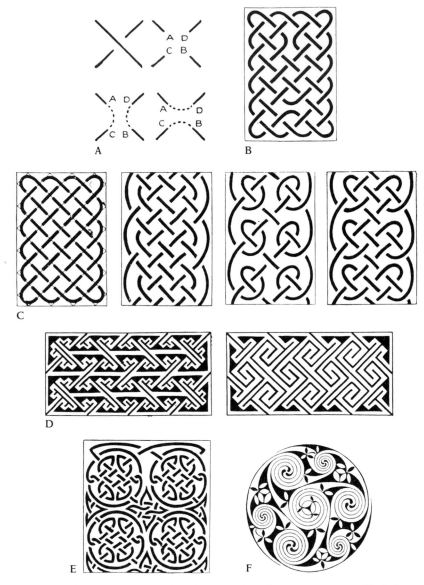

On to this basic repertoire, three major elements were grafted from
the sixth century onwards: interlace, key and fret patterns, and animal
ornament.

Of these, **key**, **step** and **fret** patterns are the easiest to define. With the
exception of step patterns, which are found on occasion in the Iron Age
and belong to a European prehistoric past, they originated in the classical
world, where **key** patterns employing a 'square spiral' were laid out in
straight horizontal lines. The Celts (and the Anglo-Saxons) diverged from
this, and used diagonal key patterns and diaper key patterns. As Romilly
Allen noted, the first stage was to turn the Greek or Roman fret through
45 degrees, as was done for example in the Lindisfarne Gospels. This left
triangular spaces round the edge, which were filled by bending the ends
of the diagonal lines round through 45 degrees to make them parallel to

the edge. In the final stage, seen for example on a Pictish slab at Farr, Sutherland, the opposite ends of the diagonal lines in the middle of the panel were bent round in a similar manner. The sharp corners were infilled in various ways. Key patterns are mostly found in sculpture, though they appear on some pieces of metalwork, such as the Athlone (Rinnigan) Crucifixion plaque. Techniques for creating them all involve square grids which can then be broken up with diagonals.

Interlace is the most typical ornamental device used by the Dark Age Celts. It can be categorized according to its complexity into regular plait-work, broken plaitwork, knotwork, circular knotwork, triangular knot-work and chainwork. The origins of interlace in Celtic art have been hotly debated. Symmetrical interlace was common in the Roman world, and survived in the Christian Mediterranean to appear in many contexts. Animal interlace seems to have developed independently in several areas in Europe in the sixth century, though there may have been some inter-action between areas. In the Celtic world, non-zoomorphic interlace appears on a mould for a sixth-century sword mount from Rathtinaun, Co. Sligo, and on late sixth/early seventh-century moulds from the Mote of Mark, Kirkcudbright. Whether this is due to influence from Anglo-Saxon England or, as is more likely, directly from the Continent, cannot yet be resolved; nevertheless, the influence of Anglo-Saxon art over the Celts cannot be doubted.

The interlace of the Early Christian Celts is distinguished from that of the Romans by the use of what Romilly Allen termed 'breaks'. These are first encountered in Coptic Egypt, for example in wall-paintings at Bawit, or even on textiles. Celtic manuscript interlace features colour changes within a single cord as, for example, in a manuscript of the fourth to early fifth century, now in the Pierpont Morgan library in New York; it is known as the Glazier Ms 67. Allen thought breaks were an invention of Lombard Italy in the eighth century, which is clearly too late given the Egyptian examples now known, but they appear in Celtic interlace much earlier, being apparent on the moulds from the Mote of Mark, Kirkcudbright, in the late sixth to early seventh century. They could have reached the Celts from Egypt, but equally it may be that they were a separate discovery by the Celts.

Interlace can be created by drawing a diagonal grid. Then, by joining the corners and turning the angles into loops, a regular pattern of plait-work is produced. The next stage is to cut out the crossings, then loop together the pairs of loose ends. In the diagram, A can be joined to C and D to B, or A can be joined to D and C to B. To create symmetrical designs, patterns have to employ four, six or ten cords. Allen argued how this was done to create a diversity of designs, illustrating from the various arrange-ments on Welsh crosses. If the breaks are made regardless of symmetry, interesting variations can be produced, and if they are made symmetrically and brought close together the result is a pattern of knotwork.

When two horizontal breaks and two vertical breaks are made along-side each other in a plait, the resultant design is a cross. Cruciform breaks were employed with some frequency in Celtic art, with very satisfactory results.

Ancient artists, however, employed other methods of creating interlace. One involved using a perpendicular grid, such as was employed in the Lindisfarne Gospels. Another made use of compass layouts, a feature that was common in western Mediterranean art. Thus, in the first cross carpet page in the Book of Durrow a simple grid of squarish rectangles was laid out, with crossings to provide the guides for the interlace. In the top and bottom panels, however, the artist used compass work, by constructing circles which he turned into figure-of-eight knots and X-shaped plaits.

There are eight types of **knot**, created using three- and four-cord plaits. Circular knotwork, which is found in manuscripts and sculpture but not in metalwork, was generally a feature of personal taste in Scotland and Ireland. Triangular knotwork was similarly favoured in Scotland and Ireland; in this, interlace was created where the setting-out lines formed only triangles, or triangles and lozenges. Chainwork and ringwork were mostly a feature of the Viking Age.

From the seventh century onwards, Celtic artists became familiar with **vinescroll** ornament, which was ultimately of Mediterranean origin. It was popular in Anglo-Saxon England, for example on the Northumbrian cross at Ruthwell, Dumfriesshire.

Naturalistic Celtic Art

Celtic art is usually seen as concerned with abstract ornament, but throughout its history naturalistic or semi-naturalistic representations occur. These are primarily of animals though human figures also occur, particularly in the Early Christian period.

In Early Iron Age Celtic art human faces and animals, usually birds, appear in various guises. The earliest human representation is probably a tiny face in one of the lentoid voids on the Torrs horns; a human face also stares out on the terminal of one of the gold torcs, or neckrings, found at Snettisham in 1990. Ambiguous human and animal masks recur in Iron Age art (for example on the Battersea Shield, p. 207). In addition, there are a number of naturalistic (or at least recognizable) animals: the presumably Hallstatt bronze boar from Westingdean, Sussex; the lost boar that once adorned the Witham Shield; the models of animals such as the Hounslow boars; and human and animal heads attached to buckets and other objects. Also naturalistic are the human and animal figures on coins. As the Westingdean boar suggests, this is a tradition of representational animal ornament which predates the development of La Tène art.

In addition to these, however, representations occur on rock faces and in caves in Britain, where the date is often very difficult to determine, but where they are likely to emanate from the Iron Age or Dark Ages. This type of representational rock art can be found as early as the Bronze Age in Scandinavia – examples in Sweden have been dated to 1500 BC – and it is found in the Early Iron Age at Val Camonica in northern Italy. In this art, animals are found juxtaposed with human figures and with various symbols which suggest that many elements of later Celtic belief were already present in Bronze Age (and arguably, Neolithic) European society.

One group of horned animals in a rock shelter at Goatscrag, North-

Naturalistic animals on rocks etc.
(A, B) Eggerness, Wigtowns
(C, D) Dunadd, Argyll (E) Kilphedir,
South Uist, (F, G) King's Cave, Arran
(H) Binney Craig, West Lothian
(drawings: Lloyd Laing)

umberland, have been dated speculatively to the early centuries AD; others can be found in the King's Cave, Arran, where the carvings seem to be of various dates, starting with a Bronze Age cup-mark and continuing through to interlacing snakes of the seventh or eighth century, and a horseman, possibly of later medieval date. In Galloway, an important series of such carvings has been found on rock faces at Eggerness, Wigtown, where the most diagnostic is a stag with hip and shoulder spirals, comparable with those to be seen on Pictish symbol stones (or other animals of known early medieval date). Here, some backward-looking creatures are reminiscent of examples on pagan Anglo-Saxon pottery – this is a tradition which is not specifically Celtic. Other animals appear on a rock face at Ballochmyle, Ayrshire.

These animals can be considered in the same context as those that appear as Pictish 'symbols' on incised stone monuments of the fifth century onwards in northern Scotland, and which are also found on cave walls, and sometimes on metalwork and small pieces of stone or bone in the Pictish region. A recent study has suggested that the immediate inspiration behind the Pictish beasts may be Roman representations of animals, but clearly, whatever the immediate prototypes, the tradition is much more ancient.

Such naturalistic animals can be found in many different Celtic contexts, in a variety of media. Usually basic outline figures, or with the minimum of detail, they have been found on an Iron Age bone slip from Lough Crew in Ireland, on Dark Age potsherds from the Hebrides, on 'motif pieces' from the later Dark Age monastery at Kingarth in Bute, and on a cist slab from the Isle of Man. At Dunadd in Argyll, they occur on a motif piece and in the form of a solitary boar on a rock face. A horse, not unlike examples in rock carvings, appears on a stone cup from Binney Craig, West Lothian. Very occasionally, schematic human figures are found in addition to the animals. At Jarlshof in Shetland, 'portrait' sketches on

Early medieval animal ornament (A) Durham A1117 (B) Collectio Canonum, Cologne (C) Durham Cassiodorus (D) 'Tara' Brooch (E) Lindisfarne Gospels (F) 'Tara' Brooch (drawings: Lloyd Laing)

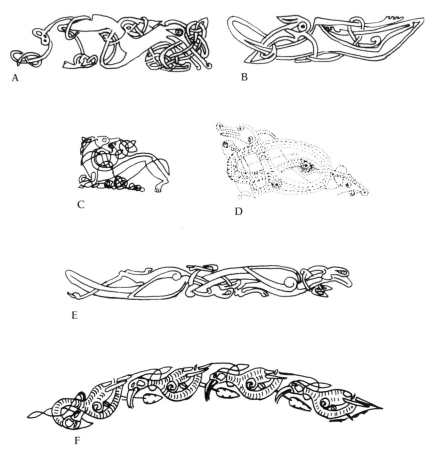

pieces of stone have been noticed. This is 'alternative' Celtic art, and serves as a useful reminder that not all art produced by Celts was what we think of as Celtic.

Growing contact with their Anglo-Saxon neighbours led artists to experiment with other types of representational animal ornament from the sixth century onwards. The fashion began with creatures borrowed from Mediterranean art of the period, and with others derived from Germanic art, notably the creatures of Anglo-Saxon inspiration found in the Book of Durrow. But, whereas Anglo-Saxon designers created animals which have a tendency to disintegrate into interlace, their Celtic counterparts retained the anatomy of their subjects: the only elements that are interlaced being the tails and what are termed 'lappets' – an extension of the ear or sometimes the lip.

The first artist so far known to adopt Anglo-Saxon animal ornament was an illuminator of the Book of Durrow, who created a procession of creatures with long snouts which bite the creatures in front. They appear only on folio 192v, and are closely related to some beasts depicted in the Sutton Hoo find and on other Anglo-Saxon objects.

Later manuscript artists employed a type of animal with jaws that do not overlap, but with a long snout with swollen nostril. This creature, which has ear lappets and interlaced tail, appears in a book known as the

Durham Cathedral A 11 17 or the Durham Gospels. It dates from the late seventh century and, as with most Insular manuscripts, its provenance has been debated – current opinion seems to favour Northumbria. A related animal appears on a foil from Dunadd, Argyll, showing one route by which such animals passed into Irish art.

The next stage in the development of the Celtic artistic repertoire is represented by animals which appear in the Lindisfarne Gospels. Here the bestiary includes shorter, open-jawed quadrupeds with bared teeth and elongated ears that end in interlace, as well as more docile felines (albeit with fierce-looking claws) and long-beaked, long-legged birds. The creatures in Lindisfarne were copied or adapted in many manifestations of Celtic art, from the Pictish stone slab in Aberlemno Churchyard, Angus, to the 'Tara' and Hunterston Brooches. Their creators gave the Celtic creatures shoulder and hip spirals, and also hatched (sometimes herringbone) infilling on their bodies. It is probably reasonable to assume that these animals were developed through an interplay of ideas between various parts of Britain and Ireland. The 'Tara' Brooch tradition of animal ornament employs quadrupeds and less frequently birds, in the guise of predators.

Symbolism and Abstraction

It has been suggested that all Iron Age Celtic art was to a greater or lesser degree symbolic, and certainly symbolism is an important factor in understanding its function in society.

Although, as has been noted, representation was of relatively minor importance in Celtic art as a whole, a study of representational Celtic art of the Iron Age aids an understanding of Celtic attitudes. A recent study of the religious art of the Iron Age Celts has argued that three factors were at work – the multiplication of the image, the schematization of the design, and the emphasis on particular attributes.

The multiplication of the image increased its potency: if deities were represented twice on the same sculpture, they became twice as powerful; if they were represented thrice, they not only had their power multiplied three-fold, but acquired additional magic through the magic number three. Thus the Three Mothers, or the three Genii Cucullati, can be found in Romano-Celtic sculpture, or a triple deity on the coins of Rheims. The triple head to the deity on a sculpture from Corleck, Co. Cavan, made the being much more potent. This rule applied to attributes as well – triple horns were more powerful than two, and the triskele was clearly a powerful symbol since it incorporated the magic number in its legs.

The second feature is schematization. It is frequently remarked that the human figure is represented in pre-Christian Celtic art in the form of a pin-man, or after the manner of a child's drawing. This was due not to incompetence, but to a desire to strip the subject down to its essentials. Accurate representation was inappropriate for a deity; the more it was simplified the more the image expressed the essential 'numen' or spirit. In addition, the more a representation was simplified, the more it could be used to mean different things to different people. A figure with rudi-

Tres Matres, Cirencester, Gloucester-
shire (Corinium Museum, Cirencester)

mentary 'horns' could be a Celtic god, or Mercury wearing a winged hat, to taste. The ambiguity of the image was in keeping with the ambiguity of religious belief; one deity could have many aspects.

The third trend in Celtic representation involved the emphasis on a part of the figure or its key attribute. This is most clearly apparent in the selection of the head for emphasis. The head was the most important part of the body and seat of the 'soul'. Accordingly, heads can be represented without bodies, or with bodies which are much more schematized; multiple heads can be represented, or heads out of proportion to their bodies, with features reduced to essentials, of which the eyes were the most important. Similarly, attributes of particular deities may be emphasised at the expense of the figure – horns for example – and the same may be done with animals.

see pp. 202–03
and p. 206

A further notable feature of pagan Celtic art which stems from the nature of its religious belief is the ambiguity of the imagery. Faces can be found in abstract ornament, and one face can be turned into another by being viewed from a different angle. Many examples can be found in this book, from the designs on the Battersea Shield to the images on the coins of Tasciovanus. Celtic belief was much concerned with shape-changing, and by producing ambiguous images the artists were perhaps hiding the power of their images from those for whose eyes they were not intended.

Visual ambiguity is seen very clearly in coinage – the more one looks at Celtic British coins, the more human and animal faces become apparent.

This ambiguity is most notably apparent on the obverses, where what started out as profile heads rapidly turned into a mass of pattern representing the hair and wreath. In this, faces start to manifest themselves. On the Westerham type of stater, for example, current in Hampshire and Sussex, early versions have a clear profile head. This became abstracted, and on later versions eyebrows and eyes, sometimes with a nose, peer out of the undergrowth of hair and wreath. What may be an owl face appears on some coins of the Corieltauvi, while a huge smiling face adorns the 'Cheriton' type of stater of the Durotriges. Perhaps the finest example of visual ambiguity, however, is apparent on the gold staters of the first coinage of Tasciovanus of the Catuvellauni, on the coins of Andocommius, which have a pair of dismayed faces with downturned mouths, back to back on the obverse.

In the context of ambiguity, the Battersea Shield is highly significant. Probably never intended for use in battle, it was perhaps a votive offering for the gods, possibly from a Thames-side shrine. Eyes of 'reversible' faces appear on it whichever way up they are viewed – this has been likened to the Cheshire Cat in *Alice in Wonderland*. The animal heads joining the terminals with the central roundel seem to be very stylized oxen, the noses of which could also serve (with rivets for eyes) for a face with a large mouth swallowing the lower roundel.

Mention has been made of the triskele as a symbolic motif. How far the other motifs of Celtic art had specific meanings is not clear, though wheels and wheel-like symbols were clearly significant, and it is very likely that trumpet patterns and spirals originated in religious belief.

One of the main developments of recent years has been the realization of the extent to which Celtic art of the Christian period is also very symbolic. The awareness of this has come only with the detailed study of early ecclesiastical texts, and many features of iconography which are still not understood may become more intelligible as research proceeds.

The symbolism stems from the Christian faith and seems to have been applicable as much to secular art as to ecclesiastical. Penannular brooches, for example, may have hidden meanings in their design. The Hunterston Brooch seems ultimately to be inspired by a reliquary – the panel on the junction of the terminals has a cross for its design, which resembles a book shrine in layout and, with its flanking bird heads, can be matched on the Continent. The symbolism does not stop there, however, since the filigree and other creatures that appear on the brooch seem to represent the beasts of the earth, sea and land alluded to in Genesis 1. A head flanked by birds on a Celtic brooch pin fragment from Skjeggenes in Norway has been seen to represent Christ, while the bird heads on the Cadboll and other Pictish brooches have been seen as symbolic, perhaps representing doves drinking at the Fountain of Life. The birds on these brooches, and the animal heads on some rare brooches with dragon-head terminals, were best seen when the wearer of the brooch looked down, suggesting that this was some kind of personal symbolism. Given that penannular brooches were produced in monastic workshops, some may well have had an ecclesiastical function (one belonging to Columba was venerated as a relic). Christian symbolism, however, does not necessarily mean an

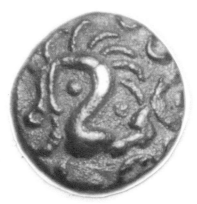

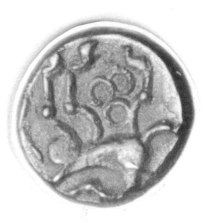

Ambiguous 'dragon' design on silver coin from near Rochester, Kent (photo: Chris Rudd; drawing Lloyd Laing)

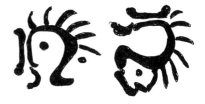

ecclesiastical usage – some of the earlier penannulars, with a cross on the terminals, may belong to the same kind of tradition as modern St Christopher badges.

It has been suggested that interlace animal ornament was seen in many Dark Age societies as protective, and there is growing evidence that the Irish Church was quite happy to draw on the pagan past to advance its status in society. It has also been pointed out that various other forms of interlace may have had a protective function. This can be seen in other areas of the world too. A pattern of interlace knotwork of the seventh or eighth century in a church mosaic in Jordan, set at the entrance to the nave, carries an inscription 'God (be) with us'. The idea of knots as a means of confusing the Devil and keeping evil spirits at bay is widespread both geographically and in time. The addition of an animal's head or legs brought the knot to life and increased its magic power. An eighth-century story about Conall Cernach, the Irish warrior, relates how he attacked a fortress defended by a serpent which slid into his waistband and enabled him to conquer the fort.

Turning to specifically Christian art, the symbolism becomes much more complex to understand as can be seen from the Ardagh Chalice and Derrynaflan Chalice and Paten. On the Ardagh Chalice, number symbolism has been seen in the arrangement of the studs, following the precepts of the Irish monk John Scotus Eriugena, and number symbolism may also have been employed in the construction of the Derrynaflan paten. This is due to the complex symbolism that was attendant on the breaking of bread, the ceremony of *fractus panem* observed in the Middle Ages. The loaf had to be broken into a number of pieces according to the liturgical calendar, then arranged in a symbolic pattern on the paten – in sixth-century Gaul this was in the form of a human figure. The Stowe Missal, an Irish manuscript of around AD 800, sets out the appropriate numerical division for various occasions, and explains the symbolism.

The filigree animals on the paten and on the Derrynaflan Chalice may also have been more symbolic than at first appears. The filigree griffin on the chalice probably represented the dual nature of Christ. On the paten we are looking at a similarly complex symbolism – some, such as the stag and serpent, seem to have come from an allegorical story from a book known as the *Physiologus*.

At first sight the bosses on the Iona crosses are simply derivatives of metalwork ornaments, but not so – the snake bosses that appear here and in Pictland are sophisticated symbols. The snake spiral is also found in various contexts in the Book of Kells. 'The snake,' wrote Françoise Henry

> can be a symbol of evil, a memory of the Fall of our first parents, but it can also be a symbol of eternity, or of resurrection, because it sheds its skin and comes out of it alive. I am inclined to think that if it had a meaning in the pages of the Book it must be the latter, because of the confidence with which the painters spread whole patterns of snakes in the most conspicuous parts of the pages. (*The Book of Kells*, 1974, 208)

Further Reading

The Prehistoric Celts in Britain and Ireland – Archaeology

The best general introduction to the Celts in Europe is Moscati, S. et al. *The Celts*, Bompiani (1991), reprinted in London. This is the volume produced to accompany the Venice Celtic Exhibition, and runs to nearly 800 lavishly illustrated pages, which discusses Britain in a wider context. A more modest study of the Celts in Europe is provided by Collis, J. *The European Iron Age*, London (1984). Somewhat older is Powell, T. G. E. *The Celts*, 2nd ed. London (1980). Iron Age Britain is exhaustively served by Cunliffe, B. *Iron Age Communities in Britain*, 3rd ed., London (1991), and by the less extensive and now slightly outdated Harding, D. W. *The Iron Age in Lowland Britain*, London (1974). The Iron Age in its wider prehistoric context can be found in Megaw, J. V. S. & Simpson, D. D. A. *Introduction to British Prehistory*, Leicester (1979), and in Darvill, T. *Prehistoric Britain*, 2nd ed., London (1987). A popular account can be found in Laing, L. *Celtic Britain*, London (1979). Regional studies of Scotland and Ireland are provided by Ritchie, A. & Ritchie, G. *Scotland*, 2nd ed. London (1992), Raftery, B. *Pagan Celtic Ireland*, London (1994) and O'Kelly, M. J. *Prehistoric Ireland*, London (1989). Turning to specific subjects, Hogg, A. H. A. *Hillforts of Britain*, London (1975) and Ford-Johnson, J. *Hillforts of the Iron Age in England and Wales*, Liverpool (1976) are good introductions. Cunliffe, B. *Danebury, Anatomy of an Iron Age Hillfort*, London (1986) is a fascinating summary account of one particular site, while Alcock, L. *By South Cadbury is that Camelot* London (1972) is another, in this case with occupation extending to the medieval period. The chariot burials of Yorkshire are discussed in Stead, I. M. *The Arras Culture*, York (1979), while the death and life of one Celt is discussed in Stead, I. M. Bourke, J. B. & Brothwell, D. *Lindow Man, the Body in the Bog*, London (1986). Overseas trade and connections are dealt with in Macready, S. & Thompson, F. H. (eds) *Cross-Channel Trade between Gaul and Britain in the Pre-Roman Iron Age*, London (1984). Religion is the subject of Piggott, S. *The Druids*, London (1968), Green, M. *The Gods of the Celts*, Gloucester (1986) and Ross, A. *Pagan Celtic Britain*, London (1967). Mac Cana, P. *Celtic Mythology*, Feltham (1983), is a fascinating introduction to its subject. Celtic society in Britain is discussed in Jackson, K. H. *The Oldest Irish Tradition: a Window on the Early Iron Age*, Edinburgh (1964) and in Dillon, M. (ed) *Early Irish Society*, Dublin (1954).

Romano-Celtic Period – Archaeology

The standard accounts of Roman Britain are Salway, P. *Roman Britain*, Oxford (1980) and Frere, S. S. *Britannia*, London (1974). Johnson, S. *Later*

Roman Britain, London (1980) and Cleary, A. S. E. The Ending of Roman Britain, London (1989) are useful studies of the overlap. For communities in North Britain, Breeze, D. J. Northern Frontiers of Roman Britain, London (1982) and Higham, N. The Northern Counties to AD 1000, London (1986) will be found particularly useful. Also, generally informative despite its date is Salway, P. The Frontier People of Roman Britain, Cambridge (1965).

The Medieval Celts in Britain and Ireland – Archaeology

The archaeology of the early medieval Celts is not as well served by books as that of their Iron Age predecessors. For the subject as a whole, Laing, L. R. The Archaeology of Late Celtic Britain and Ireland, c. AD 400–1200, London (1975) is a detailed though now outdated survey. Laing, L. & J. Celtic Britain and Ireland, the Myth of the Dark Ages, Dublin (1990) deals with specific problems. Another general survey is provided by Alcock, L. Arthur's Britain, London (1971), still useful despite its date. Surprisingly, Ireland is not well covered, though the subject is adequately treated in Edwards, N. The Archaeology of Early Medieval Ireland, London (1990), and in the older but more readable de Paor, M. & L. Early Christian Ireland (1958). Northern Scotland is better covered, with Henderson, I. The Picts, London (1967), Ritchie, A. The Picts, Edinburgh (1989), and Laing, L. & J. The Picts and the Scots, Stroud (1993). The early history of Scotland is well discussed in Smyth, A. P. Warlords and Holy Men, London (1984) and Duncan, A. A. M. Scotland: the Making of a Kingdom, London (1975).

Iron Age Celtic Art

Iron Age Celtic art in its European context is covered by Megaw, R. & J. V. S. Celtic Art, London (1989) and by Laing, L. & J. Art of the Celts, London (1990). Of particular value is Stead, I. M. Celtic Art, London (1985), which has superb colour illustrations, and is concerned specifically with Britain. A short introduction is provided by Megaw, R. & J. V. S. Early Celtic Art in Britain and Ireland, Princes Risborough (1986). Of the older works, Fox, C. Pattern and Purpose: Early Celtic Art in Britain, Cardiff (1958), remains a classic, though his grouping into regional schools is not generally now followed. Also interesting is Leeds, E. T. Celtic Ornament in the British Isles to AD 700, Oxford (1933), which is still the best discussion of some types of object. Some key pieces can be found in Brailsford, J. Early Celtic Masterpeices in the British Museum, London (1975), which has excellent illustrations. Kilbride-Jones, H. E. Celtic Craftsmanship in Bronze, London (1980) has some perceptive comments and superb illustrations, some of which reappear in this book. The art of northern Britain is dealt with fully in MacGregor, M. Early Celtic Art in North Britain, Leicester, 2 vols (1976).

Romano-Celtic Art

Little has been written on this specifically, but Romano-British art as a whole is covered by Toynbee, J. M. C. Art in Britain under the Romans, Oxford (1964) and Art in Roman Britain, London (1963), the latter an exhibition

catalogue. The art of the areas outside the province, however, are dealt with in MacGregor (1976), above. Some aspects of sculptural style is covered by Lindgren, M. C. *Classical Art and Celtic Mutations*, Park Ridge, New Jersey (1980).

Early Medieval Celtic Art

There is no general survey dealing exclusively with this period in both Britain and Ireland, except the very brief and inadequate essay published by Laing, L. *Later Celtic Art in Britain and Ireland*, Princes Risborough (1987). This does not cover sculpture, which is dealt with by Seaborne, M. *Celtic Crosses of Britain and Ireland*, 2nd ed. (1994). Ireland, however, is well covered by three volumes by Henry, F.: *Irish Art to AD 800* (1965), *Irish Art During the Viking Invasions, 800–1020* (1967) and *Irish Art in the Romanesque Period, 1020–1170* (1970), all published in London. The classic study of Irish art in this period was Mahr, A. & Raftery, J. *Christian Art in Ancient Ireland*, 2 vols, Dublin (1932 and 1941), reprinted in the US in one volume in 1970. Also useful for Irish art with superb illustrations is *Treasures of Ireland: Irish Art 3000 BC to AD 1500*, Dublin (1983). Irish art is set in a wider chronological perspective in Arnold, B. *A Concise History of Irish Art*, London (1977) and in Harbison, P. & Potterton, P. *Irish Art and Architecture from Prehistory to the Present*, London (1978). Some 'classics' that have seen recent reprints are Anderson, J. & Allen, J. R. *Early Christian Monuments of Scotland*, Edinburgh (1904), reprinted in 2 vols, Belgavie (1993); this remains a masterpiece which gathers together all the Pictish and other sculptures in Dark Age Scotland. Allen, J. R. *Celtic Art*, London (1904, reprinted London 1993), was another pioneering study, and Allen, J. R. *Celtic Crosses in Wales (1899)*, reprinted in one vol. Llanerch, Dyfed (1989), remains useful. In these essays Allen set out his original analysis of Celtic design, which he elaborated upon in the two other books cited. Also reprinted 1994 is Kermode, P. M. C. *Manx Crosses*, Balgavie. This was originally published in 1907. In addition, Romilly Allen's volume of lectures on *Early Christian Symbolism in Britain and Ireland (1885)* has now been reprinted by Llanerch (1994). This deals primarily with the symbolism in Celtic art, and again was a pioneering study. A superbly illustrated exhibition catalogue with valuable essays is Youngs, S. (ed) *The Work of Angels*, London (1989). Metalwork is also the subject of Laing, L. *A Catalogue of Celtic Ornamental Metalwork in the British Isles, c. AD 400–1200*, Oxford (1993). Two collections of papers are of paramount importance. They are Ryan, M. (ed) *Ireland and Insular Art, AD 500-1200*, Dublin (1987) and Spearman, M. & Higgitt, J. (eds) *The Age of Migrating Ideas*, Edinburgh (1993). Still with collections of papers, mention may be made of Karkov, C. & Farrell, R. (eds), *Studies in Insular Art and Archaeology*, Oxford, Ohio (1991) and Rynne, E. (ed) *Figures from the Past: Studies in Figurative Art in Christian Ireland in Honour of Helen Roe*, Dublin (1987). Although not confined to Celtic art, Higgitt, J. (ed) *Early Medieval Sculpture in Britain and Ireland*, Oxford (1986), contains a number of key studies. On specific aspects, High Crosses are exhaustively treated in the standard work, Harbison, P. *High Crosses of Ireland*, 2 vols, Bonn (1992), though they can

also be found less thoroughly described in Henry, F. *Irish Crosses*, Dublin (1964). Their iconography is discussed in Crawford, H. S. *Handbook of Carved Ornament from Irish Monuments from the Christian Period*, Dublin (1926). Welsh sculpture is accessibly discussed in Redknap, M. *The Christian Celts*, Cardiff (1991), and in the definitive corpus, Nash-Williams, V. E. *Early Christian Monuments of Wales*, Cardiff (1950). The Scottish sculptures are dealt with in the books on the Picts detailed above and in Allen and Anderson (1904), but to these may be added Jackson, A. *The Symbol Stones of Scotland,* Kirkwall (1984). Of studies of particular objects or groups of objects, mention may be made of Wilson, D., Small, A. and Thomas, C. *St Ninian's Isle and its Treasure*, 2 vols, Aberdeen (1973), Ryan, M. (ed) *The Derrynaflan Hoard I: A Preliminary Account*, Dublin (1983), and Bourke, C. *Patrick: the Archaeology of a Saint*, Belfast (1993), which discusses among other things the Blackwater Shrine. Motif pieces are discussed in O'Meadhra, U. *Early Christian, Viking and Romanesque Art: motif pieces from Ireland*, 2 vols, Stockholm (1979, 1987)..Manuscripts are the subject of Nordenfalk, C. *Celtic and Anglo-Saxon Painting*, London (1977), Henderson, G. *From Durrow to Kells, the Insular Gospel Books*, London (1987), and Alexander, J. J. G. *A Survey of Manuscripts Illuminated in the British Isles, 6th to 9th Century*, London (1977). The Book of Kells can be found in Henry, F. *The Book of Kells*, London (1974) and Brown, P. *The Book of Kells*, London (1980). Although not confined to the Celtic areas, Hicks, C. *Animals in Medieval Art*, Edinburgh (1994) is extremely useful for many aspects of Celtic art.

Index

Figures in italics refer to illustrations